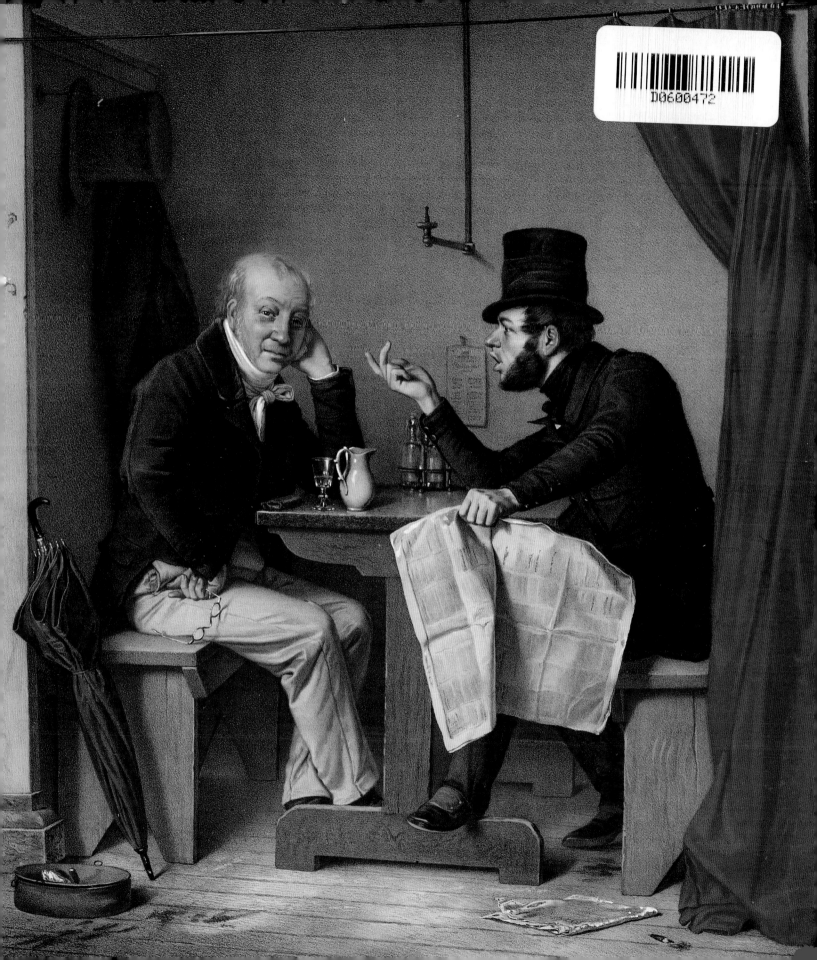

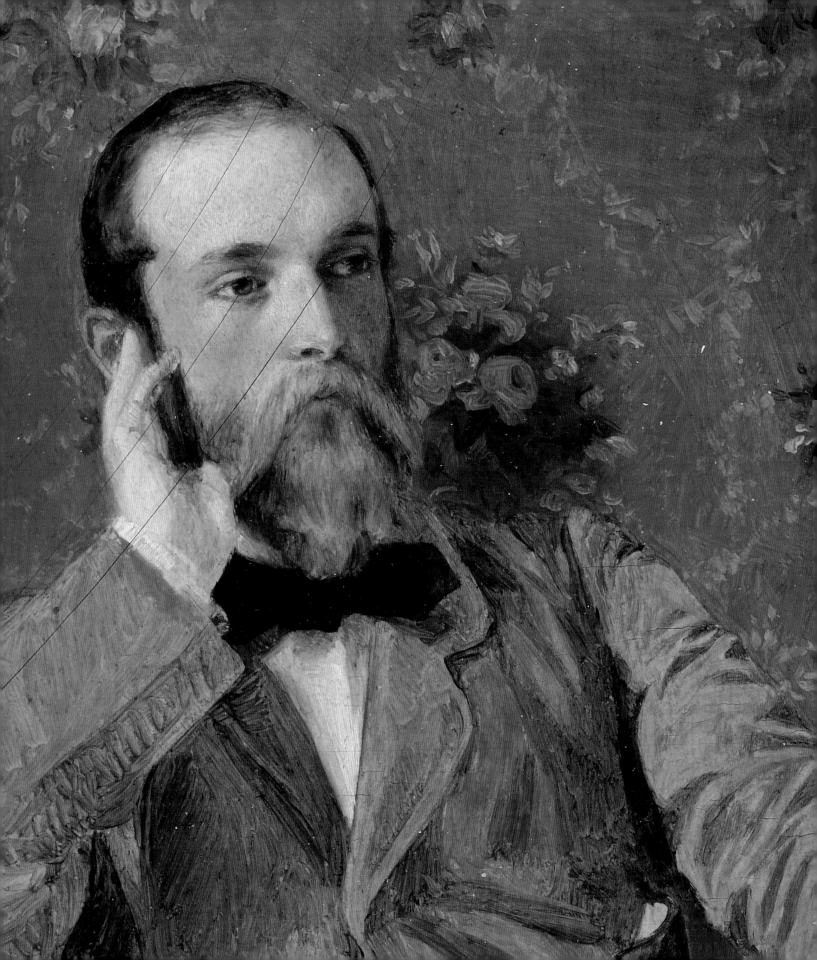

NEW EYES ON AMERICA THE GENIUS OF RICHARD CATON WOODVILLE

Edited by
JOY PETERSON HEYRMAN

With contributions by
MARIE-STÉPHANIE DELAMAIRE
ERIC GORDON
SETH ROCKMAN
JOCHEN WIERICH

The Walters Art Museum, Baltimore
Distributed by Yale University Press, New Haven and London

The exhibition has been generously sponsored by the Women's Committee of the Walters Art Museum and Wilmington Trust, with grant funds from the U.S. Institute of Museum and Library Services, the Wyeth Foundation for American Art, the Bernard Family, Charlesmead Foundation, Frederick and Mary Louise Preis, and other generous individuals.

This publication accompanies the exhibition *New Eyes on America: The Genius of Richard Caton Woodville*, held at the Walters Art Museum, Baltimore, Maryland, from March 10, 2013, to June 2, 2013, and at The Mint Museum, Charlotte, North Carolina, from June 30, 2013, to November 3, 2013.

Published by the Walters Art Museum
© 2012 Trustees of the Walters Art Gallery

The Walters Art Museum
600 North Charles Street
Baltimore, Maryland 21201
thewalters.org

Distributed by
Yale University Press
P.O. Box 209040
302 Temple Street
New Haven, Connecticut 06520-9040
yalebooks.com/art

Library of Congress
Cataloging-in-Publication Data

New eyes on America : the genius of Richard Caton Woodville / edited by Joy Peterson Heyrman, with contributions by Marie-Stéphanie Delamaire, Eric Gordon, Seth Rockman, Jochen Wierich.

 pages cm

 This publication accompanies the exhibition New Eyes on America: The Genius of Richard Caton Woodville, held at the Walters Art Museum from March 10, 2013, to June 2, 2013, and at the Mint Museum, Charlotte, North Carolina, from June 30, 2013, to November 3, 2013.

 Includes bibliographical references and index.
 ISBN 978-0-300-19450-0 (pbk.)
 1. Woodville, Richard Caton, 1825–1855—Exhibitions. I. Heyrman, Joy Peterson, editor of compilation. II. Walters Art Museum (Baltimore, Md.) host institution. III. Mint Museum (Charlotte, N.C.) host institution.
 ND237.W82A4 2012
 759.13—dc23

 2012029896

Catalogue entries by Joy Peterson Heyrman
Technical notes by Eric Gordon and Gwen Manthey

Editor & Manager of Curatorial Publications:
 Charles Dibble
Curatorial Publications Coordinator, Designer:
 Jennifer Corr Paulson

Printed in China through Four Colour Print Group, Louisville, KY

All dimensions are in centimeters; height precedes width unless otherwise indicated; print measurements are full sheet dimensions.

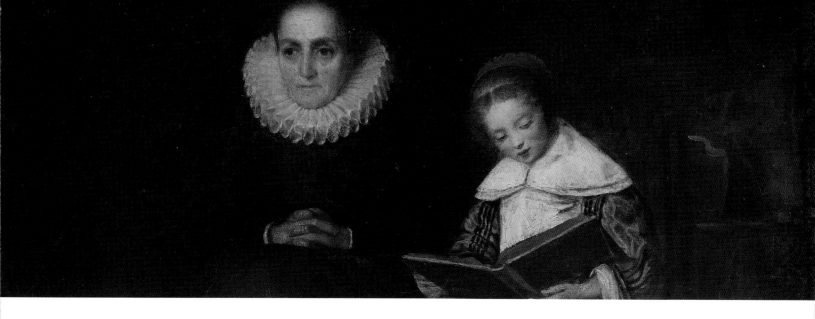

Contents

List of Lenders

The Baltimore Museum of Art Baltimore, Maryland
Collection of Stiles Tuttle Colwill
Corcoran Gallery of Art Washington, D.C.
Crystal Bridges Museum of American Art Bentonville, Arkansas
Detroit Institute of Arts Detroit, Michigan
Godel & Co., Inc. New York, New York
The Sheridan Libraries, The Johns Hopkins University Baltimore, Maryland
Maryland Historical Society Baltimore, Maryland
The New-York Historical Society New York, New York
Private Collections
The Walters Art Museum Baltimore, Maryland
Elizabeth Caton Woodville Callender

Contributors

JOY PETERSON HEYRMAN is exhibition curator for American art for *New Eyes on America: The Genius of Richard Caton Woodville*, and Deputy Director for Development at the Walters Art Museum, Baltimore, Maryland.

MARIE-STÉPHANIE DELAMAIRE is a Ph.D. candidate in the Department of Art History and Archaeology at Columbia University, New York.

ERIC GORDON is Head of Painting Conservation at the Walters Art Museum, Baltimore, Maryland.

SETH ROCKMAN is Associate Professor of History at Brown University, Providence, Rhode Island.

JOCHEN WIERICH is Curator of Art at Cheekwood Botanical Garden & Museum of Art, Nashville, Tennessee.

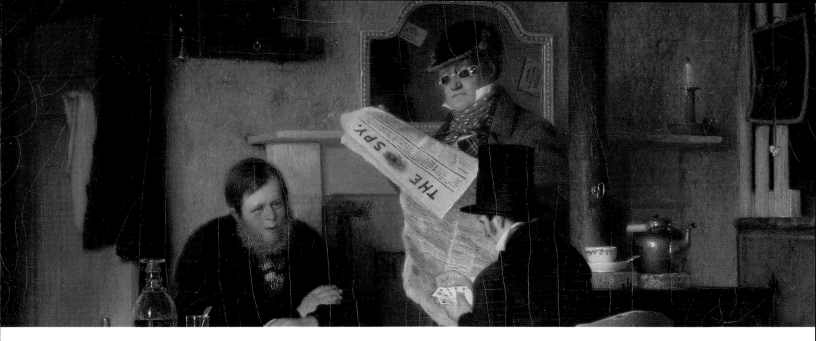

Foreword

GARY VIKAN *Director of the Walters Art Museum*

DURING THE YEARS BEFORE THE CIVIL WAR, Baltimore financier William T.
Walters patronized the artists of his time. He purchased *The Sailor's Wedding* by the
American painter Richard Caton Woodville in the 1860s. The encyclopedic collec-
tion of world art that his son, Henry Walters, bequeathed to the City and people of
Baltimore included some 650 American works: Hudson River School landscapes,
sentimental genre scenes, and an extensive collection of drawings. Through subse-
quent gifts and purchases, the Walters Art Museum now holds eight paintings and
numerous works on paper by Richard Caton Woodville, a small part of our American
collection but half of the small oeuvre of this short-lived but influential artist.

Woodville's jewel-like works offer many points of access, including the pleasure
of close looking and engagement with visual narrative and historical commentary.
He was occupied with his own times, and addressed contemporary themes that
continue to have relevance today, such as the gaps in communication and conflicts
among generations, the disruptive effects of new technologies (for him the telegraph
and railroads), and society's responses to war. The African-American figures he
included as observers to the central narrative in many of his paintings are sensitively
rendered, distinctly different from the stereotyping and caricature too often seen in
genre works of the period. The ambiguity of this artist's work is central to its last-
ing power. In a time when artists often took a clear moral, even moralizing, stance,

Woodville addressed the untrustworthy transmission of information, the uncertain relations between strangers in anonymous public spaces, and the unsettling effects of the shift in power from Revolutionary heroes to the younger, "go-ahead" post-Jacksonian generation.

Richard Caton Woodville has always intrigued viewers and scholars. A bold-faced name in the nascent art press of the 1840s and 1850s, he left no letters, no diaries. *New Eyes on America: The Genius of Richard Woodville*—the first monographic exhibition of the painter's work since 1967, including all of Woodville's known works and several that have never been published or exhibited—reexamines Woodville's brief but intense career, the political, artistic and social environments he inhabited in Baltimore and in Germany, the shift in emphasis in genre painting in the early nineteenth-century, and his central role in the distribution of visual imagery in our young country through the American Art-Union. An extensive technical study analyzing the materials and techniques of each work investigates how Woodville produced his finely crafted, complex paintings, and how they changed or developed as he moved from Baltimore to Düsseldorf to Paris to London, where he died at the age of thirty.

We are deeply grateful to the many funders who have made this project possible, including our lead sponsor, the Women's Committee of the Walters Art Museum, and our corporate sponsor, Wilmington Trust, with grant funds from the U.S. Institute of Museum and Library Services. The Wyeth Foundation for American Art provided generously for the technical research project. Additional donors, excited about the possibility of shining a spotlight on this marvelous artist, include the Bernard Family, the Charlesmead Foundation, Frederick and Mary Louise Preis, Gretchen Redden, Sally Craig, and an anonymous donor.

Acknowledgments

THE EXHIBITION'S CURATOR, Joy Peterson Heyrman, has benefited from the knowledge and assistance of individuals too numerous to fully acknowledge, including Woodville descendants Sally Craig and Gail Roberson, Elizabeth and Gordon Callender, and Pamela and Greg Graham. Stiles Colwill shared generously of his encyclopedic knowledge of artists with Maryland connections and loaned generously from his collection. Chris Pennington found the portrait of his ancestor Maria Johnston stashed in his attic. Museum colleagues have embraced this project with enthusiasm, sharing knowledge and Woodville paintings and works on paper, including David Park Curry and Rena Hoisington at the Baltimore Museum of Art, Sarah Cash at the Corcoran Gallery of Art, Kevin Murphy at the Crystal Bridges Museum of

American Art, Kenneth J. Myers at the Detroit Institute of Arts, Alexandra Deutsch at the Maryland Historical Society, and Kimberly Orcutt at the New-York Historical Society. Katherine Baumgartner provided generous access to the Godel Gallery's early painting. Bettina Baumgärtel, Chief Curator at the Museum Kunstpalast, and Sabine Schroyen, archivist at the Künstlerverein Malkasten Archive and Collection in Düsseldorf, both provided important new information and leads to pursue on Woodville's six formative years in that charming city.

The Exhibition Advisory Committee, Carol Aiken, Wendy Bellion, Jo Briggs, Peter John Brownlee, Marie-Stéphanie Delamaire, Maurie McInnis, Seth Rockman, Jonathan Sperber, and Jochen Wierich, shared their specialists' knowledge on topics ranging from imagery of American slavery, to miniature painters working in antebellum Baltimore, to the introduction of daguerreotype studios, to the city in 1839. The committee included the eminent scholars Elizabeth Johns and Justin Wolff, whose books on American genre painting and on Richard Caton Woodville respectively, are the firm foundation on which this project was built.

At the Walters, Head of Painting Conservation Eric Gordon has been a key partner, sharing his knowledge and findings from countless hours of investigation and directing the technical research, with the enthusiastic involvement of Wyeth Conservation Fellow Gwen Manthey. The cross-divisional Woodville Exhibition Team of Walters staff has brought energy, talent, and excitement to every aspect of this project, from exhibition design and publication, audience research, curriculum connections, public programs, and the myriad steps of bringing the works of art together in the galleries. Their creativity and professionalism are apparent in every detail. The project benefited greatly from the good work of interns Beth Dion, Caroline Passano, and Carrie McNeil.

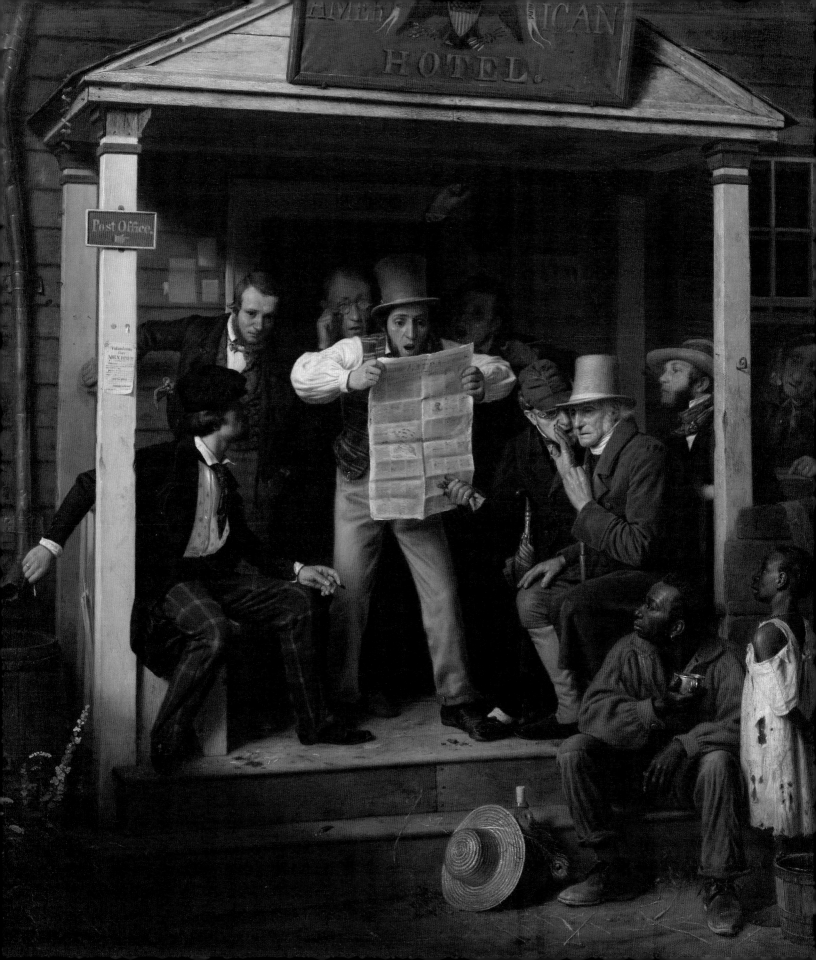

The Genius of Richard Caton Woodville

JOY PETERSON HEYRMAN

A DENSE GROUP OF MEN OF VARYING AGES clusters on the front porch of the American Hotel, which doubles as a post office. The young one at the center clutches a newspaper in both hands, arms akimbo, leaning forward and reacting with surprise to the words on the page. Around him, in a frozen moment, others listen, react, and pass on information. An African-American man and girl, on the sidelines of the action but central to the scene, listen for word of the war that might affect their fate, expanding the territory where enslaved labor was allowed from the new State of Texas west. The man's bright red shirt and blue trousers and the girl's tattered white dress place the scene in a new America, where the ideals of democracy and personal freedom that distinguished the young republic are unequally applied and the cracks and fissures of that system are on show. This erosion of founding principles is underscored by the advanced age and deaf ear of the old man from the Revolutionary era seated at the right. He receives his news from a questionable source, a man with tattered gloves, eye-shielding goggles, and umbrella, all attributes of a fast-paced new modernity.

Once our own eyes have taken in the scope of the scene, we begin to focus in on its significant and lovingly rendered details. A dazzling still life with straw hat, corked jug, and peacock feather occupies the base of the stairs. The painted wooden facing of one of the support posts has fallen off, and a kite string, with knotted ribbons, hangs enigmatically from the roof. A mullein plant and Queen Anne's lace grow weed-like by the steps. A pile of spent matches and ashes at the feet of the well-dressed young man loafing on the left and a placard calling for "Volunteers for Mexico" over his head point to the fact that the sacrifices of war service have not been universal.

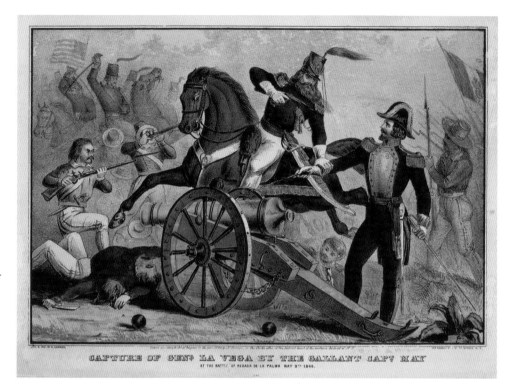

Fig. 1. Nathanial Currier, *Capture of Genl. La Vega by the Gallant Capt. May at the Battle of Resaca de la Palma May 9th 1846*, 1846. Lithograph with applied watercolor, 21.6 × 32.4. Amon Carter Museum of American Art, Fort Worth, Texas (1971.66).

War News from Mexico (cat. no. 8) is Richard Caton Woodville's most famous work. Not a battle scene, it appeared after the war's conclusion in 1848, depicting the home front and centered on a novelty of the moment: the transmission of breaking news by telegraph to the penny press. Particulars of the artist's situation add depth and nuance to our experience of this compelling painting. He produced this work in Düsseldorf, Germany, in 1848, when all of his news about the conclusion of that war would have been refracted through the revolutionary activity occurring in the streets around him. One of his closest childhood friends, the young surgeon Stedman Tilghman, died from effects of his service in the Mexican War in that year. The artist's native city of Baltimore had been divided in its support and opposition, a premonition of the deep divisions in the Civil War years to come. In a telling revision to the painting, revealed in the technical research published in this volume (see pp. 65–81), the artist altered the expression of the young man standing at left from euphoric, hat-swinging enthusiasm to pensive reflection with a gesture of knocking wood, adding to the work's ambiguity and complicating a simple reading of the artist's point of view. In the broader marketplace, this painting was a unique luxury object produced for the galleries of the American Art-Union and thus at the opposite pole of visual communication from the quickly produced "current events" prints of battlefield action marketed by Nathaniel Currier through a corps of pushcart salesmen working the streets of New York (fig. 1).[1]

Richard Caton Woodville painted a new America in a new way. His genius, revealed in a small body of highly finished, jewel-like work, was turned to a particular historical moment, the period of rapid social, political, and technological transformation in the decades before the Civil War. His paintings allow us to look back at a time, some one hundred and seventy years past, that looks familiar in many ways. The artist was clearly intrigued by and dependent on the innovations which defined that moment and reflected them in his work. He read newspapers filled with accounts transmitted by telegraph; he shipped paintings from Europe for exhibition in America on steamships; he alluded artistically to social changes brought about by the railroad and by urbanization, and to the festering issue of American slavery. The distanced perspective of an expatriate living in a dynamic artistic community and surrounded by the revolutionary politics in 1840s Germany adds complexity to his historical situation and layers of meaning to his work.

Woodville's selection of subjects reveals a prophetic understanding of the issues of the moment, and his equivocal moral stance a sensitivity to the broad differences of opinion among his potential patrons. The market for his paintings was primarily the American Art-Union, headquartered in New York and supported for a "*patriotic purpose . . . the progress and elevation of American Art*" by thousands of subscribers throughout the nation. Their enthusiasm was consolidated by means of the new postal service, their interest and knowledge advanced through periodicals made affordable through new steam-powered printing presses, and their appreciation of art promoted through the thousands of Art-Union prints, Woodville's among them, distributed by steamships and railroads that were speeding the transfer of information.

Woodville's new vision took in subjects ranging from the ambiguous encounters among strangers in an increasingly transient American society to the divergence of opinion between generations over the pressing subjects of the day. He considered the effects of change on the structure of society and the complications inherent in a shift of power from the generation of the American Revolution to that of a populist democracy driven by more self-serving, "go ahead" ideals. In *War News from Mexico* and *Old '76 and Young '48* (cat. no. 12) the Revolutionary figure he depicts is not the vital hero espoused by history and depicted by his comrade Emanuel Leutze in *Washington Crossing the Delaware* (see fig. 27), but a diminished old man reliant on others in domestic life. Attuned to the desires of a broadening market for art, Woodville also produced several works in a sentimental-romantic mode that evoked the time of the cavaliers of the English civil wars. These spoke to a broader nostalgia among his patrons, a yearning for courtliness and chivalry in a time of rapid urbanization and immigration.

His fame and the reception of his work played out on several levels: the competitive collecting of precious objects by the class of business investors who were transforming the commercial landscape; the distribution of paintings by the Art-Union lottery

system, which reflected the speculative bent of contemporary American society; and mass distribution through print reproductions for a growing middle-class audience. Lionized in the emerging art press, Woodville represented a new generation of American artists, international in viewpoint and competitive on the international stage.

Any artist who addresses the historical moment with such consciousness and clarity raises questions of context. Richard Caton Woodville is a challenging subject in that regard; while his works of crystalline realism clearly depict the modern moment, his stance on contemporary issues is expressly ambiguous. In addition, he left no written record, a fact that, given the period and Woodville's social milieu, might suggest that it was deliberately expunged. Indeed, aspects of his biography were scandalous in that early Victorian period: a secret marriage, rejection of the family enterprises, a second marriage with two additional offspring revealed only after his death by "poisonous effects of an overdose of morphine, medicinally taken" at a tragically early age.[2] While traces of his life can be pieced together, including some of the social networks and relationships that encouraged his talent and shaped his interests, questions remain that only conjecture can fill.

Richard Caton Woodville was born in Baltimore on April 30, 1825, the first son in a family positioned at the highest level of local society. His mother descended from Benjamin Ogle, a member of the Maryland colonial council, friend of George Washington, and governor of the State of Maryland from 1798 to 1801. The Ogle family maintained a residence at the intersection of King Street and College Avenue in Annapolis and the plantation "Belair," which occupied a large swath of present-day Bowie, Maryland. Through his father, William Woodville V, the artist was related to the landowning and mercantile Caton and Carroll families. His namesake and great-uncle Richard Caton, a prominent merchant, married Mary "Polly" Carroll, the daughter of Charles Carroll of Carrollton, the longest-surviving signer of the Declaration of Independence and, for many years, Maryland's wealthiest man.[3] Their daughters, the famed "Caton sisters," had taken British society by storm after the war of 1812.

While that family's massive landholding anchored their fortune, they were part of the network of Baltimore investors who built new enterprises and extended new technologies in the early decades of the nineteenth century, from gas lighting for the city streets to mechanized mills that spun out sailcloth to the railroad that made stagecoach lines and costly canal projects suddenly obsolete. When the artist was three, Charles Carroll of Carrolton laid the cornerstone for the construction of the B&O Railroad; in the coming years his father represented Carroll family interests as the railroad's Master of Transportation, serving as "an important link," according to Richard Caton, "in the executive duties of our Railroad concern."[4] There, he would have been involved in granting the right-of-way along the railroad lines to Samuel F.B. Morse's electro-magnetic telegraph. It is not hard to envision the artist at nineteen in the crowd at

Fig. 2. Richard Caton Woodville, *Early Efforts of R. C. Woodville*, detail, from *The Dr. Stedman R. Tilghman Scrapbook.* Maryland Historical Society, Baltimore, J. Hall Pleasants Papers, 1773-1957 (MS 194, p. 96), checklist no. 2

Baltimore's Pratt Street railroad depot receiving the first telegraphic message transmitted in May of 1844 from the chamber of the Supreme Court in Washington.

In his essay in this volume, Seth Rockman investigates Baltimore at this time as a city of booming commercial activity (see pp. 27–38), volatile racial and class differences, and rowdy political culture. The Woodville family lived first at Mulberry Street, then at 413 North Charles Street on the city's main north-south thoroughfare, both residences across from the Catholic Basilica. Caton Woodville, as he was known, received a classical education under the Sulpician clerics at St. Mary's College in Baltimore, in present-day Seton Hill, several blocks west of his home. Records show him enrolled in classes in Latin, writing, English, French, German, algebra, geometry, and drawing. Reflecting the interests of his mercantile family, he also studied bookkeeping and modern history. In 1840, he received an award for ornamental handwriting and was elected to the Reading Room Society for students with "more than ordinary interest in the classics." The St. Mary's schoolmates who occupied adjoining desks in study hall and beds in "Mr. Hewitt's room" included cousins from the Tilghman and Carroll families from across Maryland, and offspring of political, land-owning, and mercantile elites of the southern states and islands. His friend and cousin Stedman Tilghman, with whom Caton progressed from St. Mary's to medical school, kept a scrapbook full of newspaper clippings and other ephemera, including a number of pencil sketches by the young artist (fig. 2 and see checklist no. 2). These humorous portraits of priests and evocative sketches of schoolmates show an early talent for capturing nuances of expression and subtleties of character. The visual information to which he was exposed included popular prints of military action, which he copied at age eleven in the mawkish but competent *Battle Scene with Dying General* (see checklist no. 1).

Fig. 3. Thomas Doughty, *View of Baltimore from Beech Hill, The Seat of Robert Gilmor, Jr.*, 1822. Oil on panel, 32.7 × 42.3 cm. The Baltimore Museum of Art, gift of Dr. Mrs. Michael A. Abrams (BMA 1955.183)

In 1844, Woodville enrolled for a year of study at the University of Maryland Medical College in Baltimore, where he made amusing sketches of his professors and fellow students (see checklist no. 2). When his friend Tilghman took the post of attending physician at the new Baltimore almshouse, Woodville appears to have visited him often. En route, the artist likely stopped in at the adjacent, art-filled country homes of Robert Gilmor Jr. and Dr. Thomas Edmondson, which overlooked the city from the west (fig. 3). Gilmor's large and renowned art collection at Beech Hill contained examples, real and attributed, of such northern European painting as a *Tavern Scene* by Jan Steen and *A Musical Party with a Lady in White Satin* and a *Card Party* by Gerard Ter Borch, traditional genre subjects that Woodville would interpret later in his career. An active patron of living American artists as well, Gilmor commissioned landscapes from Thomas Cole and genre scenes from William Sidney Mount, whose painting *The Tough Story: Scene in a Country Tavern* hung in Gilmor's hallway by 1838 (fig. 4). This work was both a thematic precedent for Woodville's depictions of encounters among travelers in anonymous public interiors and an example to him of the wide distribution and attendant notice that reproductive technology made possible. *The Tough Story* was engraved for *The Gift: A Christmas and New Year's Present*, published by Carey & Hart of Philadelphia in 1841, a popular book that might have graced the center table in the Woodville family parlor.

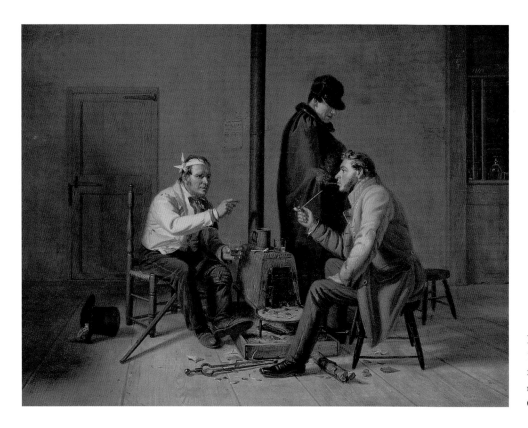

Fig. 4. William Sydney Mount, *The Tough Story—Scene in a Country Tavern*, 1837. Oil on panel; 42.5 × 55.8 cm. Corcoran Gallery of Art, Museum Purchase, Gallery Fund (74.69)

Thomas Edmondson shared background and interests with Woodville, including fathers with mercantile roots in Liverpool, medical training not pursued as a vocation, and an inclination toward the arts, which Edmondson, backed by a large fortune inherited from a bachelor uncle, enacted as an ambitious collector and patron. Edmondson clearly encouraged the younger artist: on the back of the oil portrait that Woodville painted of his friend in 1844 is scrawled "Caton Woodville's first kick into the world" (see fig. 55). Edmondson subscribed to the American Art-Union, which became the main outlet for Woodville's paintings and, in 1848 won Number 317, *Candle Light Piece: Fruit Girl* by the sentimental scene painter J. T. Peele, in that year's lottery distribution.[5]

Although Woodville is in rare company among native-born Baltimore painters, the commercial dynamism of the city attracted a wide range of visiting artists and a number who settled permanently to offer their services among his family and social circles. Sarah Miriam and Anna Claypoole Peale continued their family legacy as portrait painters in Baltimore. A number of miniature painters advertised their services in the city, such as William R. Hitching, who promised "the most striking likenesses on the most reasonable terms." As Eric Gordon proposes in his essay in this volume (see pp. 65–81), there is evidence that Woodville learned his microscopic brushwork from a miniature painter, many of whom, like L. C. Pignatelli, offered

Fig. 5 (left). William James Hubard, *Robert Gilmor, Jr.*, 1830–1832. Oil on wood, 50.8 × 37.5 cm. The Baltimore Museum of Art, Charlotte Abbott Gilman Paul Bequest Fund (BMA 1956.287)

Fig. 6 (right). Thomas Sully, *Charles Carroll of Carrollton*, 1829. Watercolor on paper, 19.3 × 14.8 cm. The Walters Art Museum, Baltimore (37.1553)

instruction on the side. The latter artist, whose worn visage Woodville sketched in the Baltimore almshouse (see checklist no. 2), specialized in the "execution of MIN-IATURE LIKENESSES in the most faithful and correct manner."[6]

British-born portrait artist William James Hubard arrived in the city in 1830 with a reputation for "extraordinary talent in painting." His small-scale, detailed portraits were commissioned by Robert Gilmor and members of the Hoffman and Carroll families (fig. 5).[7] Portrait painting was clearly the most lucrative area of art commerce, drawing several painters of national reputation for extended visits to Baltimore, including Henry Inman, Chester Harding, and Thomas Sully, the latter two painting Charles Carroll of Carrollton in 1828 and 1829 respectively (fig. 6). These artists socialized with the city's elites. If Woodville did not meet some of them as a child, he certainly saw their "heads" of familiar people hanging in the homes he frequented. Throughout his body of work, whether genre, history, or portraiture, specificity of facial feature and nuances of expression were consistent and characteristic traits of his work.

There is no record of Woodville studying art formally in Baltimore after leaving St. Mary's, but he honed his practice with sketches of inmates in the Baltimore almshouse and developed a friendship with the young artist Frank Blackwell Mayer. Mayer studied with the Baltimore-born painter of the American West, Alfred Jacob

Miller, resident in the city from 1842. Woodville bought prepared panels and oils and tried his hand at painting. Two works that he gave to his future mother-in-law, *Woman Preparing Vegetables* and *Peasant Regaling*, are a faint trace of his early interest in genre subjects. Now long lost, they were included as "first attempts in oil (without instruction)" in the first annual exhibition of the Maryland Historical Society in 1848, when the artist was achieving fame on the national level.[8]

In 1845, Caton Woodville shocked his family with two "hot-headed" announcements. For several years, his parents had tried to break off a relationship they considered unsuitable with the sister of a St. Mary's schoolmate, but in January of that year, he and Mary Theresa Buckler were secretly married. Even more disturbing, perhaps, was his desire to turn his back on medicine or mercantile interests to become an artist. In a bold move for one untrained, in 1845 he sent *Scene from a Bar-Room* (cat. no. 2) to the annual exhibition of the National Academy of Design in New York, where it was purchased for $75 by Abraham M. Cozzens, president of the American Art-Union and a prominent New York patron. The work's humble subject and coarse figures evoked the Dutch and Flemish genre paintings by Brouwer (fig. 7), Steen, and von Ostade in the collections of Gilmor and Edmondson. This success (and maybe an urge to tamp down social scandal), gave the family confidence to send him abroad to pursue his wish.

Caton left on the packet *Louis Philippe* from New York for Le Havre, France, in May of 1845 with his young wife, his friend William Pennington, and Miss Maria Johnston, an older companion, whose smaller-scale portrait he painted in 1847 (cat. no. 7) and who later served as the model for the woman in the window of *War News from Mexico*. Before embarking, Woodville likely met his patron, Cozzens; despite his father's expressed intention that he study in Italy,[9] he traveled instead to Düsseldorf, Germany, where Cozzens's friend, the German-American artist Emanuel Leutze, had lived since 1841. Cozzens's patronage had much to do with positioning Woodville's work as luxury items prized by members of the Art-Union's Management Committee. These established merchants and professionals, whose networks connected on Wall Street and in New York's philanthropic and cultural enterprises, were the artist's main collectors.[10]

As Jochen Wierich describes in his essay on the Düsseldorf years (see pp. 39–50), Caton Woodville developed rapidly in this rich artistic environment, honing the fine, dry, linear realism of the Düsseldorf style. His drawings began to show the meticulous geometry and perspective emphasized in the Academy's elementary drawing class, as well as work from live models in theatrical compositions.[11] He aligned himself immediately with Leutze and the congenial group of international artists around the renowned Kunstakademie. He and his wife courted Leutze and his German born wife, Juliane. The ledger book kept by Mary Buckler Woodville shows entries for "a gift for Leutze," "fruit for Leutze," and "lace for a cap for Mrs.

Fig. 7. Circle of Adriaen Brouwer, *Two Peasants in an Inn*, 1630-1639. Oil on panel, 21 × 16.8 cm. The Walters Art Museum, Baltimore, gift of Mrs. Helen R. Cleland, 1964 (37.2409)

Leutze" and notes extraordinary expenses incurred "the evening Mrs. Leutze spent." When Caton Woodville registered the birth of his son Henry, born on September 14, 1845, his witnesses were Leutze and Johann Gottfried Böcker. Böcker was a wine importer with one foot in New York and the other in Germany and the art collector who opened the Düsseldorf Gallery in New York in 1849, starting the fashion for that school of painting, which prevailed for the next decade. Leutze and Woodville traveled to the Netherlands together in August of 1846, where their signatures appear on the registry of visitors at the Trippenhuis in Amsterdam.[12]

In Düsseldorf, Woodville found an innovative group of painters who were elevating genre painting from low-brow depictions of lower-class life to a new synthesis with history painting, documenting the social-political concerns of workers and the emerging middle class for a new class of patron. His absorption of Düsseldorf style and subjects came as much through social contact as from his year of coursework at the Academy. After that year, he became a private pupil in the atelier of Carl Ferdinand Sohn, a portrait and genre painter. According to the *Bulletin of the American Art-Union*, Woodville "received great benefit . . . from an intimate acquaintance with such men as [Carl Friedrich] Lessing, [Wilhelm] Camphausen, [Carl] Jordan, and other of the most eminent artists, who are always ready to aid with their advice and to form his taste by affording him constant opportunities of seeing their own works in progress."[13]

With his father acting as agent, Woodville sent the first of his Düsseldorf paintings, *The Card Players* (cat. no. 3), back to America for exhibition in 1847. A startling leap forward from his awkward Baltimore beginnings, this painting is a complete and balanced composition focused on a dramatic moment, its stage properties and dramatic action rendered in a precise, miniaturist technique. The painting was exhibited first at Samson Carris's art supply and frame shop in Baltimore, then at the Pennsylvania Academy of Arts annual exhibition, and, finally and most importantly, at the American Art-Union in New York. Caton's father struck a hard bargain with the Art-Union directors, achieving a price of two hundred dollars. From that point forward, until that venue closed in 1851, all of the young artist's paintings were sent directly to New York, where they were immediately purchased and made into engravings that were then distributed to the Art-Union's national membership. *The Card Players*, *War News from Mexico*, *Old '76 and Young '48*, and *The Game of Chess* satisfied the Art-Union's specifications for the works chosen for print reproduction (see checklist nos. 17–20): "to find a painting by an American . . . which had never been engraved before, and which should unite great technical excellence with a subject of universal interest . . . [and] striking nationality of character."[14] In works like *The Cavalier's Return* (cat. no. 6), *The Game of Chess* (now known only through the reproduction in the *Bulletin of the American Art-Union*, and in a later gift book [see checklist no. 19b]) and *Old Woman and Child Reading a Book* (cat. no. 13), which

remained in his family as a treasured memento, Woodville took up a nostalgic, senti-mentalizing mode that appealed to contemporary tastes on both sides of the Atlantic.

The young Woodvilles maintained a comfortable middle-class household in Düs-seldorf, employing a washerwoman, nurse, and "servant girl," attending theater and opera performances, and spending considerable sums on piano rental, dressmaker's and tailor's bills as well as on models, academy tuition, and studio props. They lived at 56 Bolkerstrasse, among the artists' studios, art dealers, and art suppliers in the oldest part of the city surrounding the Academy, renting rooms from Stephan Schoenfeld, from whose art supply company Caton purchased paints.[15] Enigmatic mentions of expenses for "china replaced for Mrs. Schoenfeld," "mending of table," and "repairing of window glass" may give a glimpse into the tumultuous nature of their ultimately failed marriage. That neither the Woodville nor the Buckler family saved the letters sent home to Baltimore ("postage" is a frequent ledger entry) is a puzzling detail of this history. Their two children, Henry and Elizabeth ("Bessie") Woodville returned to Baltimore with their mother, sailing from Bremen in November of 1849.

Other traces expand our understanding of the artist's life during these years. In 1845, John H.B. Latrobe, general counsel of the B&O Railroad and cultural and social leader in Baltimore, made his first trip to Europe. After the requisite circuit from England through France to Italy, he traveled up the Rhine from Switzerland, apparently stopping in Düsseldorf, where he commissioned a picture from his young acquaintance. William Woodville delivered the winsome *Politics in an Oyster House* (cat. no. 9) to Latrobe in 1847, with the familiar note "Caton desires me to say to you, that if you do not like it, you must not hesitate about returning it to me, and he will, with the greatest pleasure, paint another for you."

The community of artists in Düsseldorf was remarkable for its multinational membership and for its international market reach. Its members were self-conscious in constructing a coherent community, painting "friendship galleries" of individual portraits and establishing numerous artists' clubs (fig. 8). Woodville, characteristi-cally elusive, appears only faintly in the membership rolls of the small Crignic artist

Fig. 8. Friedrich Boser, mit Carl Clasen, Leop-old Knebels, Adolf Richter, Casper Scheuren, Carl Ferdinand Sohn, Rudolf Wiegmann u. a., *Freundschaftsgalerie von 57 Einzelbildnissen der Düsseldorf Malerschüler und ihren Freun-den 1835-45*. Oil on canvas, with frame: 84.2 × 308 × 6 cm. Stiftung Museum Kunstpalast, Düsseldorf (M 2011-1)

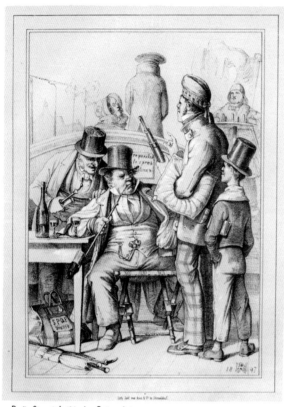

Praÿ Sir, ui heifst das Ruine da?___

___ ___ Halt's Maul, Kratzmann, sunst weifs er gleich dafs
mer Deutsche seind!___

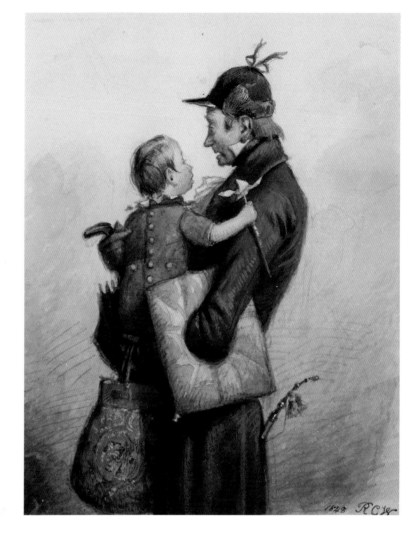

Fig. 9 (left). Henry Ritter, "Praÿ Sir, ui heifst das ruine da?—Halt's Maul, Kratzmann, sunst weifs er gleich dafs mer Deutsche seind!" reproduced from *Düsseldorfer Monathefte*, vol. 1 (1847/48), 2nd lithograph after p. 63. Stiftung Museum Kunstpalast, Düsseldorf

Fig. 10 (right). Richard Caton Woodville, *Man in Green Coat with Umbrella*. The Walters Art Museum, Baltimore (37.1538), checklist no. 14

club, but clearly observed, absorbed, and filtered the changes and advances that were happening around him. He maintained a miniaturist's aesthetic throughout, always working on a smaller scale than the Düsseldorf genre painters.

Affluence and nationality sheltered Woodville from the famine and economic turmoil that prevailed in the Rhineland during these years. Düsseldorf was a center of radical democratic action, however, and he could not have avoided the boisterous crowds that gathered in 1848 to celebrate the declaration of the French Republic, or clashed with Prussian troops in the streets. On August 6 of that year, a torchlight parade in support of a unified German republic wended through his neighborhood from city hall to a statue of Germania erected by Carl Sohn and his students in the Friedrichsplatz. Among the marchers were Leutze and other independent artists and a band of students from the Academy, cloaked in medieval costume and carrying flags of the thirty-eight German princes.[16] Eight days later, that republican spirit

turned openly rebellious, when an angry crowd showered the visiting king of Prussia with horse manure and the city erupted in violence.[17]

Several artists with whom Woodville was acquainted, including the Düsseldorf native and history painter Wilhelm Camphausen, landscape painter Andreas Achenbach, and Canadian-born genre painter Henry Ritter created biting political cartoons for a radical satirical journal, the *Düsseldorfer Monathefte*. These works promoted the democratic social agenda, aped current fashions, and exposed a society adapting to the railroad and telegraph. Although Woodville ignored German politics in his paintings, many of the details that recur among them—the black umbrella, the spittoon, the carpetbag, the newspaper—were symbols of modernity taken directly from *Monathefte* cartoons (fig. 9). He tried his hand at their humorous, satirical mode in a watercolor unique in his oeuvre. *Man in Green Coat with Umbrella* (fig. 10), treats fatherhood as a bewildering, laughable state.

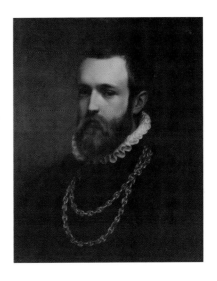

The artist remained in Düsseldorf for six years. His activities and travels—a "portrait in the style of Van Dyck," a trip to Bremen "making sketches for a *Burial of an Emigrant at Sea*," a brief visit to New York in the summer of 1851—were covered frequently in the "Fine Arts Gossip" section of the Art-Union's *Bulletin*. At some point, Woodville took up with Antoinette Schnitzler, a fellow artist and pupil of Sohn, whose fashionable portrait showed the artist in seventeenth-century attire (fig. 11). Their move to Paris in 1851 coincided with the demise of the American Art-Union and the ready market Woodville had enjoyed. In the French capital, he developed a relationship with the firm of Goupil & Company, and benefited from the burgeoning trans-Atlantic art trade in paintings and in lithographs that Marie-Stéphanie Delamaire illuminates in her essay (see pp. 51–64). The progress of *The Sailor's Wedding* (cat. no. 15), from the artist's easel, to Goupil for reproduction (checklist no. 23), to exhibition at the 1853 Crystal Palace Exhibition in New York, to art dealer Samuel Putnam Avery, who purchased it for Baltimore collector William T. Walters for $300, is characteristic of the multifaceted art commerce during this period. As Delamaire points out, Woodville returned to the card-playing subject that had launched his career in *Waiting for the Stage*. At the same time, in *Italian Boy with a Hurdy-Gurdy* (cat. no. 16), he altered his signature style in response to the dynamic Parisian art scene, experimenting with a larger canvas, single figure, and looser painting technique.

Woodville's final years are the most mysterious. He moved to London in 1853 and resided at 65 Stanhope Street near Regent's Park. Another daughter, Alice, was born in that year, and he married Antoinette Schnitzler there in February of 1854. No major work is known from this period, although he exhibited a copy of *Politics in an Oyster House*, renamed *A New York Communist Advancing an Argument*, to acclaim in the annual exhibition of 1852 at the Royal Academy. A woodblock reproduction illustrated the exhibition review in *The Illustrated London News*, which lauded the

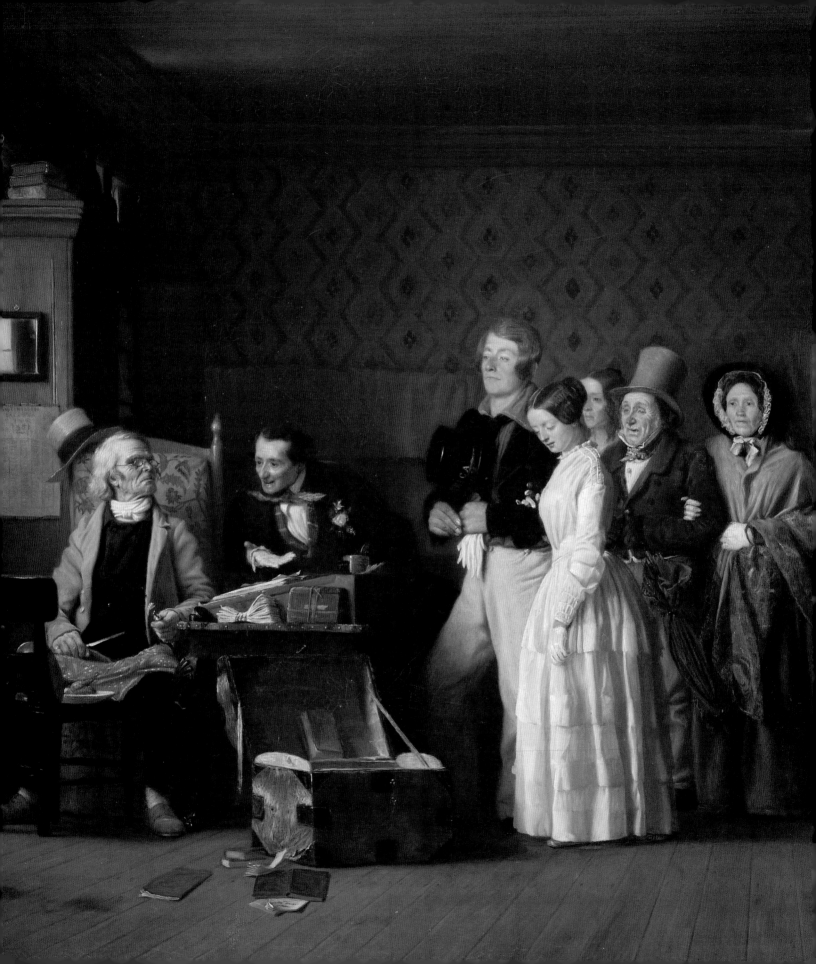

painting's details as "appropriate and carefully finished."[18] Woodville seems to have ceased painting, though when he died on August 13, 1855, of an overdose of morphine, the *Burial at Sea*, now presumed lost, remained on his easel. His son Richard Caton Woodville II, who would distinguish himself as a painter and illustrator of military subjects, was born after his father's death.

In a posthumous biography published in 1867 in the *New-York Daily Tribune*, a contemporary critic described the "satisfying pleasure" of contemplating a work by Woodville. The play of character in *The Sailor's Wedding* and the quiet drama of the meeting before the justice of the peace (fig. 12), lead the viewer to appreciate the "breadth and largeness of the treatment," and then to discover the "wonder of patient minuteness and truth" evoked in its extraordinary details. The humorous moment was rendered with remarkable economy, from the irritated reaction of the judge interrupted at his supper, to the conciliatory gesture of the bowing "groom's man," to the oblivious pride of the "scrubbed and brushed" sailor holding the arm of his "delightfully sheep-faced and prettily-modest" bride. The worn faces of the older couple, dressed in their Sunday best, contrast with those of the younger generation and presage their future. Woodville conveyed the drama of this frozen moment through nuances of facial feature and simple gesture. The scope of the scene was imparted through the frieze-like arrangement of players across the room and into the doorframe, where a crying, barefoot child struggling to escape the hand of his African-American caretaker adds a mysterious subplot to the drama.

As with many of Woodville's works, the "catalogue of details" in *The Sailor's Wedding* adds to the visual pleasure. Bundled letters on the desktop, books and ledgers scattered on the floor around a horsehair trunk, fluttering open or thrown face-down, create a visual cascade from the judge's green writing desk to the floor. The high-backed pine chair, with its flowered upholstery, and the black *klismos*-style Baltimore chair are familiar from *The Soldier's Experience* of 1847, suggesting that the artist traveled with studio props or sketches from Baltimore to Düsseldorf to Paris. An almanac page pasted to the bookcase, like the newspapers in previous paintings, places the action squarely in the modern moment, while the red spittoon, straw hat and basket, and glistening andirons, all "finished as with a microscope," are by this point signature details.

As described by the *Daily Tribune* writer, the eye of the viewer pans first over the narrative elements of the scene, moves out to assess the overall composition and then in again to appreciate the particulars of its execution. This movement between the story, its larger context, and the telling details, is descriptive of the enterprise of art history, of seeking to understand the social and historical context of works of art as well as their structure and meaning as independent images. Richard Caton Woodville poses the challenge of balancing the traces of his biography, the rich historical and social context and the mystery that surrounds him with the jewel-like

Fig. 12 (opposite). Richard Caton Woodville, *The Sailor's Wedding*, detail. The Walters Art Museum, Baltimore (37.142), cat. no. 15

clarity and the internal dramas of the scenes he painted in such small numbers. A unique synthesis of traditions and contemporary concerns informed the new eye he turned on America.

NOTES

Despite his short life and small body of work, Richard Caton Woodville has been a rich subject of inquiry in the history of American art. See p. 62 n. 2 and Abbreviated References, pp. 135–36, for further reading.

1. Martha Sandweiss et al. *Eyewitness to War: Prints and Daguerreotypes of the Mexican War, 1846–1848,* exh. cat. (Fort Worth: Amon Carter Museum, 1989), 19.

2. Francis S. Grubar, *Richard Caton Woodville: An Early American Genre Painter,* exh. cat., (Washington, D.C.: Corcoran Gallery of Art, 1967), [unpaginated] n. 10 (quoting death certificate).

3. For information on the Carroll family, see *"Any Where So Long As There Be Freedom": Charles Carroll of Carrollton, His Family and His Maryland* (Baltimore: Baltimore Museum of Art, 1975).

4. Richard Caton to Miss Anne Butler, 21 September 1835, Woodville-Butler Letters, ms.1465.1, The Maryland Historical Society, Baltimore.

5. *Bulletin of the American Art-Union,* no. 17 (December 26, 1848), 19. W. T. Walters of Baltimore, Maryland, is also listed as a subscriber that year. For information on J. T. Peele, see Henry P. Rossiter, *M. & M. Karolik Collection of American Water Colors and Drawings, 1800–1875,* 2 vols. (Museum of Fine Arts, Boston, 1962), 261.

6. I am grateful to Carol Aiken for sharing her extensive research into Baltimore miniature painters.

7. Sona K. Johnston, *American Paintings in the Collection of the Baltimore Museum of Art.* (Baltimore: Baltimore Museum of Art, 1983), 84.

8. *Catalogue of Paintings, engravings, &c. at the Picture Gallery of the Maryland Historical Society—First Annual Exhibition, 1848.* (Baltimore: printed by John D. Toy, corner of Market and St. Paul Sts.), 4, 6.

9. William Woodville to Edward King, September 4, 1955 (Walters Art Museum Curatorial Files, acc. no. 37.2370), citing letter from William Woodville V to Rev. Edward Butler, April 28, 1845.

10. Rachel N. Klein. "Art and Authority in Antebellum New York City: The Rise and Fall of the American Art-Union" *Journal of American History* 81, no. 4 (March 1995), 1534–61.

11. Hoopes 1972, 20.

12. Clark 1982, 236–37.

13. *Bulletin of the American Art-Union* 3, no. 1 (April 1850), 6.

14. *Bulletin of the American Art-Union* 2, no. 7 (October 1849), 17.

15. Bettina Baumgärtel, ed., *Die Düsseldorfer Malerschule und ihre internationale Ausstrahlung, 1819–1918,* exh. cat. (Museum Kunstpalast Düsseldorf and Michael Imhof, 2011), 318.

16. See Barbara S. Groseclose, *Emanuel Leutze, 1816–1868: Freedom is the Only King* (Washington, D.C.: Smithsonian Institution Press for the National Collection of Fine Arts, 1975), 30–32.

17. See Jonathan Sperber, *Rhineland Radicals: The Democratic Movement and the Revolution of 1848–1849* (Princeton: Princeton University Press, 1991).

18. "Fine Arts," *Illustrated London News,* no. 571 (July 31, 1852), 84.

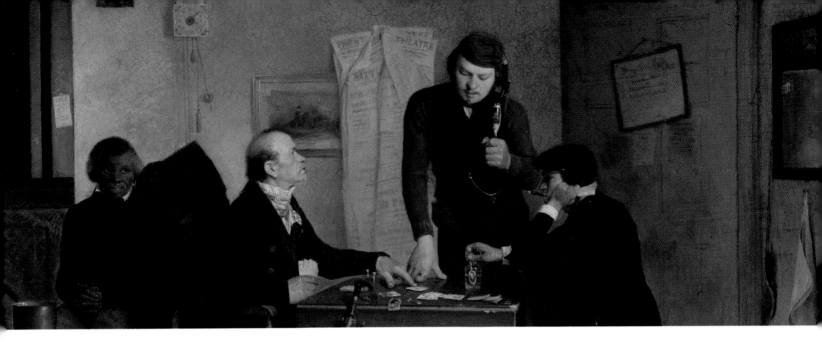

An Artist of Baltimore

SETH ROCKMAN

RICHARD CATON WOODVILLE had relatively little time to patronize the taverns, parlors, and hotels that dominate his iconic American scenes. Born in Baltimore in 1825, Woodville left the city in 1845 for Düsseldorf, and perhaps returned to the United States only thrice over the remainder of his short life. Although Woodville's American scenes mask their precise location, Baltimore surely provided the artist with a storehouse of images to deploy as he completed his work abroad. As it so often does for expatriate artists and authors, distance summoned details—the wording of a poster, a table's wood grain, the cut of a jacket—that could easily elude the notice of a street's daily sojourners or a pub's regular patrons. Yet even as such rich detail distinguishes Woodville's work, it is only by conjecture that we might recognize Fells Point fashion or a Thames Street interior in such paintings as *Politics in an Oyster House* or *The Sailor's Wedding* (cat. nos. 9, 15).

Woodville's twenty years in Baltimore coincided with a dynamic period in one of the fastest-growing and most diverse cities in the United States. A few years before Woodville's birth, a new city map ambitiously gridded acres of farmland and pasture into an urban landscape that did not yet reach the unfinished Washington Monument (completed in 1829). Baltimore was already renowned for its public markets and fountains, but notorious for a boisterous political culture that had earned it the epithet of "mobtown" in partisan riots leading up to the War of 1812. The city

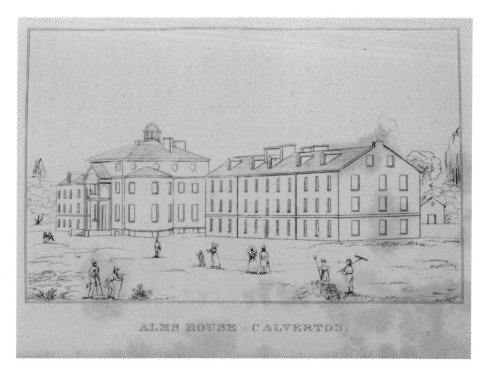

ALMS HOUSE — CALVERTON.

Fig. 13. "Alms House—Calverton" from Fielding Lucas, Jr., *Picture of Baltimore, Containing a Description of all Objects of Interest in the City, and embellished with views of the principle public buildings* (Baltimore: Fielding Lucas, Jr. 1832). American Antiquarian Society, New York (LMdL Balt Pict P832)

redeemed itself by withstanding the British bombardment, and a stately Battle Monument commemorated Baltimore's sacrifices on behalf of the nation.[1] Woodville came of age in a Baltimore whose august commercial buildings proclaimed the city safe for business, even as urban disorder alarmed visitors, moral commentators, and the ministers of the nearly fifty houses of public worship scattered throughout town. The city cleaned up nicely for visiting dignitaries like the Marquis de Lafayette or Alexis de Tocqueville; the latter's 1831 visit featured a tour of the imposing new almshouse that Woodville would frequent as a teenaged medical student (fig. 13). But when Woodville was ten, the city exploded into violence once again, this time aimed at malfeasant bankers who speculated the savings of their working-class depositors into oblivion. The militia was required to restore the peace, but imposing order on the unruly city would remain—as it long had been—an unwinning proposition. Within elite families like Woodville's own, one might readily hear laments that Baltimore's population was too polyglot, its streets too dangerous, and its politics too democratic.[2]

The census completed in 1830, five years after Woodville's birth, counted some eighty thousand Baltimore inhabitants, four-fifths Euro-American and one-fifth African American. The majority of black Baltimore residents were legally free, although denied civic equality, vulnerable to police violence, and excluded from lucrative employments. Many of the city's four thousand slaves had been sent to Baltimore by their rural owners to seek wages as day laborers and domestic servants.

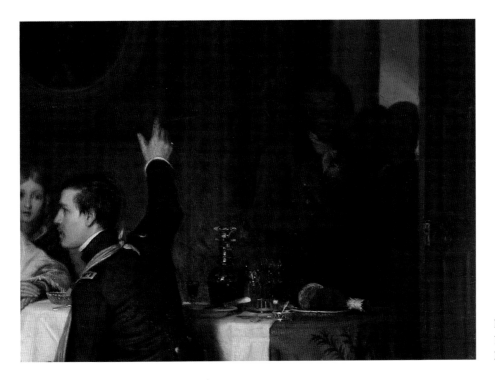

Fig. 14. Richard Caton Woodville, *Old '76 and Young '48*, detail. The Walters Art Museum, Baltimore (37.2370), cat. no. 12

Enslaved men and women often toiled alongside white workers on construction sites or in the kitchens of wealthy families, situations that generated little solidarity among those whose labor sustained the city's rapid economic development and social refinement. Baltimore's overwhelmingly white majority made the city unusual among places with slavery in mid-nineteenth-century America: while black men and women (both slave and free) were relegated to the worst jobs, white workers constituted the bulk of those emptying privies, sweeping streets, and hawking fruit. This was a function of demography, not colorblindness, and attested to the volatility of race and class in a city where a clever slave might bribe famished Irish kids with bread in exchange for reading lessons. This was, of course, Frederick Douglass's story. Woodville's Baltimore was also Frederick Douglass's, at least until the world's most famous fugitive slave liberated himself in 1838.[3] The two had little in common other than an eagerness to flee Baltimore. But whereas Douglass acknowledged Baltimore slavery as formative to his being, Woodville made no explicit attribution in his art. If the obscured black visages peering in from the margins of *Old '76 and Young '48* (fig. 14) suggest Baltimore's influence on Woodville, they also convey the characteristic qualities of white privilege, namely, the ability simultaneously to see—and not see—people of color living in close proximity.

Fragments of biographical data situate Woodville precisely in urban space (fig. 15): his family's home was on Charles Street across from the Catholic basilica (fig. 16); he attended classes at St. Mary's College, where Green Street veered northwest to

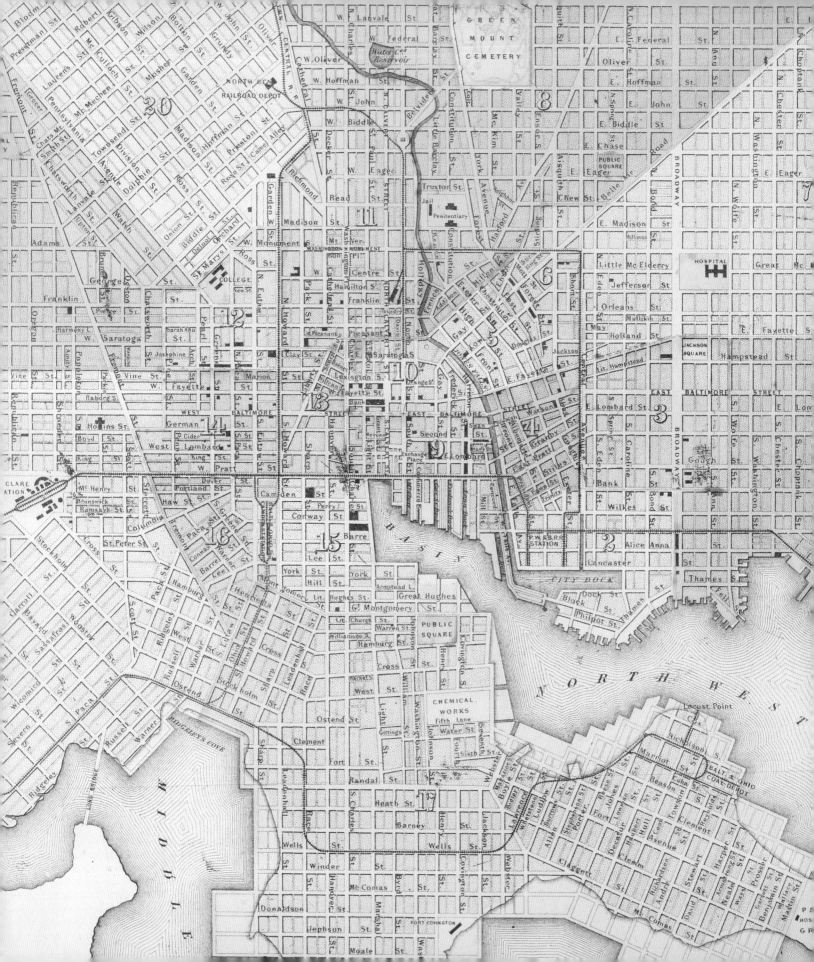

become Pennsylvania Avenue; the Medical College stood at the corner of Green and Lombard Streets, its colonnaded façade protected by a high brick wall. Woodville's almshouse visitations required him to travel two and a half miles from the center of the city, a westerly journey toward Franklintown made easier on one of the city's first macadamized roads. With kin among Maryland's wealthiest landholding families (the Carrolls and the Catons), it is fairly certain that Woodville traveled further into the Maryland countryside, acquainting himself with the type of village setting featured in *War News from Mexico* (cat. no. 8)—a gathering more suited to a hamlet like Westminster or Easton than to the bustling seaport of Baltimore. Whether Woodville visited other states before arriving in New York in 1845 is unknown.[4] Insofar as geographical mobility typified the American experience of the 1830s and 1840s, Woodville's twenty-year residence in Baltimore was perhaps unusual. In contrast, consider Woodville's contemporary, George Caleb Bingham, the genre painter whose early biography featured a family migration from Virginia to Missouri. Woodville experienced no similar relocation that might expose him to the multiple Americas of the nineteenth century; absent other evidence, one suspects that the artist's scenes of American sociability originated locally in Baltimore.

The Card Players (cat. no. 3) contains the only textual reference to Baltimore in Woodville's art: the elongated rectangular playbills of the city's most famous stage, the Front Street Theatre. These ephemeral publications hang from the wall of the waiting room of an unidentified train, stage, or steamship depot (fig. 17, and see cat.

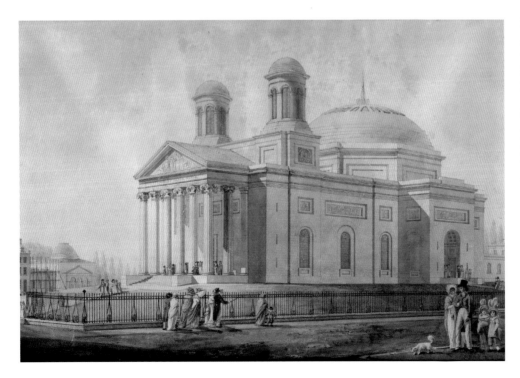

Fig. 15 (opposite). *Colton's City of Baltimore, Maryland* (New York: J.H. Colton & Co, 1855), detail. Lithograph, hand colored. Private Collection, Baltimore

Fig. 16 (left). Benjamin Henry Latrobe, *Basilica Cathedral, Baltimore*, 1805. Drawing, with frame: 64.8 × 84.6 cm. Maryland Historical Society, Baltimore (1897.1.3)

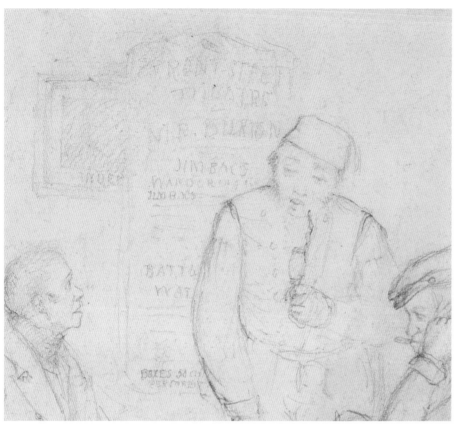

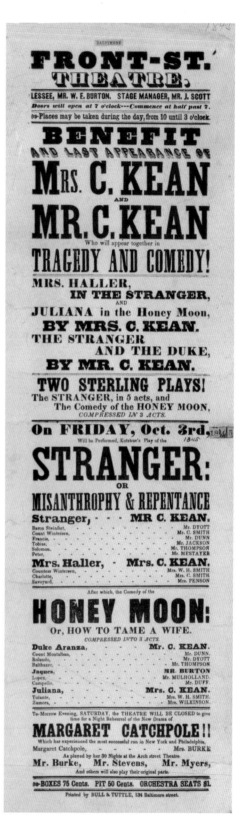

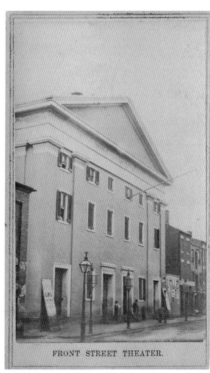

Fig. 17 (above). Richard Caton Woodville, *The Card Players*, detail. The Walters Art Museum, Baltimore, gift of Mr. Kurt Versen, 1991 (37.2650), checklist no. 12

Fig. 18 (far right). *Front Street Theatre Playbill* (Friday, 3 October, 1845). Ink on paper. Maryland Historical Society, Baltimore, Ephemera Collection (box W18)

Fig. 19 (right). Daniel R. Stiltz, *Front Street Theatre*, ca. 1864. Albumen carte de visite, 10.2 × 5.7 cm. Maryland Historical Society, Baltimore, D. R. Stiltz & Co., Views of Baltimore Collection (PP 106.38)

no. 3).[5] While a nineteenth-century audience might immediately have recognized a side-room of the General Wayne Inn on Baltimore Street from which a stagecoach departed three times a week for Emmitsburg, Maryland, and Chambersburg, Pennsylvania, today's viewer must rely on the few words discernible in the background. The painting captures a tense moment between two unscrupulous card players, one secreting an extra card under his leg and the other aided by a mirror reflecting his opponent's hand; a third party adjudicates the dispute, while a fourth—a seated middle-aged black man—looks on from behind, his hands folded. Several other notices and posters appear on walls, but only those announcing upcoming theatrical performances are legible. This may owe simply to the playbills' prominent position as the vertical axis of the painting. Alternatively, Woodville might have highlighted the playbills to emphasize the theatricality of the scene itself. Gestures to the theater would distinguish Woodville's body of work: *Politics in an Oyster House* is framed by a drawn curtain, *War News from Mexico* is set on a raised stage, and most every interior space is adorned with distinctive props such as the brass spittoon, copper pot, and striped satchel punctuating the drama of *The Card Players*. The word "Theatre" so centrally located in *The Card Players* marks this waiting room itself as a performance space, one in which various cultural scripts are followed or broken: the player slouching over his backwards-facing chair violates every middle-class rule of bodily comportment; the African-American man looking on surreptitiously suggests racial deference as a role to be played rather than as an innate characteristic of people of color; the ability of the other three men to ignore him portrays whiteness itself as an act.

The Front Street Theatre was a notable Baltimore landmark (figs. 18, 19), its Greek Revival edifice designed in 1838 by William Minifie, a foundational figure in American architectural education. Built atop an earlier theater known informally as "the circus" for the equestrian shows held there, the new Front Street Theatre would loom over the Old Town landscape for the rest of the century. Capable of seating an audience of several thousand, Front Street attracted performers of international repute. The English actor William E. Burton leased the theater in 1844 and 1845 and staged plays with an acting company he brought from Philadelphia. Although Burton's name is not legible on the playbills in *The Card Players*, Woodville's preliminary sketch for the painting features "Mr. Burton" vividly, as well as the opportunity to see him perform as "Jim Bacs" (a corruption of Jem Baggs, the lead character in Henry Mayhew's 1834 farce, *The Wandering Minstrel*). Burton's arrival in Baltimore had generated significant excitement, both for the caliber of his actors and his success in preventing "rowdies," to quote from the *Baltimore Sun*, from driving away "the beauty and fashion of our city."[6] Nineteenth-century theaters were renowned as volatile spaces for cross-class and interracial encounters, a dynamic invoked in *The Card Players*.

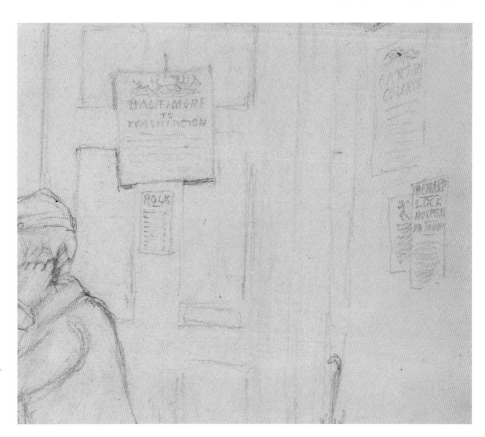

Fig. 20. Richard Caton Woodville, *The Card Players*, detail. The Walters Art Museum, Baltimore, gift of Mr. Kurt Versen, 1991 (37.2650), checklist no. 12

Woodville's preliminary sketch for the painting contained additional Baltimore references (fig. 20). Affixed to the wall is a notice for the Lock Hospital, a Pratt Street infirmary where Dr. Hitzelberger treated sufferers of venereal infections (or what his advertisements referred to euphemistically as "a *particular* branch of disease"). A ballot for James K. Polk dates the scene to the election season of 1844, while the notice for the Canton Course also evokes that presidential contest since Henry Clay's nomination as the Whig candidate was celebrated at the racetrack. A poster announces the stagecoach from Baltimore to Washington, D.C., even as most passengers by that time were traveling the route on a branch of the Baltimore & Ohio Railroad.[7] It is notable that Woodville privileged the older technology of the stagecoach over the newer one of the train, considering that his father had previously served as an auditor for the B&O. Indeed, the poster's pairing of Baltimore and Washington would have conjured an even newer technology for a 1840s audience, the telegraph. In May 1844, Samuel F. B. Morse asked "What hath God wrought?" in a message sent from the basement of the U.S. Capitol to the B&O depot on Pratt Street in Baltimore. As the telegraph and the railroad together worked to "annihilate time and space," the bumpy carriage ride to Washington would have seemed excruciatingly slow.[8]

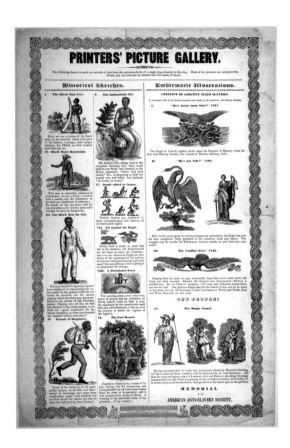

Fig. 21. Printers' Picture Gallery (New York: American anti-slavery society, 1800). Print, 55.5 × 37.5 cm. Library of Congress, Washington D.C., Printed Ephemera Collection (portfolio 133, folder 29, rbpe 0220120b)

The most compelling local detail in the preliminary sketch, however, is a stick-figure man in motion (see fig. 20), the emblematic image of the runaway slave from newspaper advertisements and reward posters. As abolitionist propagandists pointed out, this figure was so common that virtually any printer would have had it on hand (fig. 21). The runaway icon is as prominent in early American typography as the eagles and pointed fingers (fists) that distinguish the mastheads and margins of the era's printed material. Equivalent to a stock image in present-day media, the runaway figure had accentuated advertisements for recapturing slaves since the eighteenth century and changed little even while those escaping slavery in the 1830s and 1840s might, like Frederick Douglass, as easily slip away by railroad as by foot. Runaway advertisements, as the scholar Marcus Wood has argued, gained their efficacy in describing a given man or women in precise and individual terms; yet by offering a standardized caricature—the running man with a knapsack over his shoulder—they conveyed the idea that every runaway was interchangeable, and more important, that every black man or woman—slave or free—was a potential fugitive.[9] A single-sheet reward advertisement, as featured in Woodville's sketch, was tantamount to a "Wanted" poster and incentivized whites, whether slaveholding or not, to participate in the maintenance of the slave system by scrutinizing unfamiliar people of color as

potential runaways. This was especially damaging to free black men and women in a city like Baltimore, eager to assert their independence yet subjected to constant surveillance and deemed inherently suspicious.[10]

The runaway slave advertisement featured in this sketch offers an important lesson regarding print culture in antebellum America. The newspapers that appear in so many of Woodville's paintings—*Politics in an Oyster House, War News from Mexico*, and *Waiting for the Stage* (cat. no. 14), for instance—are often interpreted as a testament to the broader public culture of the Jacksonian Era, when common Americans had access to a proliferating amount of political information and used that knowledge to debate in the service of a robust democracy. This is what Alexis de Tocqueville saw when he visited Baltimore in 1831 and named as a defining aspect of American culture in *Democracy in America*. Newspapers and the broader array of pamphlets, posters, broadsides, and magazines were undoubtedly crucial to the democratic aspirations of the age, but they could also work against the democratic possibilities of minority populations who found themselves marginalized via a press (and printing industry) they did not control. As suggested by the ubiquitous runaway icon that transformed every person of color into a potential slave, print culture also served the more nefarious end of upholding the nation's most illiberal and retrograde institution.

Little in Woodville's art betrays a moral position on slavery, even as slavery was crucial to his family's history. Caton's father, William Woodville V, arrived in Baltimore in the early 1810s as a twenty-year-old in search of new mercantile opportunities in the Atlantic economy. This William Woodville would have fewer opportunities for fast fortune than his progenitors, the William Woodvilles who were involved in twenty-seven known slaving voyages between Liverpool, Africa, and the British Caribbean from as early as 1766 until 1795. That year, for example, a William Woodville served as captain of the *Mars*, a Liverpool vessel that conveyed nearly three hundred people in chains from Loango (now the Republic of Congo) to slave markets in Jamaica.[11] The British abolition of the slave trade in 1807 diminished economic opportunity in Liverpool and sent the entrepreneurial sons of slave-trading families in search of new livelihoods in places like Baltimore. Caton's father established himself as a successful commission merchant in the city, no longer involved in transporting slaves, but like any Atlantic businessmen of the period, buying and selling the cotton, rice, tobacco, hemp, and sugar that enslaved people grew on plantations stretching from Maryland southward to Brazil. The class comforts of Caton's upbringing would be hard to disentangle from the broader economy of slavery over several generations of Woodville enterprise.

That the African-American figures in Woodville's paintings are not outright caricatures suggests to some that the artist's racial politics were more nuanced than those of many of his contemporaries. Woodville seems to poke at the hypocrisy

of American freedom by placing a black girl in tattered rags within the expanding "empire of liberty" commemorated in *War News from Mexico*. The red, white, and blue clothing of the two African-American figures in that painting recognizes black exclusion as a foundational American value, just as much as the eagle astride the American Hotel placard welcomes viewers into the white republic of boisterous public democracy. Yet like many nineteenth-century Americans, Woodville could recognize slavery as a troubling contradiction without necessarily embracing emancipation or the civil equality of people of color. This stance, largely adopted by those who soon would rally beneath the standard of Abraham Lincoln's Republican Party, was one of racial resignation, an acknowledgment of the black presence in American life without any commensurate commitment to social inclusion. The preliminary sketch of *The Card Players* frames the game between the runaway slave advertisement on the one side and the nervously bemused black man on the other, as if to say that the social interactions of white Americans would unfold in the uncomfortable space between slavery as a legal institution and actual African Americans as fellow occupants of intimate spaces. Likewise, the black men and women featured on the peripheries of Woodville's other paintings indicate that white domestic life rarely transpired beyond the eyes of African-American maids, butlers, and valets. But such recognition is not an inherent critique, and certainly not one of much conviction. More telling is the absence of the runaway slave ad in the final execution of *The Card Players*. Woodville expunged the most inflammatory image of black life in antebellum America, and with it, made his art palatable to white consumers more likely to be troubled by the abstraction of the distant fugitive slave than the marginalization of black men and women living under the same roof.

To be sure, Woodville's representations of African Americans are ambiguous. So too is most everything else about his art. *War News from Mexico* might be celebrating or mocking a military campaign whose dubious origins were widely debated in public life. Such possibilities raise a larger question about the relationship of social history and artistic production. Historians have readily deployed genre painting by Woodville and his contemporaries George Caleb Bingham and William Sidney Mount as direct reflections of antebellum American life. Yet in the case of Woodville, the artist's intent cannot be discerned from textual sources. Because there is no archive of personal letters, the social context of the artist's time necessarily substitutes for other sources. The result is a circularity, as notions of the Jacksonian Era's boisterous public life that owe to Woodville's representations become explanations for Woodville's representations. Without a single word in Woodville's hand, we hope that Baltimore's racial demography and local geography might reveal the intention behind a brushstroke or pose, but the connection between social history and art is never so linear. And of course, Woodville does us no favors in expunging direct references to Baltimore from the work that made him famous. That decision may

have been made with an eye to the art market, or it may have been a preference for the general over the local as a means of capturing some larger truth about American life. Ambiguity has the merit of leaving open the widest range of reception. Quite purposefully, Woodville might have hoped that the uncertainty of a scene's location would generate the kind of vibrant debate evoked in the scene itself. And in that light, the ostensible absence of Baltimore from Woodville's work is precisely what makes us want to argue over how and why the city matters for our understanding of the art itself.

NOTES

1. Mary P. Ryan, "Democracy Rising: The Monuments of Baltimore, 1809–1842," *Journal of Urban History* 36 (2010): 127–50.

2. Robert E. Shalhope, *The Baltimore Bank Riot: Political Upheaval in Antebellum Maryland* (Urbana: University of Illinois Press, 2009).

3. Seth Rockman, *Scraping By: Wage Labor, Slavery, and Survival in Early Baltimore* (Baltimore: Johns Hopkins University Press, 2009).

4. Justin Wolff, *Richard Caton Woodville: American Painter, Artful Dodger* (Princeton: Princeton University Press, 2002), 17–51.

5. On the importance of ephemeral prints posted throughout the urban landscape, see David Henkin, *City Reading: Written Words and Public Spaces in Antebellum New York* (New York: Columbia University Press, 1998).

6. David L. Rinear, *Stage, Page, Scandals, and Vandals: William E. Burton and Nineteenth-Century American Theatre* (Carbondale: Southern Illinois University Press, 2004), 88.

7. *The Baltimore Directory for 1845: Containing the Names of the Inhabitants, Their Places of Business and Dwelling Houses, the City Register, Directions for Finding the Streets, Lanes, Alleys, Wharves, &c. With Much Other Useful Information* (Baltimore: John Murphy, 1845).

8. John Lauritz Larson, *The Market Revolution in America: Liberty, Ambition, and the Eclipse of the Common Good* (New York: Oxford University Press, 2010), 83.

9. Marcus Wood, *Blind Memory: Visual Representations of Slavery in England and America, 1780–1865* (New York: Routledge, 2000), 78–99.

10. Christopher Phillips, *Freedom's Port: The African American Community of Baltimore, 1790–1860* (Urbana: University of Illinois Press, 1997), 83–115.

11. Voyages Database, 2009. *Voyages: The Trans-Atlantic Slave Trade Database.* www.slavevoyages.org (accessed March 14, 2012).

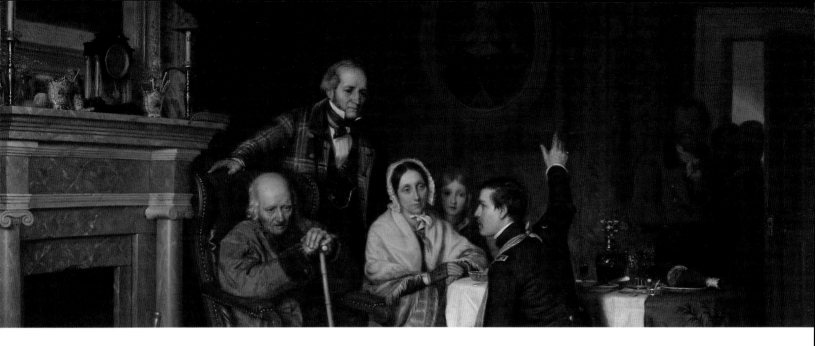

Woodville and the Düsseldorf School

JOCHEN WIERICH

WHEN RICHARD CATON WOODVILLE arrived in Düsseldorf in 1845, the city was an internationally significant commercial and cultural center. Politically, it was controlled by Prussia, but culturally it was as much influenced by Amsterdam, Brussels, or Paris as it was by Berlin. What made this mid-size city a metropolitan cultural center with an international reputation was a creative class of artists, writers, and musicians, and a supportive environment of patronage. Artists were not a subculture but freely intermingled with other professionals including artisans, doctors, and lawyers. Woodville was quickly immersed in the artistic, political, and personal ambitions that made Düsseldorf a destination for artists from around the world.

A key to the formation of artistic and cultural identity in the city was the presence of the Düsseldorf Kunstakademie. The Academy not only provided rigorous professional training and official recognition; virtually synonymous with the Düsseldorf School of Painting (*Malerschule*), it was effectively the gateway to becoming a successful artist. The Academy was organized as a system of concentric circles. In the center was the director, who oversaw the curriculum, the teachers, and the overall artistic standards that they upheld. From 1826 through 1859, the director was Wilhelm von Schadow, a painter of historical and religious allegories in the tradition of the Nazarenes. This group of early nineteenth-century German artists, centered around Franz Pforr, Johann Friedrich Overbeck, and Peter Cornelius, originated in

Vienna and Rome, and eventually spread a revival of religious painting in German art academies. Cornelius, who preceded Schadow as director, left a legacy of large-scale, mural-size painting at the Düsseldorf Academy. Schadow helped maintain a rigorous academic hierarchy with historical and religious subjects at the top and landscape, portrait, and genre subjects on a lower rung. However, when Woodville arrived, artists had begun to introduce historical themes into landscape, portraiture, and genre scenes, subverting the hierarchy; and critics were debating whether that hierarchy still had any validity for contemporary art.[1]

Schadow was the principal instructor for students who had reached the master class, the final stage in their three-tiered academic education. Around him were several professors who instructed students in preparatory classes, including Ferdinand Theodor Hildebrandt for history painting, Carl Ferdinand Sohn for genre, and Johann Wilhelm Schirmer for landscape. Outside this official circle were a number of artists who taught independently but had virtually the status of full academicians, including Emanuel Leutze, Carl Friedrich Lessing, Carl Hübner, and Andreas Achenbach.[2] As a new arrival, Woodville would have been part of an outer circle. Like many of his American colleagues, he enrolled for one semester as an academy student and then pursued independent studies. Woodville might well have dropped off into obscurity had he not found two important mentors during his first year: Sohn and Leutze. He enrolled in Sohn's drawing class. Sohn, a teacher from Berlin who had been appointed by Schadow, together with his colleagues Hildebrandt and Lessing, represented the new, more progressive German art. In one portrait by Julius Hübner, Sr., the three form a triumvirate of bust portraits, confidently showing off their elevated status as representatives of the new guard: political and artistic ideals merged into one image (fig. 22). In the words of art historian Wend von Kalnein, Schadow had initially accepted genre painting as an "illegitimate child of the academy" (illegitimes Kind der Akademie).[3] Yet within a more democratic framework, genre painting began to gain some acceptance in the 1840s. Sohn, who was predominantly a portrait painter, was a gifted teacher who sought to give his students a solid foundation in drawing the figure, no matter whether they were genre or history painters.[4]

The German-American Emanuel Leutze was a second and more significant mentor for Woodville. He had arrived in Düsseldorf in 1841 from Philadelphia and established himself as one of the new guard. No other painter who hailed from the United States was as well connected and respected as Leutze. His success with several paintings on the subject of Christopher Columbus put him in company with Lessing, a rising star in the Düsseldorf School lionized for his historical paintings of the Protestant heroes Jan Hus and Martin Luther.[5] Like Lessing, Leutze developed a reputation as an independent modern history painter who scrupulously researched his subject and infused it with contemporary meaning. Both Lessing and Leutze

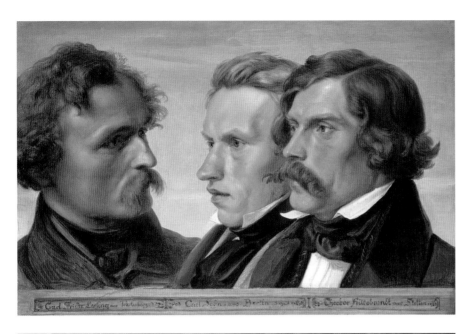

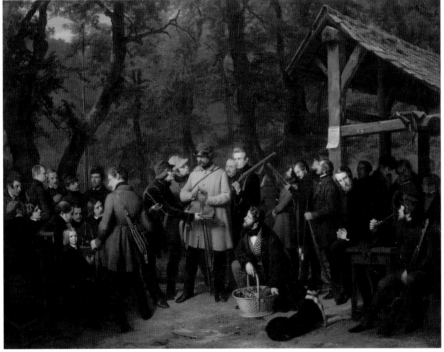

Fig. 22 (top). Julius Hübner, *Young Düsseldorf: Group Portrait of the Painters Carl Friedrich Lessing, Carl Ferdinand Sohn, and Theodor Hildebrandt*, 1839. Oil on canvas, 38.6 × 58.4 cm. Staatliche Museen zu Berlin, Nationalgalerie (A I 929)

Fig. 23 (bottom). Carl Friedrich, Adolf Boser, and Carl Friedrich Lessing, *Bird Shoot of the Düsseldorf Artists in the Grafenberg Forest*, 1844. Oil on canvas, 96.2 × 104.8 cm. New-York Historical Society, The Robert L. Stuart Collection, on permanent loan from the New York Public Library (s-92)

declined to give formal instruction but ran independent studios where younger artists could create social bonds and were encouraged to find their own artistic paths.

Social bonding seemed to be one of the most consistent motives for artists to become a part of the Düsseldorf artistic scene. A painting by Lessing and Friedrich Boser, *Bird Shoot of the Düsseldorf Artists in the Grafenberg Forest* (fig. 23), shows a

Fig. 24. Portrait sketch, possibly of Richard Caton Woodville from the Crignic Log Book (December 1846), p. 48. Künstlerverein Malkasten, Düsseldorf (s 60)

group of twenty-seven assembled as a hunting party in the forests just outside of the city. Lessing and Sohn take prominent positions: Lessing is in the center, receiving a glass of wine, while Sohn carries his shotgun across the shoulder. Hildebrandt, the third in the triumvirate, is seated at a table with wine bottles on the left. Leutze, on the other hand, is in the background behind Sohn's left, the back of his head wedged between two gun barrels. Despite his location outside the ostensible hierarchies in the Düsseldorf artistic community, Leutze was highly regarded by his peers. In 1859, after Schadow resigned, Leutze was offered the position of Academy Director, which he declined.

Woodville does not seem to figure in any of the quasi-satirical group portraits of the Düsseldorf School artists, but he was very close to the inner circle, and we can assume he created ties with established and emerging artists. Woodville and Leutze joined the Crignic, a sketch club that evolved into the larger Malkasten, of which Leutze was a founding member and leading officer. (*Crignic* is an acronym of the founding members' last names: W. Camphausen, H. Ritter, R. Jordan, H. F. Duge, R. von Norman, F. Jensen, and G. J. Canton [with the letter *I* substituting for the *J*]. Woodville joined the group in 1846, possibly submitting a self-portrait with a meerschaum pipe (fig. 24). The group's main mission was to discuss compositions or sketches in an informal setting, often a local pub.) As a student of Sohn, Woodville would have met and befriended Ludwig Knaus, who had great success as a genre painter (and who spent extended periods of his life in Paris and London starting in 1852). In Leutze's studio, of course, Woodville would have met the core group of American artists that included Worthington Whittredge and Eastman Johnson, who recorded Woodville's departure from Düsseldorf in 1851. It is possible that Woodville even served as a mentor of sorts for Johnson, for in 1853 the latter painted *The Card Players* (private collection) following Woodville's very successful *The Card Players* (cat. no. 3). (Knaus painted a variation on the theme, *Die Falschspieler* [The

Card Sharps] in 1851 [fig. 25].) The grouping of card players around a table, a standing figure observing or actively manipulating the game, different kinds of still lifes within the boxlike space are common compositional devices. But Woodville's scene of card players is more ambiguous than the others. Is the setting a tavern or a waiting room? Who are these men? What is the role of the African-American man in the corner? Who is actually the victim? Woodville and his peers thus reinterpreted the classic genre subject of card playing in an interior for nineteenth-century audiences. More important, all three artists were affiliated with the transatlantic art union movement early in their careers.[6]

Woodville came to Düsseldorf to study genre painting and found a ready market back home. His painting *War News from Mexico* (cat. no. 8) was purchased by the American Art-Union committee member and treasurer George W. Austen and widely distributed in thousands of prints. Through the medium of genre painting, the artist directly addressed a historical event that made news around the world. In 1846, the United States declared war on Mexico after a skirmish between Mexican and U.S. forces near the Rio Grande River. The terms of peace negotiated in the Treaty of Guadalupe Hidalgo (1848) following Mexico's surrender gave the United States a vast gain of territory, including land that now makes up the states of California, New Mexico, Arizona, Nevada, and Utah, and parts of Colorado and Wyoming.

Woodville compressed the international conflict into a scene situated on the home front, the imagined American Hotel, a place that served as a kind of public

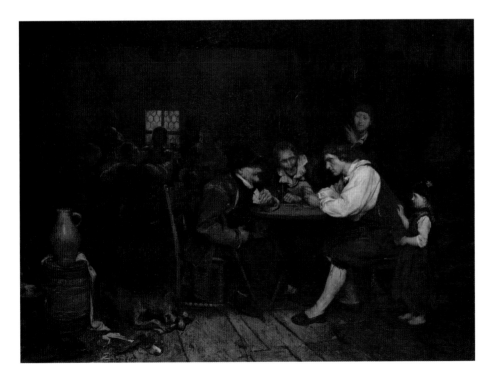

Fig. 25. Ludwig Knaus, *Die Falschspieler*, 1851. Oil on canvas, 81 × 104 cm. Stiftung Museum Kunstpalast, Düsseldorf (M 4027)

square in small-town America. As Elizabeth Johns has pointed out, when *War News* was exhibited in the United States (together with other paintings that Woodville created in Düsseldorf), critics described the scene as distinctly non-urban, a location that no one wanted to claim as one's own backyard.[7] Woodville's own removed position in Düsseldorf might have enabled him to create a generic image of America that referred in general terms to the war, but could be read as a familiar scene by many. Scholars debate the painting's political implications and its portrayal of class, race, or gender relations.[8] However, with all its political and historic resonance, with its focus on a war that stirred emotions and debates in the United States, the painting ultimately inhabited a political and geographic middle ground.

This is not to say that Woodville was unaware of the political controversies and partisan battles that preoccupied Americans during the war years. On the contrary, one could argue that he placed the two African-Americans, presumably a father and daughter, outside the porch of the American Hotel as a poignant reminder that slavery was at the heart of the United States' domestic struggle even while the nation waged an expansionist war abroad. Indeed, for many critics of the war, the acquisition of new territory was a fatal step in tilting the balance in favor of a pro-slavery expansion agenda. There was probably not an artist working in the German Rhineland who could understand the political atmosphere in the United States as well as Woodville. But he avoided taking a position by deflating the political conflict into a cacophony of social types, sharing the war news through facial expressions, gazes, and implied sounds. From the central figure with a stovepipe hat who stares at the newspaper with a gaping mouth, the news spreads across the community with a ripple effect that includes the spoken and written word. One can imagine the news traveling around the world with lightning speed to reach the young American artist in an apartment on Bolkerstrasse in Düsseldorf.[9] And one wonders whether the note on the side post of the porch calling for "Volunteers for Mexico" was not a self-referential reminder that Woodville included for himself and his fellow American students in Germany.

With all its war fervor, *War News from Mexico* strikes a benign note compared with a painting that his comrade Leutze was working on at the time. Leutze received a commission from Albert Binney, a scientist and businessman from Boston, to paint a scene from William Prescott's popular *History of the Conquest of Mexico*, published in 1843. Probably in dialogue with Binney, Leutze chose the final and decisive battle on top of the largest of three pyramids, the Teocalli, which resulted in the defeat of the Aztecs by Cortez and his troops. Whether or not Leutze intended his *The Storming of the Teocalli by Cortez and His Troops* to be a direct comment on the war between Mexico and the United States, the analogy was more than a coincidence (fig. 26). In the United States, war supporters and critics alike made reference to the similarities between U.S. invasion and Spanish conquest.[10] Leutze painted a scene of historical mayhem, a confrontation of two foes in merciless mortal combat. For visitors to the

American Art-Union galleries, where *Storming of the Teocalli* was exhibited in 1849, the painting had few redeeming qualities. It was painted by the leading American history painter of the time, someone the Art-Union had championed for many years. But following on the heels of the Mexican-American War, *Storming of the Teocalli* hit a raw nerve with audiences. In the words of one critic, it was a litany of violence, an "accumulation of horrors" that made the painting almost unintelligible.[11]

Leutze produced a historical painting that made the consequences of war and fanaticism painfully visible for his American audience. Yet both Leutze's and Woodville's works from the late 1840s were framed by a more immediate political conflict taking place in Germany. Düsseldorf was a hotbed of radicalism during the Revolution of 1848, and artists actively participated in mass rallies for democracy and German unity. For a torchlight procession, some of Sohn's students created an allegorical statue of Germania with shield and sword; Leutze, Lessing, Knaus, and others walked in front of the procession. The ensuing repression of the revolution by Prussian troops was marked by violence and arrests of political dissidents. While Woodville's *War News from Mexico* is seemingly unburdened by these circumstances, it demonstrates how historical events were quickly and efficiently transmitted into everyday life as news.[12]

While Düsseldorf was in the midst of political upheaval and the United States was embroiled in conflict with Mexico, Woodville created genre paintings that had a subtly confrontational narrative. This is certainly true for *Old '76 and Young '48* (see cat. no. 12), a painting that addresses the Mexican-American War as the impetus for domestic drama. Leutze, at this time, was preparing sketches for his epic *Washington Crossing the Delaware* (1851) (fig. 27), a painting that he conceived as the culmination of

Fig. 26 (left). Emanuel Gottlieb Leutze, *The Storming of the Teocalli by Cortez and His Troops*, 1848. Oil on canvas, 215.3 × 250.8 cm. Wadsworth Atheneum Museum of Art, Hartford, The Ella Gallup Sumner and Mary Catlin Sumner Collection Fund (1985.7)

Fig. 27 (right). Emanuel Gottlieb Leutze, *Washington Crossing the Delaware*, 1851. Oil on canvas, 378.5 × 647.7 cm. The Metropolitan Museum of Art, New York, gift of John Stewart Kennedy, 1897 (97.34)

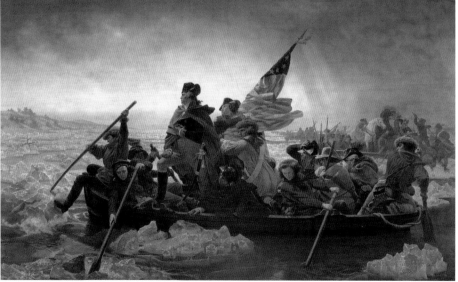

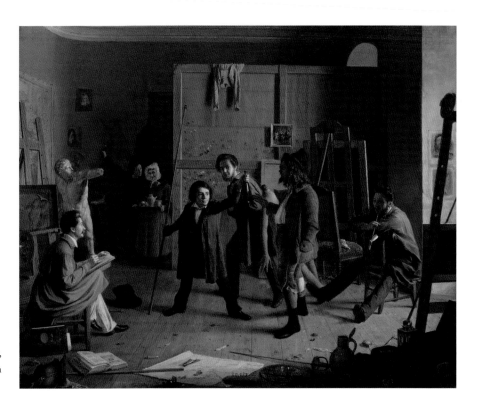

Fig. 28. Johann Peter Hasenclever, *Studio Scene*, 1836. Oil on canvas, 72 × 88 cm. Stiftung Museum Kunstpalast, Düsseldorf (M 4376)

his historical cycle: after Columbus and Cortez, Washington was next to advance the course of liberty in the New World. In *Old '76 and Young '48*, history is domesticated and relocated from the battle field into the comfortable home of a multigenerational American family. The American Revolution is a distant echo but very present in the figure of the old veteran and the bust of Washington in the background. As in *War News from Mexico*, the figure of Old '76 stands in for the generation that fought the revolutionary war; he is also an American father time, a symbol of the nation's aging. While the veteran on the porch of *War News from Mexico* is deaf and straining to hear, the grandfather in *Old '76 and Young '48* looks rather skeptical and annoyed by the young man's excitement. Woodville based this painting on a watercolor and pencil drawing dated 1847 that focuses on the central juxtaposition of a war-weary old man and an eagerly pointing young soldier (checklist no. 13). That the painting was finished during the Mexican-American war is a coincidence but an important turn of events, in the same way that Leutze's *Teocalli* assumed additional significance as commentary on the recent war. But Woodville understood that genre painting could speak to the historic present more directly than history paintings of long-ago events. In *Old '76 and Young '48*, the African-Americans in the doorway are not mere bystanders but central to the narrative that unfolds. While they are listening in on the debate between old and young, it is their lives that are at stake in the great historic struggle over territorial expansion and slavery.

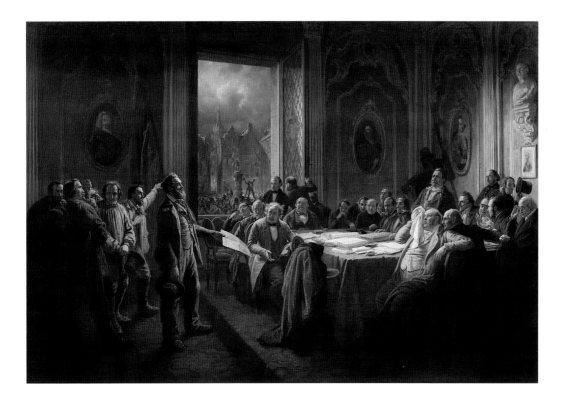

Fig. 29. Johann Peter Hasenclever, *Workers before the Magistrate*, ca. 1848/50. Oil on canvas, 154 × 225.4 cm. Stiftung Museum Kunstpalast, Düsseldorf (M 1978-2)

Woodville's willingness to address the historical present within the cabinet-size format of genre painting can be attributed to his exposure to artists like Leutze, Lessing, Sohn, and Hübner. One other painter associated with the Düsseldorf School needs to be taken into consideration, however. Unlike Schadow, Lessing, and Sohn, Johann Peter Hasenclever was a native Rhinelander who as an architecture student was encouraged by Schadow to study painting. Hasenclever and a circle of young artists from the Rhineland dedicated themselves almost exclusively to genre painting, rejecting the hierarchical system maintained by Schadow. Hasenclever and several of his friends left Düsseldorf in 1836 to continue their studies at the Munich Academy, an institution that was more hospitable to genre painting. In that year, he painted a satirical studio scene portraying himself and his friends in the basement of the Düsseldorf Academy (fig. 28), a biting comment on a hierarchy that was enshrined in the division of floors: on the top of the Academy building were the history painters, below were the landscape painters, and banished to the bottom were the genre painters. Things had changed quite a bit by the time Woodville arrived. Around 1840, Hasenclever had settled in Düsseldorf, maintaining a studio and working on genre paintings. Like Woodville, Hasenclever was member of the Crignic group, in which the two would have exchanged and critiqued each other's sketches.

Woodville would have heard of if not seen Hasenclever's *Workers before the Magistrate* from 1848 (fig. 29). Hasenclever painted a scene from the historic present

that occurred on October 9, 1848, during the height of the revolution. The Düsseldorf city council or magistrate had laid off six hundred workers who were working on a construction project. The following day, workers sent a delegation to deliver a petition to the assembly, but the magistrate refused to reverse its decision. Hasenclever, a genre painter and political leftist, took a political stance, but his image of revolutionary confrontation maintained a satirical edge. The magistrates' expressions display a range of emotions that boil down to one central reaction: fear. The worker representatives, holding a document that presumably contains more truth than all the books and documents filling the magistrates' table, have the moral upper hand. However, Hasenclever also includes the figure of a man holding a flask containing the liquor the workers drank to build up their courage. A serious historical moment is thus humanized and articulated through the contrast of human frailty with courage.[13]

Woodville did not reach quite as deeply into satire as Hasenclever, but he would have found encouragement in the latter's example. In *War News from Mexico* and *Old '76 and Young '48* Woodville demonstrated that in pictorial terms the historic present was most effectively revealed as a theater of human expression and emotion. He packed the melodrama of historical painting into cabinet-size genre scenes filled with material detail and complex human interaction. Compare, for instance, the facial expression of the people on the porch in *War News* with some of the magistrates on the right side of the table, the bespectacled man with his mouth wide open, or the man with a quill between his teeth. Consider also the material detail that Hasenclever included in the table display of inkwell and snuff box as well as the gold chain and ring on the gentleman on the right. In a similar attention to detail, but even more obsessively, Woodville filled his paintings with tangible material reality: in *War News*, the splits and cracks in the wood of the porch, the holes in the gloves of the man speaking into the ears of the veteran, the earring worn by the man in the red shirt; in *Old '76*, the objects on the mantelpiece, the apple, the matching porcelain cups, the dried corn, the clock, the Japanese fan, and the cracked glass on the print above it.

The artistic education that Woodville took with him from Düsseldorf and Paris to London is complex. He did not radically change his format, continuing to work with the boxlike, tightly delineated spaces that he had already used in the American scenes painted in Düsseldorf. But his ability to enrich the content of his paintings with historical and human drama gave his work more gravitas and narrative possibility. Moreover, it is ironic that such emerging artists as Hasenclever and Knaus probably left a stronger influence on Woodville than the established artists Leutze and Lessing. Leutze, no doubt, was a major factor in Woodville's life and one who opened doors for him. But artistically, Woodville moved in a very different direction, one that was perhaps more in tune with the general taste for genre paintings among the art-buying public on both sides of the Atlantic.

I am grateful to the participants in the Woodville Advisory Committee meeting at the Walters Art Museum for an inspiring discussion. Thanks to Joy Heyrman for her comments on an earlier draft of this essay.

1. For a discussion of the Nazarene movement's influence on the Düsseldorf School of Painting, see Cordula Grewe, "Nazarene or Not? On the Religious Dimension in the Düsseldorf School of Painting," in *The Düsseldorf School of Painting and Its International Influence*, ed. Bettina Baumgärtel, exh. cat. (Stiftung Museum Kunstpalast, Düsseldorf, 2011), 87–97. See also Grewe, *Painting Religion in the Age of Romanticism* (Farnham, England: Ashgate, 2009).

2. The German literature on the history of the Düsseldorf Academy is extensive. For a good overview (in English translation) of the academic system under Schadow, see Ekkehard Mai, "Schadow's Success Model: The Düsseldorf Art Academy in Comparison," in Baumgärtel, *The Düsseldorf School of Painting*, 50–61.

3. Wend von Kalnein, "Einleitung," in *The Hudson and the Rhine: Die amerikanische Malerkolonie in Düsseldorf im 19. Jahrhundert*, exh. cat. (Kunstmuseum Düsseldorf, 1976), 14.

4. According to art historian Martina Sitt, the collection of Dutch genre paintings in the possession of Archduke Jan Wellem had been moved from Düsseldorf to Munich in 1806. In 1831, only ten percent of the works exhibited at the Art-Union (Kunstverein) in Düsseldorf were genre paintings. That number increased steadily over the next decade. See Sitt, "Genremotive im Zeitalter der 'Telegraphenungeduld,'" in *Angesichts des Alltäglichen: Genremalerei zwischen 1830 und 1900*, exh. cat. (Kunstmuseum Düsseldorf, 1997), 17–31.

5. Wilhelm Schadow is said to have praised Leutze's *Columbus before the High Council of Salamanca* (1842) and recommended its acquisition by the Düsseldorf Art-Union (Kunstverein Rheinland Westfalen). See Barbara Groseclose, *Emanuel Leutze, 1816–1868: Freedom Is the Only King*, exh. cat. (Washington, D.C.: Smithsonian Institution Press, 1975), 73. For a discussion of the professional relationship between Lessing and Leutze, see also William Gerdts, "The Düsseldorf Connection," in William Gerdts and Mark Thistlethwaite, *Grand Illusions: History Painting in America* (Fort Worth: Amon Carter Museum, 1988), 149–52. There is a striking similarity between the figure of Jan Hus in Lessing's *Hus before the Council of Constance* (1842) and Leutze's first Columbus painting of the same year. For further insight into the affinities between these two painters, see Sabine Morgen, "The Dissemination of the Düsseldorf School of Painting in America," in Baumgärtel, *The Düsseldorf School of Painting*, 222.

6. Johnson's *The Card Players* and Knaus's *Die Falschspieler (The Card Sharps)* have a stronger affinity with Dutch art than with Woodville's version. Johnson painted four known variations of the card-playing theme, all of them while living and working in the Netherlands. I am grateful to Patricia Hills, who shared with me her records on Johnson via e-mail, March 8, 2012. Knaus based his *Card Sharps* on sketches he made during a trip to several villages in the Black Forest area in the fall of 1850. The Düsseldorf Art-Union acquired the painting in 1851.

7. Elizabeth Johns, *American Genre Painting: The Politics of Everyday Life* (New Haven and London: Yale University Press, 1991), 180–81.

8. For a brilliant reading of *War News from Mexico* and the painting's political and cultural context, see Bryan J. Wolf, "All the World's a Code: Art and Ideology in Nineteenth-Century American Painting," *Art Journal* 44 (Winter 1984): 328–37.

9. For an extensive discussion of the history of the telegraph and Woodville, see Justin Wolff, *Richard Caton Woodville: American Painter, Artful Dodger* (Princeton and Oxford: Princeton University Press, 2002), 97–111. However, the first fully operating transatlantic cable was not developed until 1865–66.

10. An excellent overview of American attitudes toward Mexico and the war is Robert H. Johannsen, *To the Halls of Montezumas: The Mexican War in the American Imagination* (New York: Oxford University Press, 1985). For a more extensive discussion of Leutze's *Storming of the Teocalli*, see

Jochen Wierich, *Grand Themes: Emanuel Leutze, Washington Crossing the Delaware, and American History Painting* (University Park: Pennsylvania State University Press, 2012), 49–71.

11. "The Paintings on Exhibition at the Art-Union," *The Literary World,* September 8, 1849, 204.

12. See Groseclose, *Emanuel Leutze,* 30–31. For an overview of Düsseldorf during the revolutionary years, see Jonathan Sperber, *Rhineland Radicals: The Democratic Movement and the Revolution of 1848–1849* (Princeton, N.J.: Princeton University Press, 1991).

13. For an extensive discussion of Hasenclever and the painting *Workers Confronting the Magistrature* (Boime's translation), see Albert Boime, *Art in an Age of Civil Struggle, 1848–1871* (Chicago and London: University of Chicago Press, 2007), 536–54.

Woodville and the International Art World

MARIE-STÉPHANIE DELAMAIRE

HIS EXTENDED RESIDENCE ABROAD notwithstanding, Richard Caton Woodville participated in the art worlds of both Europe and the United States. With the reception of *The Card Players* (1846), *War News from Mexico* (1848), and *Old '76 and Young '48* (1849) (cat. nos. 3, 8, 12)—all three exhibited in the galleries of the American Art-Union between 1847 and 1850, and engraved in large editions for the union's members of 1850 and 1851 (checklist nos. 17, 18, 20)—Woodville became one of the Art-Union's favorite artists. He also exhibited in Düsseldorf and London, and established a productive relationship with the Paris-based international art dealer and publisher Goupil and Company. Goupil published three of his American genre paintings: *Politics in an Oyster House* (1848, published in 1851), *Waiting for the Stage* (both signed and published in 1851), and *The Sailor's Wedding* (1852, published in 1855), and commissioned the latter two as well (cat. nos. 9, 14, 15, checklist nos. 21, 22, 23).[1]

Many scholars have examined the ambiguous pictorial narratives in Woodville's paintings and shown how these works reflected on significant issues that roiled antebellum America: economic and social change, westward expansion, the Mexican War, and the growing concern with the role of African Americans in American society. These analyses have successfully demonstrated the eloquence and intricacy of Woodville's art. Yet they have primarily been concerned with situating his

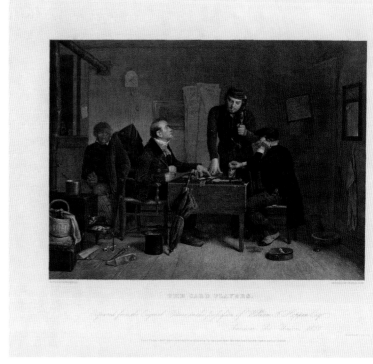

Fig. 30. Christian Schultz, *Cornered!* after Richard Caton Woodville, *Waiting for the Stage* (London, Paris, and New York: Goupil & Co., 1851). Lithograph. Bibliothèque nationale de France, Paris, Cabinet des Estampes (AA-4 [Schultz, C.])

Fig. 31. Charles Burt after Richard Caton Woodville, *The Card Players.* Collection of the New-York Historical Society, American Art-Union Collection (PR 159), checklist no. 17

significance within a national framework, despite Woodville's active engagement in the international art world during the last five years of his life.

The decade of Woodville's artistic pursuit in Europe, from his arrival in Düsseldorf in 1845 to his death in London in 1855, coincided with a moment of great internationalization for the European art publishing industry, which had been steadily expanding since the 1820s. Innovations in printing and transportation technologies created new possibilities for extended production and circulation of reproductive prints. By mid-century, leading European art firms like Goupil & Co. fostered and sustained transnational networks of artists and publishers that reached as far as Russia and the United States. Most importantly for Woodville, the house of Goupil opened its first foreign branch in New York early in 1848, establishing direct contact with the American art world. The firm's New York managers organized traveling exhibitions, created an extensive network for the distribution of the company's prints throughout the United States, and published more than a hundred American works of art, including lithographic reproductions of paintings by the leading genre painters of the antebellum era: William Sidney Mount, George Caleb Bingham, and Woodville. Goupil's lithographs were produced in Parisian *ateliers*, published simultaneously in the firm's main European and American headquarters located in Paris, London, Berlin, and New York, and disseminated throughout the company's international network. Goupil's reproductions after Woodville's paintings not only

contributed to several French critics' awareness of this "American Wilkie's" talent, but also to the circulation of new images of American art in Europe.[3]

While most American artists' collaboration with the house of Goupil was organized through the New York branch, Woodville, who moved to Paris in 1851, developed his relationship with the dealer and publisher directly at the firm's headquarters in the French capital. Several of his paintings were listed in Goupil & Co.'s stock book, which indicates that he delivered *Waiting for the Stage*, under the title of its later publication, *Cornered!*, on March 27, 1851, for 500 francs—well above the dealer's average price. The picture remained in the hands of Goupil until 1852, the amount of time necessary for the production of Christian Schultz's lithographic reproduction, which was copyrighted toward the end of 1851 (fig. 30). Schultz's print, *Cornered!*, was listed in the eighth supplement to the French Goupil catalogue of early 1852. It was simultaneously published in Paris, New York, and London.[4] By the time Woodville moved to and settled in London in 1853, he was not only one of Goupil & Co.'s most highly compensated artists, but also one of the most widely published (nationally and internationally) American painters of his time. Indeed, between the patronage of the American Art-Union and that of Goupil & Co., all but one of Woodville's American genre scenes, *Scene in a Bar-Room* (cat. no. 2), would be reproduced in engraving or lithograph before the painter's untimely death in 1855.

Throughout his career, but most directly while painting *Waiting for the Stage* for Goupil & Co., Woodville engaged in the momentous transformations affecting the mid-nineteenth-century conditions of production and dissemination of works of art. Several scholars have noticed the painting's thematic proximity to Woodville's earlier work, *The Card Players*, exhibited at the American Art-Union in 1847, and published by the institution for the members of 1850 (fig. 31).[5] In fact, Goupil & Co. probably commissioned Woodville specifically for a close variation of the successful *Card Players*, a painting unavailable to Goupil since it was about to be published by the American Art-Union. The firm had just published Woodville's only available American genre scene, *Politics in an Oyster House* (see fig. 37), and its New York manager was engaged in an extensive campaign of American publications, trying to secure, in particular, the reproduction of popular works by leading American genre painters in order to ensure Goupil & Co.'s role in the American art world.[6] Coinciding with Goupil's commission of *Waiting for the Stage*, the firm negotiated with George Caleb Bingham for the publication of *Mississippi Rafts-men Playing Cards*—also an earlier purchase of the American Art-Union—and settled instead for a close variation of the work, a painting titled *In a Quandary*.[7] The title of Woodville's painting as it was registered in Goupil & Co.'s stock book further attests that *Waiting for the Stage* was commissioned for publication. The painting's original title, *Cornered!*, is characteristic of the firm's practice of bestowing arresting titles on pictures whose revenues from print sales were expected to exceed those from the sale of the original by a wide margin.

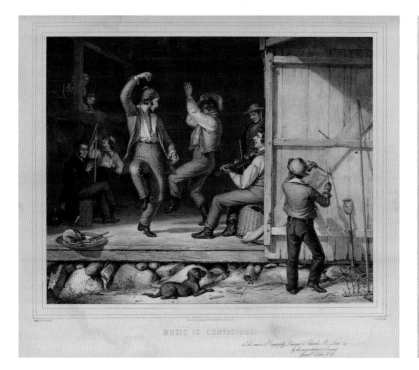

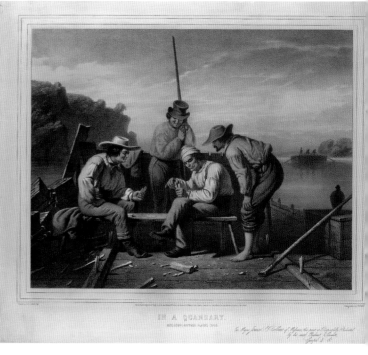

Fig. 32 (top left). Alphonse Léon Noël, *Music Is Contagious!* after William Sidney Mount, *Dance of the Haymakers* (New York: Goupil, Vibert & Co., 1849). Lithograph, sheet: 50 × 57 cm. American Antiquarian Society, New York (Lithff GoupV Noel Musi)

Fig. 33 (top right). Claude Régnier after George Caleb Bingham, *In a Quandary: Mississippi Raftsmen Playing Cards* (New York: Goupil & Co., 1852). Lithograph, colored, 35.1 × 50.3 cm. The State Historical Society of Missouri (2005.0002)

Fig. 34 (right). Groupil & Co. advertisement from *The Literary World* 7, no. 204 (Dec. 21, 1850): 515. American Antiquarian Society, New York (PR, ID 17558)

Schultz's lithograph was proposed in the firm's catalogue as a pendant to William Sidney Mount's *Music Is Contagious!* (a lithographic reproduction by Léon Noël of *Dance of the Haymakers* (fig. 32) and George Caleb Bingham's *In a Quandary* (reproduced by Claude Régnier) (fig. 33). Goupil's commission of *Waiting for the Stage* as a variation on *The Card Players*, and the company's marketing of its reproduction together with Bingham's and Mount's works fitted easily in the firm's American print series of 1848–51, which had been widely advertised in American literary magazines and newspapers at the time (fig. 34), and had made the New York house not only an importer of French prints and paintings in America but also an influential element of American art and culture at large.[8]

Woodville's variation on *The Card Players* resulted in a work of art far exceeding its model despite a basic similarity in the composition: two white men playing cards in a country stagecoach inn with a bystander, innkeeper, or traveler, mildly interested in the game. In *The Card Players*, an African American figure at the left of the picture observes the dispute about to arise between the players, while in *Waiting for the Stage* a black woman peeks at the scene through the back window at the far left of the composition. Several iconographic details found in *The Card Players*' preparatory drawing (checklist no. 12) and modified in the 1846 painting—the birdcage and the side drawer of the player's table in particular—are included in Woodville's new composition, suggesting that the painter went back to his earlier drawing as a starting point for the new painting. The similarities between the two works end here. A decisive change in the scene's perspective constructs a less theatrical image, a picture where the figures are more naturally integrated into their surrounding. While both paintings reflect Woodville's predilection for the accumulation of numerous objects in a small interior space, *Waiting for the Stage* does not convey the visual catalogue found in the former work, but rather the painter's preoccupation with an intense description of the material world at large. In *Waiting for the Stage*, figures, walls, and objects and furniture receive the same degree of attention from the painter's brush. The painting largely dispenses with the narrative at the core of the earlier work and becomes a primarily descriptive image.

Waiting for the Stage's descriptive mode is unique in the artist's representations of American life, and certainly proceeded in part from Woodville's interest in ensuring the painting's translatability in the reproduction process. His prior depictions of engravings in several American genre scenes not only acknowledged the expansion of reproductive print culture in contemporary life—from the shabby country barroom to the elegant upper-middle-class parlor—but also indicated the artist's skeptical outlook as to the printed images' power to convey the true nature of artistic creation. In the absence of personal papers, Woodville's assessment of the cultural and artistic role of reproductive prints before the 1850–51 Goupil commission can only be deduced from the painter's repeated inclusion of prints in his pictures of

Fig. 35. Waterman L. Ormsby after John Trumbull, *The Declaration of Independence of the United States of America: July 4, 1876* (New York: George Pratt, 1849). Engraving, sheet: 74.5 × 101 cm. American Antiquarian Society, New York (Engrff Trum Orms Decl)

American life: *The Card Players, Soldier's Experience,* and *Old '76 and Young '48.* In *The Card Players,* a largely indistinct image is half-hidden behind the large broadside from Baltimore's Front Street Theatre. *Soldier's Experience* features both a framed engraving above the veteran—indiscernible as well, but representing an event dated 1776 (see checklist. no. 13), therefore most likely a print after Trumbull's *Declaration of Independence* (fig. 35)—and a more elusive printed image casually attached to the cabinet door behind the young soldier. The most significant of these three representations is the later work, *Old '76 and Young '48,* since Woodville represented the monumental framed engraving after Trumbull's *Declaration of Independence* at the forefront of his composition (fig. 36), where it plays a key iconographic role. Not only crowning the intensely described fireplace, the engraving also leads the main diagonal and connects the entire family to both the young soldier and his sword on the floor at the bottom right of the painting. By positioning the print above the fireplace (a change made in the course of its production), Woodville placed the engraved image in the most brightly lit area of his picture, where its nondescriptive aspect as a black-and-gray square could stand in strong formal contrast to its exquisitely detailed surroundings—the gray-and-white marble fireplace, brass andirons, tongs, fender, the hearth's glowing embers, and bricks—and its cracked protective glass and richly sculpted gilt frame. In all of these pictures, Woodville gives us enough visual information to identify what kind of print we are looking at but not enough

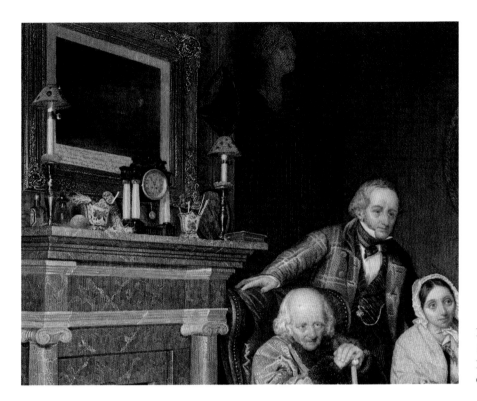

Fig. 36. J. I. Pease after Richard Caton Woodville, *Old '76 and Young '48*, detail. Collection of The New-York Historical Society, American Art-Union Collection (PR 159), checklist no. 20

to precisely recognize the specific elements of the work of art he is alluding to. Only iconographic necessity helps us identify the two representations of a large engraving as reproductions after Trumbull's work in *Old '76 and Young '48*, and the earlier *Soldier's Experience*. In *Old '76 and Young '48*, Woodville is most eloquent at articulating a print's inability to convey the original artwork beyond its historical status as a relic of a glorious past in an upper-middle-class American home. Indeed, despite the significance of Trumbull's image in printed form in the painting, Woodville's illegible brushwork for the surface of the engraving itself insists on the reproduction's failure to communicate anything of artistic significance about the original work of art itself.

While his previous representations indicate that Woodville was largely unconvinced as to reproductive prints' capacity to accurately convey the essence of a work of art, Goupil & Co.'s 1850 commission offered him a unique opportunity to address the reproduction of one of his paintings beforehand. This was a critical moment for Woodville since four of his own pictures were being translated and published into engravings and lithographs at the same time. With *Waiting for the Stage*, the artist explored his own visual means of representation in order to ensure that the lithographic translation of his painting would convey the most significant aspects of the original. In the process, Woodville created his most compelling adaptation of a seventeenth-century theme to modern American life.

Whereas the American Art-Union always engaged line engravers for the reproduction of their paintings, Goupil & Co. preferred to publish American works of art as lithographs because the process allowed the company to release the prints faster on the American market.[9] On the one hand, both media used widely different techniques for modeling and representing light and shade. As a result of the flatness of the stone's printed surface, lithographs had an evenness of tone among all the inked areas, which was used to a particular degree of effectiveness and sophistication in mid-nineteenth-century Parisian ateliers. What Francis Grubar defines as Woodville's use of a "homogenous saturation of light and shadow" to describe the material world of *Waiting for the Stage* was in fact particularly well adapted to the delicate balance of tonal values achieved by Parisian crayon lithography.

On the other hand, Goupil & Co.'s American genre scenes were all drawn on stone by a relatively small team of artists-lithographers living in Paris that included Léon Noël, Michele Fanoli, Claude Thielley, and Christian Schultz. Most of these artists benefited from an academic training in drawing and painting, which shaped their interpretation of American genre paintings. For instance, Fanoli was first a

Fig. 37 (left). *Politics in an Oyster House*, detail. The Walters Art Museum, Baltimore, gift of C. Morgan Marshall, 1945 (37.1994), cat. no. 9

Fig. 38 (right). Michele Fanoli after Richard Caton Woodville, *Politics in an Oyster-House / Les Politiques au Cabaret*, detail. The Walters Art Museum, Baltimore, gift of Miss Sadie B. Feldman in memory of her brother, Samson Feldman, 1987 (93.145), checklist no. 21c

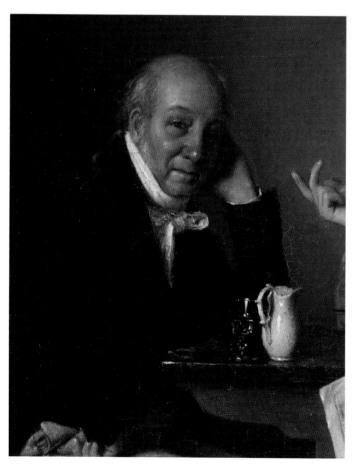

pupil at the Accademia di belle arti in Venice and became a famous lithographer for his rendering of Canova's *Amor and Psyche* before settling in Paris toward the end of 1840. The lithographers' artistic education made them masters of the detailed representation of the human figure. As a result, their lithographic reproductions tended both to carry a high level of interpretation in the expression of the human figure and to excel in the exquisite rendering of a painting's details.

The reproduction, in Paris, of American genre scenes had significant consequences for the pictures' reception. Looking at a mid-nineteenth-century engraved or lithographic reproduction invited close viewing, which often translated into the creation of visual narratives based on a critical analysis of details. Michele Fanoli's singular transformation of the old gentleman's expression in *Politics in an Oyster-House,* for instance, had a considerable impact on the reception of Woodville's picture in New York, where one critic saw in Fanoli's image a representation of a "benevolent-looking" gentleman rather than a possibly mildly intoxicated man (figs. 37, 38), and invented a long story around the old gentleman based on identical iconographic details between *The Card Players* and *Politics in an Oyster-House:*

> Our old friend is not as choice as he might be in his company: you remember that hard looking youth he was playing card with in the country, and here in the city he has fallen in with one of the same kidney. . . . This companion looks as if he was fresh from Tammany Hall or the Park in the heat of a Presidential canvass. He has his coat closely buttoned, a fiercely brushed pair of whiskers, a carelessly tied neckcloth, with a suspicious absence of linen where it is generally perceptible in a gentleman's apparel.[10]

The excessive attention to the figures' expressions and pictorial details inherent in mid-nineteenth-century practices of medium-to-medium translation thus not only affected the narrative created around the work of art in significant ways, but also reinforced a kind of scrutiny that endorsed the visual analysis of detail at the expense of the work's clarity as a whole.[11] Woodville was concerned with both in *Waiting for the Stage* and as a result designed a picture that became Goupil's consummate translation of an American genre scene. On the one hand, he based his representation on the attentive description of the world at the expense of narrative action—objects, people, and light equally deserving the artist's careful brushwork. On the other hand, to avoid Parisian lithographers' tendencies to alter the representation of human expressions, Woodville eschewed the representation of emotions in the three main figures: one of them is impassive, while the other two are hidden—eyes behind dark glasses for one, and the other with his back to the viewer. The absence of meaningful gestures in *Waiting for the Stage* also excluded the possibility of interpreting the protagonist's feelings. Woodville's predilection for intense visual description was beautifully carried over into Schultz's drawing on the lithographic stone. His preoccupation with the translatability of the essence of the work of art in reproduction,

evoked in *Old '76 and Young '48,* and addressed directly in *Waiting for the Stage,* led the painter to direct his attention to the imitative or descriptive richness of pictorial representation—that is, to concentrate on a basic conception of painting as representation rather than as visual rhetoric and narration.

The artist's commitment to translatability greatly diminished the *raison d'être* of narrative action in his new interpretation of the seventeenth-century theme. In contrast to *The Card Players,* where the intense description of the material world helped the viewer understand the where, when, and what of the action taking place at center stage—a crucial moment in a game of cards played between a middle-aged gentleman and a young card sharp, in the barroom of a stagecoach inn located between Baltimore and Washington at about five past four o'clock—here, the accumulation of material details only called attention to the painter's skilled hand and his exquisite representation of various surfaces, but did not contribute to a better apprehension of the location of the scene, nor to the moral character of the picture's protagonists and the possible outcome of their exchange. While the first painting can be seen as a transposition of a seventeenth-century theme into an American modern setting, where the game of card functions as metaphor for Americans' penchant for gambling and speculation, *Waiting for the Stage* is no longer preoccupied with the representation of an anecdote as a commentary on a specific trait of American contemporary culture.[12] As Peter J. Brownlee has shown, speculation and gambling, which had become part of all aspects of American culture by mid-century, were both games of chance with risky outcome. As a result, American visual culture depicted a game, a raffle, or any other metaphor for speculation at its most "tantalizing moment before the outcome of the game, the moment of greatest narrative tension and therefore, the greatest visual interest."[13] In contrast, the card game in *Waiting for the Stage* is not about to reach a climactic moment, and it is not the most dramatic element of the composition. Ultimately, *Waiting for the Stage* avoids moral judgment or specific cultural characterization. It is significant that the artist carefully eliminated all of the material details included in *The Card Players* that would have been seen as the unmistakable markers of the American stagecoach inns, in particular the wash basin, towel, brush, and comb customarily shared by American inns' customers and feared by European travelers. *Waiting for the Stage* and its descriptive mode rather call attention to the deceptiveness of representation itself. The world of the painting is certainly one of illusion, a world of random encounters between strangers, who can only rely on external appearances to decide whom to trust and what to do next. In contrast to *The Card Players,* where the spectator is shown what most of the painting's figures can't see—a card hidden under the thigh of the young player—Woodville gave the viewer of the later painting neither more nor fewer visual clues than its protagonists. Woodville thus blurred the distinction between the realm of representation and the world of the observer. Exploring the painting's ability to reflect artistic creation even

in translated form, Woodville composed a genre scene dedicated to exploring painting's power of representation, beyond the confines of its American setting.[14]

The commission and publication of *Waiting for the Stage* in 1851 certainly brought Woodville's remarkable artistic talent and his ability to create an art of international stature to Goupil's attention. Indeed, the *Bulletin of the American Art-Union* soon reported that Woodville was working on a new painting "purchased in advance by Goupil & Co," which would be the artist's last known American genre scene.[15] Published in 1855, the year of Woodville's death, in France, Germany, England, and the United States, *The Sailor's Wedding* (fig. 39; see cat. no. 15), was bought for 1,500 francs by the Parisian dealer, who thus paid an extremely high price for a small cabinet piece painted by an artist barely known to the Parisian art world. With this

Fig. 39. Claude Thielley, *Un mariage civil aux États-Unis.* after Richard Caton Woodville, *The Sailor's Wedding.* Collection of Stiles Tuttle Colwill, checklist no. 23

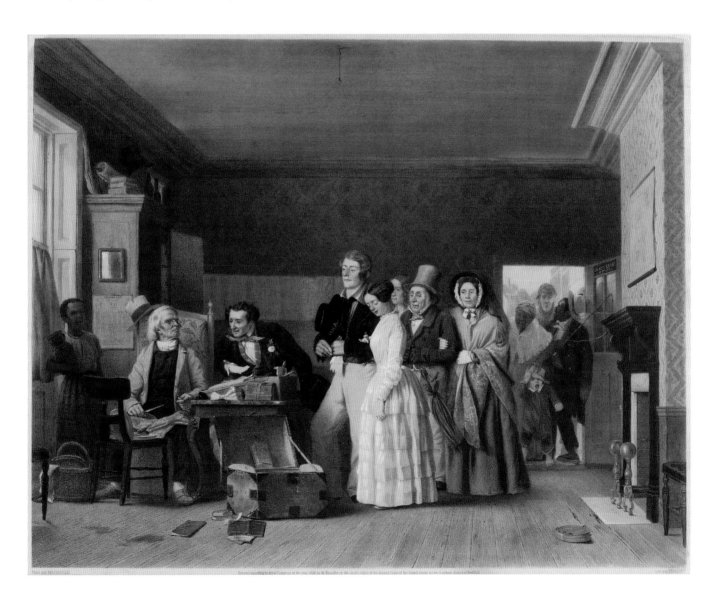

purchase, Woodville joined the ranks of such internationally famous painters as Paul Delaroche and Ary Scheffer to become one of the very few highly compensated artists in the dealer's stock book.[16] *Waiting for the Stage* was thus instrumental in changing Woodville's stature in American and European art at the mid-century, from that of an American expatriate painter largely equated to Mount and Bingham—that is, to painters whose audiences remained largely local—to that of an international artist contributing to a vigorous international art world.

NOTES

1. Goupil and Co. started as Henry Rittner in 1829, followed by Rittner et Goupil (1831–41), then Goupil et Vibert (1841–46), then Goupil, Vibert et Companie (1846–50), and finally Goupil et Companie (1850–84). Despite the changes of names over time, I will refer to the company as Goupil & Co. throughout this essay. For Woodville's exhibitions in Düsseldorf and London, see John W. Ehninger, "The School of Art at Düsseldorf," *Bulletin of the American Art-Union*, 1 (April 1850): 7; *The Illustrated London News*, 550 (March 20, 1852): 240; "Fine Arts. Exhibition of the Royal Academy," *The Illustrated London News Supplement* 571 (July 31, 1852).

2. See Bryan J. Woolf, "All the World's a Code: Art and Ideology in Nineteenth-Century American Painting," *Art Journal* 44 (Winter 1984): 328–37; Elizabeth Johns, *American Genre Painting: The Politics of Everyday Life* (New Haven and London: Yale University Press, 1991); Gail E. Husch, "'Freedom's Holy Cause': History, Religious, and Genre Painting in America, 1840–1860," and Ron Tyler, "Historic Reportage and Artistic License: Prints and Paintings of the Mexican War," in *Picturing History: American Painting, 1770–1930*, ed. William Ayres (New York: Rizzoli, 1993); Wendy Greenhouse, "Imperiled Ideals: British Historical Heroines in Antebellum American History Painting," in *Redefining American History Painting*, ed. Patricia M. Burnham and Lucretia Hoover Giese (Cambridge: Cambridge University Press, 1995); Justin Wolff, *Richard Caton Woodville: American Painter, Artful Dodger* (Princeton: Princeton University Press, 2002).

3. See Henri Delaborde, "La Gravure depuis son origine jusqu'à nos jours," 3: École anglaise.—Raynbach: *le Payeur de rentes, le Colin-Maillard* d'après Wilkie.—Cousins: *Pie VII* d'après Lawrence. *Estampes* d'après M. Landseer.—La gravure aux États-Unis," *La Revue des Deux Mondes*, nouvelle période, première série, tome 9 (January–March 1851): 43–48. Goupil & Co.'s New York branch eventually transformed the scale and nature of artistic exchanges between Europe and America. The company's American print series were circulated widely in Europe. Despite their continuous availability in the company's catalogue, it remains difficult to evaluate their reception in Europe precisely. The sheer quantity of material published by the house of Goupil at the time made it difficult for these prints to attract any critic's sustained attention. None of them were exhibited at a major public show such as the Paris Salon during this period. For a discussion of the European reception of Goupil's reproduction after American genre paintings, including Woodville's, see Marie-Stéphanie Delamaire, "American Prints in Paris or the House of Goupil in New York (1848–1857)," in *With a French Accent: French and American Lithography before 1860*, ed. Georgia B. Barnhill (Worcester, Mass: American Antiquarian Society, 2012), 65–82.

4. *Waiting for the Stage* was later sent to New York and sold for $80. Goupil & Cie./Boussod, Valadon & Co. stock books, in the Dieterle family records of French galleries, 1846–1986, the Getty Research Institute Research library, now available online at: www.getty.edu/research/tools/provenance/index.html. Even though Schultz's lithograph was copyrighted in 1851, it must have been released on the market quite late, since the print appears only in Goupil & Co.'s eighth supplement, published in the spring of 1852. (Goupil & Co. generally published a list of their new publications twice a year, in the

spring and in the fall of each year.) Many thanks to Pierre-Lin Renié, formerly of the Goupil Museum in Bordeaux, for sharing with me the museum's extensive collection of Goupil's catalogues and supplements. There is no evidence of the print's reception in the United States. William Schaus, then manager of the New York branch, did not advertise any of the company's new publications in 1852. Frustrated with what he felt was an unfair remuneration from the American publications since 1850, Schaus finally left the company in August of 1852 to set up his own business in New York. See the Schaus-Mount correspondence published in Alfred Frankenstein, *William Sidney Mount* (New York: Abrams, 1975): 162–63. Regular and extensive advertisements for Goupil's publications resumed in the New York press in 1854.

5. Francis S. Grubar, "Richard Caton Woodville: An American Artist, 1825–1855" (Ph.D. diss. Johns Hopkins University, 1966): 145; and Wolff, *Richard Caton Woodville*: 137, 146–50.

6. Michele Fanoli's lithograph after Woodville's *Politics in an Oyster-House* was copyrighted early 1851. However, it was released in New York late in 1850. See the advertisement published in *The Literary World* 7, no. 25 (December 21, 1850): 515.

7. Bingham to J. S. Rollins, New York, March 30, 1851, and Bingham to J. S. Rollins, Philadelphia, June 27, 1852, in "Letters of George Caleb Bingham to James S. Rollins," ed. C. B. Rollins, Part I, *Missouri Historical Review*, 32, no. 1 (October 1937): 21, 26. The lithograph after Bingham's painting was released early in 1852, a few months after Schultz's *Cornered!*

8. With the American print series, and the creation of an International Art-Union based in New York in 1849, Goupil's New York house aimed at attracting wide middle-class audiences throughout the Union. As a result, Goupil became a direct competitor of the powerful American Art-Union.

9. For an analysis of Goupil's American publications as a marketing campaign for the art publisher in America, see DeCourcy E. McIntosh, "Merchandising America: American Views Published by the Maison Goupil," *Antiques* 166, no. 3 (September 2004): 124–33, and "American Genre Prints in the Service of French Commerce," *Antiques* 171,

no. 4 (April 2007): 102–9. To balance DeCourcy's analysis, however, French lithographs were very well known and appreciated in the United States much earlier, in particular for their "mellowness of expression and a rich blending of light and shade which cannot be obtained from copper." "From the Lowell Journal—Lithography," *Berkshire Journal* [Lenox, Massachusetts] 1, no. 50 (August 12, 1830): 1, quoted in Lauren B. Hewes, "'French Lithographic Prints: Very Beautiful': The Circulation of French Lithographs in the United States before 1860," in Barnhill, *With a French Accent*, 33–47.

10. The entire quotation reads: "Most of our readers are probably familiar with the painting by Woodville, distributed by the Art-Union recently and engraved by them last year, entitled the Card Players. They will, therefore, need no introduction to the benevolent-looking old gentleman who is therein depicted. . . . Our old friend is not as choice as he might be in his company: you remember that hard looking youth he was playing card with in the country, and here in the city he has fallen in with one of the same kidney, who looks as if he might be city cousin to the youth aforesaid. . . . This companion looks as if he was fresh from Tammany Hall or the Park in the heat of a Presidential canvass. He has his coat closely buttoned, a fiercely brushed pair of whiskers, a carelessly tied neckcloth, with a suspicious absence of linen where it is generally perceptible in a gentleman's apparel. . . . The orator is capital and thoroughly American, as is the entire scene, an oyster cellar." "Fine Arts: Politics in an Oyster-House," *The Literary World* 9, no. 13 (September 27, 1851): 251.

11. For a discussion of how the most celebrated mid-nineteenth-century reproductive engravings tended to destabilize the relationship between the work of art as a whole and its details, see Stephen Bann's account of the reception of Mercuri's engraving after Paul Delaroche's *Jane Grey*, in *Parallel Lines* (New Haven and London: Yale University Press, 2000), 135–41.

12. For an extensive analysis of American visual culture's representations of gambling and the development of the market economy in antebellum America, including Woodville's *Card Players*, see Peter J. Brownlee, "Francis Edmonds and the Speculative Economy of Painting," *American Art*

21, no. 3 (Fall 2007): 31–53; Wolff, *Richard Caton Woodville*, 66–69, 142–47.

13. Brownlee, "Francis Edmonds," 39.

14. "The bar seems the only inhabited apartment about the house," wrote a British traveler in 1830, "and there, upon arrival, the company immediately proceed: within it are always to be met with conveniences for washing—the very first operation—and a comb and a brush attached together by a string . . . and used *sans ceremonie* by all comers and goers, though *I* took the liberty of declining the accommodation." (John Fowler, *Journal of a Tour in the State of New York in the year 1830, with remarks on agriculture in those parts most eligible for settlers; and return to England by the Western islands, in consequence of shipwreck in the Robert Fulton* (London: Whittaker, Treacher, and Arnot, 1831), 71–72.

15. *Bulletin of the American Art-Union*, 4 (July 1851), 63.

16. Goupil stock books show that less than 10 percent of Goupil's artists received more than 1,000 francs for their work between 1846 and 1852.

Woodville's Technique

ERIC GORDON

Among the most appealing aspects of the paintings of Richard Caton Woodville are their richly observed and meticulously executed details. One of the pleasures of studying these works is the extent to which they repay close observation. The quality of Woodville's almost miniaturist style may in fact be apparent only when the paintings are viewed under magnification, revealing, for example, the kaleidoscopic effect of light reflected in an eye, the individual threads of an embroidered coin purse, or the shimmer of gold on a gilded frame hidden in the dark corner of a room.

Only sixteen paintings by Woodville are known, of which the Walters Art Museum owns eight. The small size of his oeuvre and its concentration near Baltimore raised the hope among the exhibition's organizers that we might be able to bring together all of Woodville's works to ascertain how he developed as an artist, what materials he used, and whether he appropriated materials and techniques specific to the locales in which he lived. Such technical findings might also make it possible to establish the sequence in which the works were painted and to establish data relevant to their attribution. As it happened, our expectations were exceeded, and we were able either to bring to the Walters' conservation laboratory or examine at their home institutions all of Woodville's paintings, as well as an attributed work and a contemporary copy.

These findings include data on supports, grounds, underdrawing, *pentimenti*, representative and possibly unique pigments, and where still extant, original coatings. The paintings underwent visual, microscopic, ultraviolet, infrared, x-radiation, x-ray diffraction, x-ray fluorescence, gas chromatography mass spectroscopy, cross-sectional, and Ramen analysis, though not all methods were used in each instance. Research on such a scale into a single artist's entire oeuvre is unparalleled, and for this opportunity we are grateful to the paintings' owners, to the Wyeth Foundation for American Art, to the University of Delaware's conservation program, to the National Gallery of Art (specifically to John Delaney, senior imaging scientist, for his expertise and for generously allowing us to use the Gallery's cutting-edge equipment), and to the Walters' enthusiastic Wyeth Foundation Fellow in Conservation, Gwen Manthey.

THE EVOLUTION OF WOODVILLE'S TECHNIQUE

Woodville likely began his early artistic training at St. Mary's College in Baltimore, possibly with the instructor Samuel Smith. It has been suggested that, like his friend Frank Blackwell Mayer, Woodville might have studied with Alfred Jacob Miller, who was teaching painting and drawing in Baltimore as early as 1842.[1] To test that hypothesis, we studied four of Miller's paintings from the 1840s in the collection of the Walters Art Museum—*Portrait of Antoine*, *The Savoyard*, *The Marchioness*, and *Sioux Indians in the Mountains*—and compared our findings with data from our technical examination of the Woodville paintings. Our analysis shows few points of similarity between Miller's works and Woodville's early paintings: both artists used boards as supports, but Miller favored white grounds, whereas Woodville preferred gray; Miller's underdrawing was free, loose, and often incorporated into the design, whereas Woodville's was linear, limited to small contours and boundaries, and typically concealed by the paint. Miller's paint application was looser, thinner, and broader than Woodville's.

Woodville's earliest extant painting from Baltimore, *Portrait of Dr. Thomas Edmondson* (cat. no. 1), reveals some of the shortcomings that one might expect of a novice painter. X-radiography shows that he had trouble placing the eyes and that he struggled with the height and size of the hat and the position of the sitter's right arm (fig. 40). Indications of the artist's emerging style are nonetheless evident in the tight brushwork and assured rendering of the subject's face. This work, unusually small for a standard portrait, combines a loose, thin painting technique for the background and clothing with finer, tighter brushwork for the face. Also unusual for a formal portrait is the artist's choice of support: a small commercially prepared pasteboard rather than the medium- to large-format canvases typically used in American portraiture of the 1840s. Pasteboard—a generic term for boards composed of sheets of paper pasted

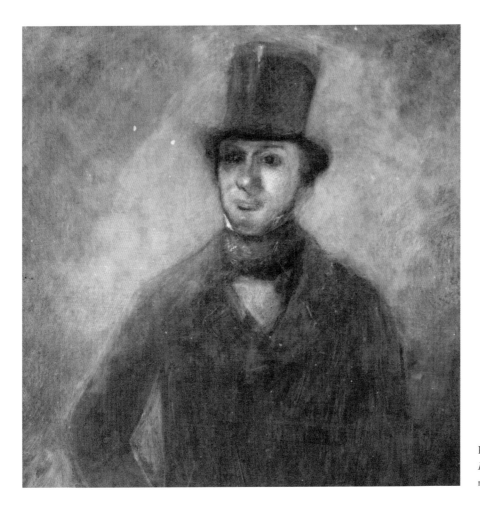

Fig. 40. X-radiograph detail of *Portrait of Dr. Thomas Edmondson*. Maryland Historical Society, Baltimore, cat. no. 1

together—was fairly new on the market and was often used for landscape painting or sketching because of its easy portability.[2] The support of Woodville's only other Baltimore painting, *Scene in a Bar-Room* (cat. no. 2), a very small genre scene, is also a commercially prepared pasteboard. A small pasteboard support might have been easier to navigate and to some extent might have masked artistic weaknesses. In both cases, no underdrawing is discernible; the figures were laid in and the background was subsequently brushed loosely around them; final adjustments were made in the proportions and compositions after the paint had dried.

The practice of reworking on the support is illustrated in the unbalanced composition in *Scene in a Bar-Room*, which has led to speculation that the right edge of the painting might have been trimmed at some point. X-radiography revealed that the figure on the right was added on top of the door frame after the paint had dried completely and that the proper left hand of figure on the left was repainted. Furthermore, microscopic examination of the right side revealed ground and paint drips over the edge, disproving that hypothesis.

Fig. 41. Andreas Johann Jacob Müller, *The Christ Child*, 1849. Oil on panel, 11.6 × 15.1 cm. The Walters Art Museum, Baltimore (37.178)

Woodville might have been exposed to the miniaturist technique through the example or direct tutelage of the many miniature painters practicing in and around Baltimore during the mid-nineteenth century. Similar use of stippling, hatching, and washing is typically found in miniature paintings by Thomas Sully, James Peale Jr., Henry Inman, and Richard Morrell Staigg, all of whom practiced in the Baltimore area during Woodville's short career.[3]

Woodville's skills matured rapidly during the course of his year of study at the Düsseldorf Kunstakademie in 1845 and his subsequent private studies with Carl Ferdinand Sohn. Additionally, his exposure to the clarity, serenity and polish of northern European painting influenced the development of his technique. At the academy, he absorbed the school's highly polished, meticulous style and developed his skills in modeling forms with light and color and in confidently situating multiple figures in clearly legible spaces. The artist's first painting from his Düsseldorf years, *The Card Players* (cat. no. 3), is also his first extant work on canvas. Woodville's choice of a canvas support may attest to his embrace of the academic style; certainly the assured technique evident in that painting is a departure from the awkward passages of *Scene in a Bar-Room*. In place of the earlier work's ambiguous background, Woodville represented a room in perspective, delineated by floorboards, walls, ceiling, and stovepipe, in which figures occupy a well-defined space enhanced by details that augment the narrative. Artists of the Nazarene school in Düsseldorf were admired for the delicacy of their meticulous renderings; their aesthetics, like those

of the British Pre-Raphaelites, evoked the early Renaissance ideals of beauty and clarity, in which every blade of grass and flower petal was described in minute detail. Although the subjects differ, the tight brushwork, the manner of applying paint, and meticulousness characteristic of Woodville's technique is evident in one such work, *The Christ Child*, by the Nazarene painter Andreas Johann Jacob Müller (fig. 41). The small scale of the painting, moreover, accords with Woodville's preferred size, especially that of his portraits.

Close study of *The Card Players* reveals interesting information about Woodville's choice of materials and the sequence in which he composed his paintings. As in all the Düsseldorf paintings, Woodville used a commercially prepared support (here, twill-weave linen) and grounds. Twill weaves were more expensive than plain weaves and were considered unsurpassed as a support, since the diagonal pattern has the capacity to retain more paint. Woodville used thicker, plain-weave linens as a support in *The Cavalier's Return* (cat. no. 6) and *Politics in an Oyster House* (cat. no. 9). In paintings dating from his residence in Paris and London (cat. nos. 14, 15, and 16), Woodville chose very fine, plain-weave linen.

In a preparatory pencil drawing for *The Card Players* (checklist no. 12), Woodville blocked in the figures and articulated the architectural space and details predominantly with contour lines, limiting hatching to the depiction of shadows (fig. 42). While the figures remain substantially the same in the sketch and the painting (fig. 43),

Fig. 42 (left). Richard Caton Woodville, *The Card Players*, detail. The Walters Art Museum, Baltimore, gift of Mr. Kurt Versen, 1991 (37.2650), checklist no. 12

Fig. 43 (right). Richard Caton Woodville, *The Card Players*, detail. Detroit Institute of Arts, gift of Dexter M. Ferry, Jr., cat. no. 3

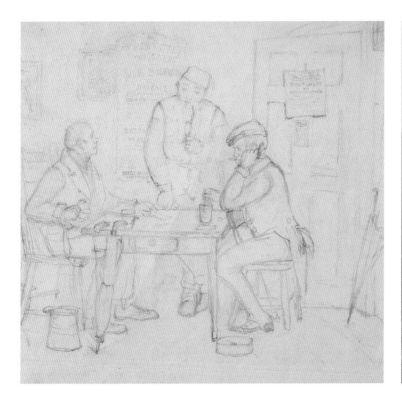

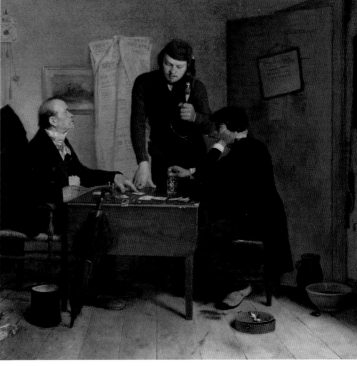

Fig. 44. Richard Caton Woodville, *War News from Mexico*, detail. Crystal Bridges Museum of American Art, Bentonville, Arkansas, cat. no. 8

the sketch includes two umbrellas, slightly different hats, a drawer in the table, and different broadsides, all loosely drawn. No discernible underdrawing was detected in *The Card Players*, but a thin red-brown paint layer blocking in the composition in areas of shadow suggests that a preliminary sketch over the ground was guided by a drawing. The red-brown paint was applied with a coarse-bristled brush, leaving the underlying ground exposed in some areas. Woodville then built up forms with a more opaque paint to define the composition and establish colors. Glazes were added for modeling, and then thinner-tipped or smaller brushes were used to highlight details.

The figures were painted with direct, wet-into-wet modeling and even, regular brushstrokes, some of which take up the entire width and length of colored passages, such as sleeves and trousers. Woodville used a similar technique to model the table surfaces and floorboards. In contrast, he painted faces and small objects with very precise, tiny strokes. The reeds of the basket and the orange highlight on the watch chain, for example, are only millimeters in length. Loose, multidirectional

brushstrokes define the background around the figures; a deep gray layer was followed by a thinner, lighter gray tone. After the floor and foreground were added, the outline of the spittoon was blocked in with hot orange and when the paint had dried, darkened with thin glazes of deeper red. Highlights were applied with smaller brushes into the red paint, wet-into-wet, detailing the metal seams, and in the surrounding area, splotches of color added to render the tobacco and debris. The lines between the floorboards were then painted around the spittoon.

The size of the brushstrokes in passages such as these suggests that Woodville used magnification. In *War News from Mexico* (cat. no. 8), for example, it is easy to overlook the iridescent reflection off a colored strand of a peacock feather (fig. 44), the cream-colored highlight bouncing off the enamel of a tooth, the white stubble of beard on the old man's chin, or the spent match tossed on the porch. While the layers are built up, the paint itself is very delicately applied using the finest, narrowest brushes in dots and strokes of only a few millimeters. It is hard to imagine that Woodville would not have needed optical enhancements to achieve such effects.

With two exceptions—the portrait of Thomas Edmondson and the *Self-Portrait with Flowered Wallpaper* (cat. no. 11) (the former on pasteboard, the latter on a commercially prepared mahogany panel)—Woodville's portraits and head-studies are executed on canvas. The *Portrait of Maria Johnston* (cat. no. 7), while on canvas, appears to have been adhered to a paperboard support with a gold liner in a small frame by the artist himself, perhaps in imitation of the Düsseldorf artists' typical compositional devices in self-portraits.[4] Those intended as finished works, such as the portrait of Maria Johnston, are as tightly painted as his genre scenes, whereas the *Portrait of a Woman* (cat. no. 4) and *Head of a Soldier* (cat. no. 5) have broader, freer brushwork, painted wet-into-wet, and were probably left unfinished or intended as studies. (The soldier's head, in fact, closely resembles that of the cavalier in *The Cavalier's Return.*)

The free, loose brushwork characteristic of Woodville's oil sketches is carried over into a finished work in what may be Woodville's latest extant painting: *The Italian Boy with a Hurdy-Gurdy* (cat. no. 16). After he left Düsseldorf for Paris and London, Woodville's exposure to contemporary French painting might have broadened his range of painting techniques, encouraging him to work not only on a larger scale but also with freer, more assured brushwork. The painting's subject is at least a third larger than those in his genre scenes. The brushwork in the painting, notably in the back wall, is vigorous, with admixtures of color in the off-white impasto, recalling the brushwork of the French academic painter Thomas Couture, who taught other American artists such as Daniel Huntington and William M. Hunt. Woodville used a variety of brushes, blending paint on his palette and on canvas and applying it thickly enough to create a moderate impasto. The figure's face, hand, and shirt collar are well blended; the patterned, textural sleeve was daubed on for a flannel-like appearance.

At the same time, fine, minute details—hallmarks of Woodville's meticulous technique—highlight the instrument, its tuning keys, and the figure's left hand, down to the reflection off the boy's thumbnail and the dirt under his fingernails (see fig. p. 65).

It is apparent in the x-radiograph that the artist worked out his final composition on the canvas in paint; there are numerous changes in the boy's face, collar, hat, and hand, and textural brushstrokes often do not correlate to the visible image. In an earlier version, the boy stared directly at the viewer (figs. 46–47), hat pulled down to his brows (highlighted here in red); in a second version the figure's head (highlighted in blue) was tilted back slightly over his proper left shoulder, and in the final version, his head (highlighted in green) is inclined even further back. A proper right eye (highlighted in yellow) is detectable just below the final proper right eye. These eyes do not correlate anatomically, further suggesting that there were at least three earlier arrangements before the artist settled on the fourth, final position. The effect of the figure's pose in the finished painting is less confrontational and more seductive.

Cross sections taken from the face and the hurdy-gurdy reveal interlayer varnishes (probably composed of a blend of tri-terpenoid resins [mastic or dammar], drying oils, and possibly shellac) between each version and below the instrument. Woodville might have considered the painting finished with the completion of each version of the face and before adding the hurdy-gurdy, or he might have wished to saturate the painting with varnish to see how it looked while working.

On the evidence of his last known surviving painting, one can speculate that Woodville's painting technique was in the process of becoming freer and more vigorous, echoing the more avant-garde movement in Europe while retaining the meticulous attention to detail characteristic of the paintings from Woodville's years in Düsseldorf. In the brief span of ten years, the artist developed from an awkward, small-scale painter to one with a command of elegant, intricate detail combined with lively impasto. From the *Scene in a Bar-Room* to *Politics in an Oyster House* to *The Italian Boy with a Hurdy-Gurdy,* the progression is swift, intense, and noteworthy in the extent to which the young artist absorbed all he could from his surroundings and made these new techniques his own, producing some of the most enduring images of nineteenth-century American painting.

Findings from the technical examination of Woodville's painting are reported in tables 1 and 2 and are summarized below:

SUPPORTS

Woodville's two surviving oils from his early years in Baltimore are painted on pasteboard supports; pasteboard was a relatively new product among artists' materials in the United States in the early 1840s. The reverse of *Portrait of Dr. Thomas Edmondson* bears a label identifying the board's manufacturer as [George] "Rowney" (see fig. 55),

Fig. 45 (left). Richard Caton Woodville, *The Italian Boy with Hurdy-Gurdy*, detail. The Walters Art Museum, bequest of George C. Doub, 1982, cat. no. 16

Fig. 46 (below left). X-radiograph detail of *The Italian Boy with Hurdy-Gurdy*

Fig. 47 (below). X-radiograph detail of *The Italian Boy with Hurdy-Gurdy*, with overlay showing changes to the composition

	TITLE	DATE	FRAME	STRETCHER	LINED	ORIGINAL SUPPORT
BALTIMORE	Dr. Thomas Edmondson	ca. 1844	Post-1850s (American)	None	—	Pasteboard
	Scene in a Bar-Room	1845	Not original	None	—	Pasteboard
DÜSSELDORF	The Card Players	1846	Possibly original	Replacement	Yes	Twill (n/a)[1]
	Portrait of a Woman	1846–49	Not original	Original	No	Plain (44/48)[1]
	The Soldier's Experience	1847	Not original	—	—	Paper
	Head of a Soldier	1847	Possibly original, 1830–70, (European)	Original	No	Twill (41/48)[1]
	The Cavalier's Return	1847	—	Replacement	Yes	Plain (46/36)[1]
	Portrait of Maria Johnston	1847	Original	None	Glued to board	Plain (n/a)[1]
	War News from Mexico	1848	Not original	Possibly original	Yes	Twill (n/a)[1]
	Politics in an Oyster House	1848	Not original	Replacement	Yes	Plain (42/36)[1]
	Man in Green Coat with Umbrella	1848	Not original	—	—	Paper
	Self-Portrait in a Black Coat	1848–50 (?)	Not original	Replacement	Yes	Plain (30/30)[1]
	Self-Portrait with Flowered Wallpaper	1848–50 (?)	Not original	None	—	Panel
	Old '76 and Young '48	1849	Original	Replacement	Yes	Twill (16/25)[1]
	Old Woman and Child Reading a Book	1840s	Possibly original (Period, European)	Possibly original	Yes	Fine plain (30/32)[1]
PARIS & LONDON	Waiting for the Stage	1851	—	Replacement	Yes	Fine plain (31/29)[1]
	The Sailor's Wedding	1852	Not original	Replacement	Yes	Fine plain (36/36)[1]
	The Italian Boy with Hurdy-Gurdy	ca. 1853	Not original	Replacement	Yes	Plain (40/44)[1]

NOTE 1. (thread/in)

a leading British manufacturer of paints and other artists' materials that exported its products to the United States; *Scene in a Bar-Room*, which is painted on both sides, bears no label or stamp. The only other instance of a non-canvas support in Woodville's oeuvre is the mahogany panel (with a Winsor-Newton London label on the reverse) of the *Self-Portrait with Flowered Wallpaper* (cat. no. 11).[5]

The only certain original stretchers are found in the oil study of a *Head of a Soldier* and *Portrait of a Woman*; in both cases, the canvases were never removed from their structural supports. Both are lap-joined and contain no crossbars; the *Head of a Soldier* does not have keys, whereas the portrait has eight. *Old Woman and Child Reading a Book* (cat. no. 13) and *War News from Mexico* appear to be on nineteenth-century stretchers; it is not known whether they are original, since both canvases were removed from their stretchers before lining.

In the Düsseldorf paintings, Woodville typically chose commercially prepared, fine twill-weave linen. The exceptions are *Politics in an Oyster House, Portrait of Maria Johnston* (which is adhered to thin paperboard, most likely by the artist), and *The Cavalier's Return*. In Paris and London, the artist selected a commercially prepared, plain-weave linen that was thinner than the canvas from Düsseldorf. Twill weaves, which were more expensive, were considered more desirable as they picked up more paint.

GROUNDS

The grounds on Woodville's paintings were commercially applied lead white in oil. The canvas texture was first filled in with a blend of lead white and the cheaper fillers barium sulfate and calcium carbonate, followed by a thinner layer of lead white. This significantly cut costs for the commercial supplier. The only ground that Woodville applied himself was in his self-portrait on canvas (cat. no. 10), in which a second layer was brushed over an earlier portrait of a man in order to obscure the image.

UNDERDRAWING

Though only a few preliminary drawings survive for Woodville's genre scenes, it is likely that his ideas were born on paper and transferred (at least in part) to canvas. For instance, *Old '76 and Young '48* (cat. no. 12) was worked up from a complex gouache sketch that was signed and dated (checklist no. 13). Grids indicate the transfer of a drawing to canvas, and they are detectable in three of the paintings. In *The Cavalier's Return* and *War News from Mexico*, grids are visible through light-colored passages in infrared images (fig. 48). In *Politics in an Oyster House*, remnants of a grid and perspective lines overflow onto the unpainted perimeter. Complex compositions may have fairly complete underdrawing, although the underdrawing may not be entirely visible with infrared imaging because of carbon-containing paint layers above.

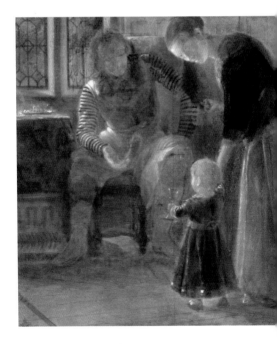

Fig. 48. Infrared detail of *The Cavalier's Return*. New-York Historical Society, bequest of Kate Warner, cat. no. 5

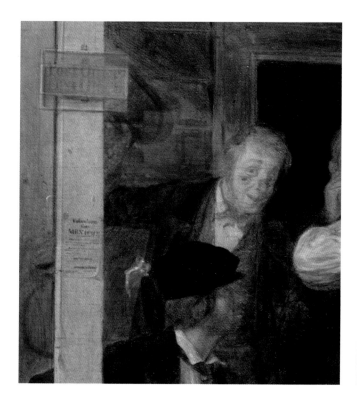 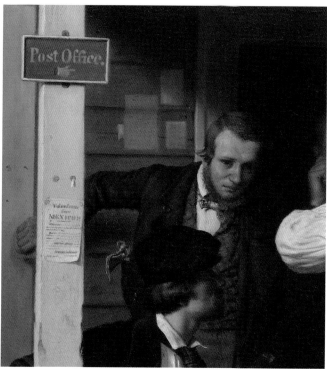

Fig. 49 (left). Infrared detail of *War News from Mexico*. Crystal Bridges Museum of American Art, Bentonville, Arkansas, cat. no. 8

Fig. 50 (right). *War News from Mexico*, detail

Woodville did not rigidly adhere to an independent sketch and at times drew freely on the ground. A good example of that practice can be seen in *War News from Mexico*, where the artist experimented with the placement of the right arm of the standing figure at far left, moving it up and down and eventually entirely eliminating a broad-brimmed hat that the figure originally held (figs. 49, 50). The painting in fact contains more pentimenti than any other of Woodville's paintings, indicating a progressive refining of the composition.

Another case of a loose, assured sketch drawn directly on commercially primed canvas is the unfinished *Portrait of a Woman*, in which a lovely, delicate, and quite extensive underdrawing in graphite was sketched with sharp, short strokes on the ground layer to delineate the contours; shadows are indicated by discreet hatching. The torso and head are fully drawn, as are finer details, such as the ringlets of hair, ruffled collar, and black ribbon. Faint lines, much lighter and thinner than the rest of the underdrawing, encircle the sitter's eyes, possibly suggesting eyeglasses (fig. 51). Next, thin paint glazes were used to build up forms, and the chin, neck, and curls were enhanced in ink on top of the paint (fig. 52). The watercolor *Man in Green Coat with Umbrella* (checklist no. 14) was similarly composed by overlaying a drawing with paint and graphite accents.

For the most part, Woodville's underdrawings are linear, limited to outlines, and contain little hatching or shading. Graphite hatching appears only in the sitter's

Fig. 51 (left). Infrared detail of *Portrait of a Woman*. The Walters Art Museum, Baltimore, gift of Kurt Versen, cat. no. 4

Fig. 52 (above). Photomicrograph detail of *Portrait of a Woman*

sleeve in the self-portrait on panel (cat. no. 11), the *Portrait of a Woman*, and *Politics in an Oyster House*. Shading is typically worked up in the first paint application, in which the artist blocks in darker and lighter compositional elements.

PAINT APPLICATION

After sketching the composition onto canvas, Woodville usually blocked in broad passages with thin red-brown paint, leaving room for figures (with the exception of dark clothing), using a fairly stiff, broad brush. The ground was not completely

TABLE 2: *Grounds, Underdrawings, Underpaint, and Pigments of Woodville's Paintings*

	TITLE	DATE	GROUND	UNDERDRAWING	UNDERPAINT	WHITE
BALTIMORE	*Dr. Thomas Edmondson*	ca. 1844	Chalk[1] in glue, lead white[1] in oil, mixed gray in oil	No	—	Lead white[1,2]
	Scene in a Bar-Room	1845	Lead white[2] in oil, mixed gray in oil	No	—	Lead white[1,2]
DÜSSELDORF	*The Card Players*	1846	Lead white?	Yes	Red-brown	Lead white
	Portrait of a Woman	1846–49	Lead white in oil	Yes, dry and wet reinforced	Red-brown	—
	The Soldier's Experience	1847	n/a	Yes, dry	No	Lead white
	Head of a Soldier	1847	Lead white in oil	No	Red- brown	Lead white[2,3]
	The Cavalier's Return	1847	Lead white in oil	Grid: dry and wet	Red-brown	Lead white[2]
	Portrait of Maria Johnston	1847	Lead white in oil	No	Red- brown	Lead white
	War News from Mexico	1848	Lead white[2] in oil	Yes, dry and wet; Grid: dry	Yes	Lead white[2]
	Politics in an Oyster House	1848	Lead white[2] in oil	Grid: wet	Red-brown	Lead white[2]
	Man in Green Coat with Umbrella	1848	n/a	Yes, dry	No	Lead white
	Self-Portrait in a Black Coat	1848–50 (?)	Lead white[2] in oil	—	—	Lead white[2]
	Self-Portrait with Flowered Wallpaper	1848–50 (?)	Lead white and quartz in oil	Yes, dry	No	Lead white[3]
	Old '76 and Young '48	1849	Lead white[2] in oil	Yes, wet	Red-brown	Lead white[1,2]
	Old Woman and Child Reading a Book	1840s	Lead white in oil	No	—	Lead white
PARIS & LONDON	*Waiting for the Stage*	1851	Lead white[1,2] in oil	Yes, wet Bone[2]	Yes	Lead white[1,2]
	The Sailor's Wedding	1852	Lead white[1] in oil	Yes, wet	Yes	Lead white[1]
	The Italian Boy with Hurdy-Gurdy	ca. 1853	Lead white[2] in oil	Possibly	—	Lead white[1]

NOTES All pigments characterized by XRF 1. confirmed through Raman

BLACK	RED	ORANGE	YELLOW	BLUE	GREEN	OTHER
Carbon[1,2]	Vermilion[2]	—	Iron oxide[2]	Prussian[1]	Verdigris[1,3]	Chalk[1]
Carbon,[1,2] Bone[2]	Vermilion[1,2]	Mixture	Iron oxide[2]	Prussian[1]	Emerald[2]	Chalk[1] (in paint)
Carbon, Bone	Vermilion	Chrome	Iron oxide, Chrome, Naples	Prussian, Cobalt	Mixture	Magnesium dioxide, Copper
Carbon	Vermilion, Chrome, Red lake[3]	—	Iron oxide, Chrome	—	—	—
Bone	Vermilion	Mixture	Iron oxide	Prussian	Mixture	—
Carbon, Bone[2]	Vermilion	—	Iron oxide[2]	Cobalt	—	Copper, clay,[3] interlayer varnish
Carbon[2]	Vermilion, Red lake	—	Iron oxide,[2] BaSrCr	Prussian	Mixture	Interlayer varnish
Carbon	Vermilion	—	Iron oxide	Prussian	Mixture	—
Carbon,[2] Bone[2]	Vermilion, Cadmium, Chrome	Cadmium, Chrome	Iron oxide,[2] BaSrCr, Chrome[1,2]	Prussian, Copper-based	Mixture, Copper-based	Copper, Cobalt
Carbon, Bone[2]	Vermilion[2]	—	Iron Oxide,[2] Chrome[2]	Prussian	Mixture	Magnesium dioxide[2]
Bone	Chrome, Vermilion	Chrome, mixture	Iron oxide, Chrome	Cobalt, Prussian	Mixture	Copper
Charcoal,[2] Bone[2]	Vermilion, Chrome	—	Iron oxide,[2] Chrome	—	—	Barium,[2] Magnesium dioxide[2]
Charcoal	Vermilion, Chrome	—	Iron oxide, Chrome	Prussian	Mixture, Copper-based	Quartz,[3] Copper
Carbon, Bone	Vermilion,[1,2] Cadmium, Chrome[1]	Cadmium, Chrome	Iron oxide, Chrome,[1] Cadmium[1]	Prussian, Ultramarine[2]	Emerald[2]	—
Carbon	Vermilion	—	Iron oxide	—	—	—
Carbon,[1] Bone[2]	Vermilion,[1,2] Cadmium, Chrome[1]	Cadmium, Chrome[1]	Iron oxide,[1,2] Naples,[2] Chrome[1]	Prussian[1,3]	Emerald[2]	Lead sulfate / sulfite drier[1]
Carbon[1]	Vermilion,[2] Chrome	Chrome	Iron oxide, Chrome[1]	Prussian[1]	Emerald	Barium sulfate[1]
Carbon,[2] Bone[2]	Vermilion,[2] Cadmium, Chrome	Cadmium, Chrome, mixture	Iron oxide,[2] Chrome,[1,2] Cadmium, Naples[2]	Prussian[3]	Emerald[1,3]	Gypsum,[1] interlayer varnish

2. confirmed through Scanning Electron Microscopy-Energy-Dispersive Spectroscopy (SEM-EDS)

3. confirmed through Fourier Transfrom Infrared Spectroscopy (FTIR)

covered and became part of the design of the surface. He then built up forms with more opaque paint to define the composition and establish colors. Glazes were added for modeling and then thinner-tipped, smaller brushes used to lay in details, most likely with the aid of magnification.

Woodville often adjusted the background color around his portraits with a second tone, for example in the portraits of Thomas Edmonson and Maria Johnston. Pentimenti were often separated by a discrete varnish layer, for example in *The Cavalier's Return* and *The Italian Boy with a Hurdy-Gurdy.*

PIGMENTS

Woodville's palette contained pigments typical of the first half of the nineteenth century, including lead white, carbon black, vermillion, chrome yellow and chrome red, Naples yellow, Prussian blue, emerald green, and a commercially blended mixture of Prussian blue and chrome yellow. Lemon yellow was chosen for select highlights—for example, in the flowers in *War News from Mexico.* The only unusual pigment is cadmium yellow, an expensive color that entered the market around 1848 in Düsseldorf. It was found in the peacock feather in *War News from Mexico* (see fig. 44) and in the gold highlights on the china vase on the mantle in *Old '76 and Young '48.*

INTERLAYER VARNISHES

Woodville might have applied interlayer varnishes when he considered a painting finished or to saturate an area while he was painting. They are confirmed in cross sections between all layers in the *Head of a Soldier* (perhaps to resaturate an area between sittings), in the foreground chair, green curtain, and soldier's hand in *The Cavalier's Return*, and between different versions of the face and near the hand on top of jacket and beneath the hurdy-gurdy in *The Italian Boy with a Hurdy-Gurdy.*

VARNISHES

Because all the paintings have been cleaned, no overall original varnishes survive. The *Portrait of a Woman* hidden beneath another painting arrived at the Walters in 1991 with a semi-opaque, matte surface coating that was likely applied by the artist. The coating obscured the image and was partially dissolved in an enzyme solution when cleaned, but it did not test positive for proteins when a sample was stained, perhaps due to its degraded condition. It might have been an egg-white coating applied as a temporary varnish.

Fig. 53. Photomicrograph detail of *The Italian Boy with Hurdy-Gurdy*. The Walters Art Museum, bequest of George C. Doub, 1982, cat. no. 16

INHERENT VICE [6]

A feature found in many passages of Woodville's paintings is a wrinkling, traction crackle, or alligator cracking of the paint layer. These may be caused by layers of paint drying at different rates and/or the inclusion of a drying oil in the media. In paintings built up in thin layers, like *Politics in an Oyster House*, the result is a slight separation of the paint layer that resembles a minimal alligator crackle. Traction crackle is evident in paintings with a medium paint application, such as *Old '76 and Young '48*. In thicker paint surfaces where there is impasto, as in the face of the boy in *The Italian Boy with a Hurdy-Gurdy*, the layer appears wrinkled (fig. 53).

NOTES

1. See, for example, Supplement to the *Baltimore Sun*, November 15, 1881, cited in Justin Wolff, *Richard Caton Woodville: American Painter, Artful Dodger* (Princeton, N.J.: Princeton University Press 2001), 38 and n. 83.

2. Lance Mayer and Gay Myer, *American Painters on Technique: The Colonial Period to 1860* (J. Paul Getty Trust: Los Angeles, 2011), 147.

3. Notes from conversation with Carol Aiken, August 3, 2011.

4. See, for example, Carl F. Sohn, *Self-Portrait*, oil with gold ground, 1844, Stiftungmuseum Kunstpalast, Düsseldorf, M 2011-1 (no. 26) [p. 21, fig. 8].

5. Alfred Jacob Miller's pasteboard supports in the 1840s were approximately twice as thick as those that Woodville used; the "Müller" stencil on the reverse of *Sioux Indians in the Mountains* (Walters Art Museum, acc no. 37.1996) identifies it as a French board that was sold in America.

6. "Inherent vice" is the susceptibility of an artwork to damage and disintegration from within.

RICHARD CATON WOODVILLE

Catalogue of Paintings

———

Checklist of Works on Paper

1. *Dr. Thomas Edmondson*, ca. 1844

Oil on board, 25.2 × 20.3 cm
Maryland Historical Society, Baltimore, The Dr.
Michael and Marie Abrams Memorial Purchase
Fund (1984.6)

Inscribed: lower left: "R C [W]oodville 1845" in red
paint; on reverse: "Caton Woodville's first 'kick
into / the world' — portrait of T Edmondson" in
black ink

Provenance: The Misses Hough, Baltimore, 1933;
Mrs. Alida E. Ransby, great-great-granddaughter of the sitter, by descent; Maryland Historical
Society, by purchase, 1984

Technical Notes: A label on the pasteboard's reverse
reads in part *G. Rowney & Co. Artists' colourmen, / 51 Rathbone Place, London.* Both sides of the
board were coated with two grounds (chalk in glue
followed by lead white in oil) and a final, middle-value gray tone. The ground layers intermittently
extend over the four sides, and there is no detectable underdrawing. The artist first painted the
figure, then vigorously brushed in a background
containing Prussian blue subtly adjusted with a
gray-green pigment. Texture from the brushstrokes and the irregular pasteboard support
is discernible in the background. The paint was
applied opaquely, with little to no added media.
The delicate paint strokes around the face and
the precisely placed impasto of the collar contrast with the looser brushwork in the waistcoat
and background. The face has a subtle, pebble-like consistency, while the background is thinner
and more fluid. Woodville's signature and date
in red and black paint applied as a *trompe l'oeil*
shadow are more elegant and precise than in his
other works. Woodville may have struggled with
Edmondson's proportions and features, adjusting the figure's outline and raising the height and
brim of the hat. The artist reworked the sitter's
right eye; x-rays reveal adjustments in its shape
and directional gaze (see fig. 40).

Although trained at the University of Maryland Medical College, Thomas Edmondson
(1808–1856), a member of one of Baltimore's
wealthiest mercantile families, never practiced medicine. Instead, a substantial inheritance from a bachelor uncle allowed him to
pursue a life of scholarship, music, art collecting, and horticulture. He had a valuable
library and large collection of paintings at
his estate "Harlem," the site of present-day
Harlem Park on Edmondson Avenue in west
Baltimore. In particular, he patronized the
German genre painter Ernst Georg Fischer,
who painted Edmondson and his family at
leisure (fig. 54), the Neapolitan view-painter
Nicolino Calyo, who documented Edmondson's Baltimore home in 1834, and local artists Alfred Jacob Miller, Michael Laty, and
Hugh Newell. He also owned works attributed to Brueghel, Hondecoeter, and Seghers.[1]

Woodville's and Edmondson's fathers
were both successful merchants who had emigrated from Liverpool. The sitter's friendly
and encouraging relationship with the young
artist seventeen years his junior is made clear
by the inscription on the painting's reverse
(fig. 55). This is very likely Woodville's first
oil portrait. Clearly, he had learned how to
layer and glaze with oil paint, but there is a
marked contrast between his ability to capture specifics of Edmondson's face, top hat,
and neckwear and the awkward, unfinished
quality of the jutting right arm and body.

NOTE

1. Baltimore 1984, vi, 13–14.

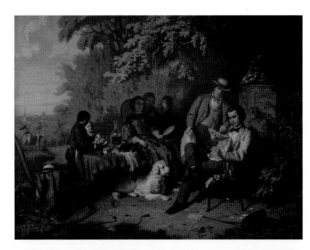

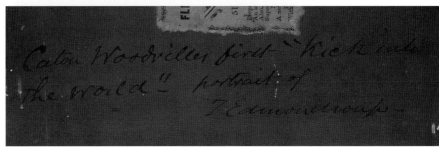

Fig. 54. Ernst Georg Fischer, *Country Life of a Baltimore Family*, 1850. Oil on canvas, 38.1 × 48.3 cm.
Maryland Historical Society, Baltimore (1962.103.6)

Fig. 55. *Dr. Thomas Edmondson*, reverse, detail

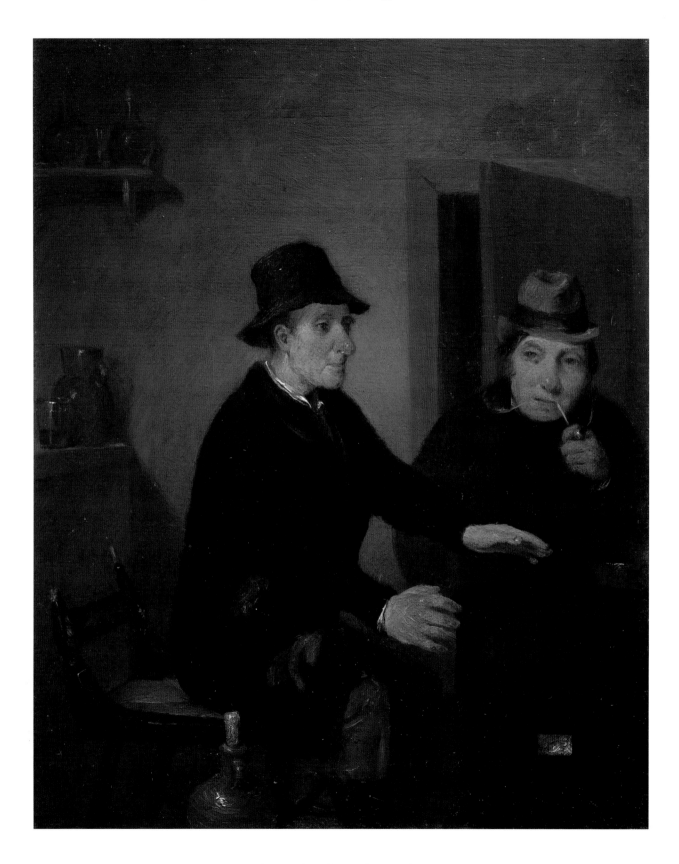

2. *Scene in a Bar-Room*, 1845

Oil on panel, 21.6 × 17.1 cm
Godel & Co., Inc., New York

Inscribed: lower right: "RCW 1845" in gray paint on stove door; on reverse: "Woodville," "Van Allen," "#6," "#6," in purple crayon; "120722.1" in black pen; "R.C." rubber stamp, encircled

Provenance: Abraham M Cozzens, New York, by 1845; Van Allen, from 1868; Kennedy Galleries, New York, by 1982; Private collection; Alexander Gallery, New York; Godel & Co., New York; Berry-Hill Galleries, New York; Private collection, until 2006

Technical Notes: The composition, painted on an off-white, lead ground on a commercially prepared pasteboard support, has little to no detectable underdrawing, although infrared examination and irregular texture reveal hidden brushstrokes below. The left figure was painted wet-into-wet, and highlights of the pants, hat, and blue lapcloth were blended on the board. It appears that the painting originally portrayed only the center figure, which would account for the somewhat unbalanced composition. To accommodate the change, the proper left hand of the left figure was repainted. Most of the brushwork is loose, made with fairly thick, wide strokes. The faces were modeled with smaller, stiffer strokes, and the underlying ground and paint layers are detectable through the impasto of the flesh tones.

Despite its humble subject, somewhat awkward figures and diminutive scale, this painting launched Woodville's career as an artist. Two men sit in comfortable companionship in a dark, constricted interior. One smokes his pipe and muses, while the other warms his swollen hands over a metal stove with a fire glowing orange through a small vent. The large corked ceramic jug in the foreground, the brick exposed through cracked plaster above the half-open door, and the broken chair on which the man on the left is seated all indicate a rough tavern environment, where liquor is swigged communally and fights may be part of an evening's entertainment. Both men are coarse-featured with the bulbous red noses and vacant expressions of habitual drinkers. As would be characteristic in all of his paintings, the young artist lavished attention on the telling barroom details, setting the scene with carefully rendered glassware, pitchers, and carafes.

In its seventeenth-century form, genre painting depicted peasant life as an object of condescension for upper-class patrons. Woodville would have known works by Dutch and Flemish genre painters in the Gilmor and Edmondson collections in Baltimore. Edmondson had a *Village Festival* by Wouwerman,[1] while Gilmor owned *Smokers in a Tavern* and *A Smoker* attributed to Adriaen van Ostade, works by Jan Steen and *Interior with Men Drinking* by the Flemish painter Adriaen Brouwer.[2] This exposure had a lasting effect on Woodville, who engaged with similar subject matter throughout his brief career.

The artist sent this painting to New York to the 1845 exhibition of the National Academy of Design. In an article about Woodville that appeared in the *New-York Daily Tribune* in 1867, an unnamed art critic intimates some backroom dealings, perhaps by one of the Baltimore collectors:

> A friend of our townsman, Mr. Abraham Cozzens, known far and wide as a generous and discriminating lover of art, told him that this little picture had been sent, and asked him to buy it for the sake of encouraging the artist. Mr. Cozzens accordingly bought it without seeing it . . . when the exhibition opened, the picture was marked "sold," a word which an artist need not be mercenary to see with real pleasure, for it means not merely "cash" but "appreciation," "recognition," and he is a dull soul to whom those are not dear.[3]

The $75 purchase by such a prominent patron convinced William Woodville V to allow his son to leave for Europe to pursue art training.

On the board's reverse (fig. 56) are two heads, inverted relative to the front of the board. In the lower left, a one-quarter, reverse-profile sketch of a long-bearded man was lightly drawn in pencil in quick, sparsely modeled contour lines. At the upper right is an oil study of a woman's head fashioned with little to no detectable underdrawing and sketched first with a thinned, reddish-brown underlayer.

NOTES

1. Baltimore 1984, 14.
2. Lee 1998, 101, 117–20, 142.
3. *New-York Daily Tribune*, January 22, 1867, 2, quoted in Wolff 2002, 21.

Fig. 56. *Scene in a Bar-Room*, reverse

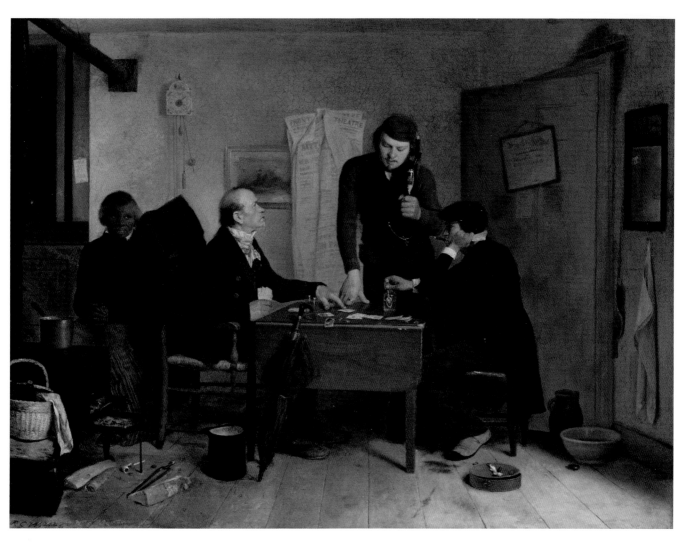

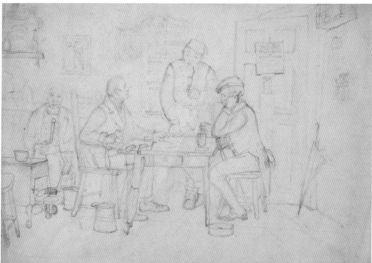

Fig. 57. Richard Caton Woodville, *The Card Players*.
The Walters Art Museum, Baltimore, gift of Mr.
Kurt Versen, 1991 (37.2650), checklist no. 12

3. *The Card Players*, 1846

Oil on canvas, 47 × 63.5 cm
Detroit Institute of Arts, gift of Dexter M.
Ferry, Jr. (55.175)

Inscribed: lower left: "R. C. Woodville / Düsseldorf"
in gray paint as if carved into a floorboard, abraded

Provenance: Thomas Foster, Utica, N.Y., 1847–49;
William J. Hoppin, from 1849; The Hoppin Family,
by descent; Argosy Gallery, New York; Dexter
M. Ferry, Jr., Grosse Pointe, Mich., 1955; Detroit
Institute of Arts, by gift, 1955

Technical Notes: The support is a fine, commercially
prepared twill linen. Evidence of an underdrawing
could not be detected, but a thin layer of red-brown
paint in areas of shadow, detectable between pas-
sages of paint, suggests that a preliminary sketch
might have been used to block in the composi-
tion over a cream-colored, lead-based ground. The
figures were painted with direct, wet-into-wet
modeling and even, regular brushstrokes, some of
which are the width and length of colored pas-
sages, including sleeves and trousers; a similar
technique was used to model the table surfaces and
floorboards. In contrast, faces and small objects
were painted with very precise, tiny strokes. A
number of changes occurred during the painting
process. The table originally did not have a drop-
leaf front but rather a drawer, as in the sketch;
x-ray and infrared images reveal the upper legs of
the left seated and standing figures as well as the
edges of the square table legs and drawer. The coat
tails of the left figure's jacket initially draped over
the back edge of the chair but later were tucked
under his seat. Some elements were clearly painted
in a later stage, when the paint layers below had
dried, such as the overcoat over the back of the left
chair, the stove pipes, and the log directly in front
of the stove. The frame may be original.

In this, the first painting he sent back to
America and his first major success, Wood-
ville adopted the time-honored European
genre subject of cheating at cards. The action
takes place in an inn or waiting room, localized
to America by the presence of a thoughtfully
rendered African-American observer, the-
atrical advertisements for Baltimore's Front
Street Theatre, broadsides for the stagecoach
service between Baltimore and Washington,
and other evocative details. Unaware of the
complicity between the two younger men,
including the card the one facing him across
the table conceals beneath his leg, the older,
balding "mark" confronts them both, stab-
bing his finger at the offending card in front
of him. A nearly empty glass of amber liquor
and coins and bills scattered across the table
attest to the drinking and gambling that
preceded this tense moment. In profile, the
younger opponent is dour and faintly bellig-
erent of expression, holding his cards over
his left shoulder and stirring the liquid in his
glass, while his companion stands over the
action, his size and slightly foreign acces-
sories (a fez-like red cap popular among
Düsseldorf artists at the time, and a long
ceramic pipe), lending a mood of ambiguity
and underlying menace to the scene.

Comparison with the preparatory draw-
ing (fig. 57) gives a clear sense of the artist's
working method, translating a rougher obser-
vation into the fine, clear detail that was a
hallmark of the Düsseldorf style. The draw-
ing, possibly made in Baltimore, has even
more localized details (see pp. 31–33). Tech-
nical study of the painting reveals a process
of compositional refinement through altera-
tions, giving the table a drop-leaf to create a
cleaner central focus and adjusting the still-
life details that surround the central action.

Woodville sent this painting from Ger-
many to his father, William Woodville V, in
Baltimore, who put his mercantile skills to
work to negotiate exhibition venues in Balti-
more, Philadelphia, Boston, and New York.
In May 1847, a reviewer in the *American &
Commercial Daily Advertiser* drew attention to
the technical progress Woodville had made as
a student at the Kunstakademie in Düsseldorf
and expressed his wish "that this work of art
may be secured for Baltimore, since it is local
in its design and is the first work of an artist
of Baltimore, who is likely to reflect credit
upon his native city as well as upon the art to
which he is devoted."[1]

After exhibition at the Pennsylvania
Academy of the Fine Arts, and possibly at the
Boston Atheneum, the elder Woodville con-
vinced officials of the American Art-Union in
New York to purchase the work for two hun-
dred dollars, a higher price than nearly all of
the other paintings they acquired that year. In
the Art-Union lottery, *The Card Players* went
to subscriber Thomas Foster of Utica, New
York. The winner appears to have sold it back
to Art-Union manager William J. Hoppin,
who showed it again in the annual exhibition
of 1849. Engraved by Charles Burt as one of
the five small folio line engravings published
as a membership premium for American Art-
Union subscribers in 1850 (see fig. 31), the
painting was described in *The Literary World*
on November 30 of that year as numbering
"its admirers by thousands. All frequenters
of the gallery have been familiar with it."[2]

NOTES

1. Detroit Institute of Arts 1991–2005, 2:256.
2. *The Literary World*, November 30, 1850, 432.

4. *Portrait of a Woman*, 1846-49

Oil on canvas, 23 × 18 cm
The Walters Art Museum, Baltimore, gift of Kurt
Versen, 1990 (37.2652)

Provenance: Kurt Versen, by descent from the artist,
prior to 1990; Walters Art Museum, 1990, by gift

Technical Notes: The painting, apparently an unfinished oil sketch, is in nearly original condition. A
fine, plain-weave linen with a lead white ground
followed by a warm gray layer is tacked onto a
four-piece, lap-joined stretcher. Washes of paint
brushed with loose, free movements, describe the
sitter's torso and the background; tighter, though
still thinly applied small strokes define her face,
hair and blouse. A lovely, delicate, and quite extensive underdrawing in graphite was first sketched
onto the prepared canvas, using sharp, short strokes
to delineate the contours and limited hatching to
denote shadow. The torso and head are fully drawn,
as well as finer details, such as the ringlets of hair,
ruffled collar, and black ribbon. Faint lines, much
lighter and thinner than the rest of the underdrawing, encircle the sitter's eyes, possibly suggesting
glasses (see fig. 52). Subsequently the artist applied
thinned layers of black and brown paint, blocking
in the sitter's hair, dress, and black ribbon. The hair
was further articulated with different brown hues
and the background applied around the contour of
the figure, leaving a slight reserve. The underdrawing, the warm gray toning layer, and the texture
of the canvas are visible through the paint, as the
thinnest layers of the black dress, and the brown
background may have been rubbed or scraped away.
The contour of the head and hairline was reinforced
with ink (see fig. 51). Over the ink, painted highlights in the hair, flesh tones and white shirt were
reinforced and hatching in the chin, neck and curls
redefined. An empty, unpainted space for a chair
back was left behind the woman; two small strokes
of red lake in the lower right corner, suggest a seat
cushion or shawl. The painting was discovered in
1990 at the Walters Art Museum underneath a self-
portrait of the artist on canvas (cat. no. 10). As the
linen supports of the two portraits have different
thread-counts, it is presumed that they were not
painted as a pair.

Depicted in three-quarter length, the subject
turns slightly to the left. Her hairstyle, pulled
back in a bun with a cascade of corkscrew
curls along the side of the head, was fashionable on both sides of the Atlantic and helps
date the portrait to the 1840s. Although she
demurely directs her eyes downward, there is
strength of character in the young woman's
clear gaze and determined expression. The
subject is not identified, but she resembles the
artist's first wife, Mary Theresa Buckler, with
whom he had a tempestuous and ultimately
failed relationship. As mysterious a figure as
her artist husband, traces of her activities and
interests can be found in a ledger book that
has descended in the Woodville family, in
which purchases of black ribbon, lace, and
other sundries are interspersed with entries
for food, servants' wages, subscription to a
musical library, piano rental, and theater
tickets.

Under the direction of Wilhelm von
Schadow, the Düsseldorf Kunstakademie had
elevated the status of portrait painting, and at
least fifty artists were listed in that specialty
by the 1830s. Their admiration for the work
of Raphael is manifest in numerous portraits
of beautiful, demure women, defined by their
piety, humility, passivity, and introspection
(fig. 58).[1] After a brief period of enrollment in
the first class of figure drawing at the academy, Woodville became a private pupil of Carl
Ferdinand Sohn, who specialized in such idealized portraits of Düsseldorf's political and
artistic elite. Sohn's portrait of Mary Buckler
Woodville in an historical costume (fig. 59),
gives expression, through the set of her jaw
and firm anchoring of hands to hip, to the
subject's strength of will.

NOTE

1. Düsseldorf 2011, 1:122.

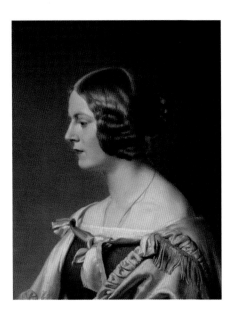

Fig. 58. Carl Ferdinand Sohn, *Portrait of Elisabeth
von Joukowsky*, 1843. Oil on canvas, 62.5 × 49.5 cm.
Stiftung Museum Kunstpalast, Düsseldorf (M 5042)

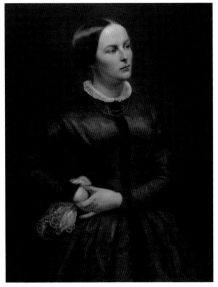

Fig. 59. Carl Ferdinand Sohn, *Portrait of Mary
Buckler Woodville in Historical Costume*, ca. 1846-49.
Oil on canvas, 89 × 67.7 cm. Private Collection

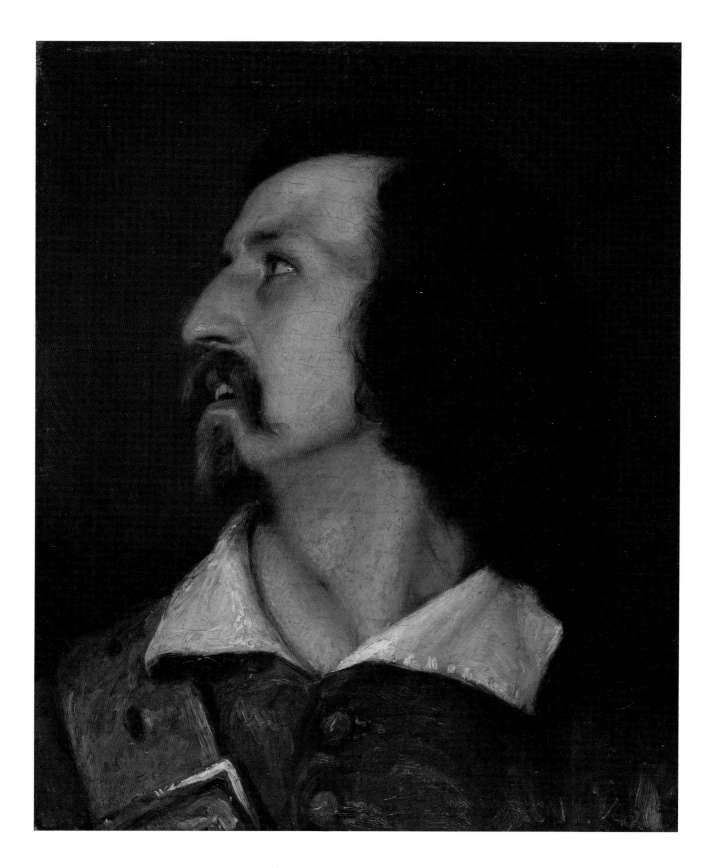

5. *Head of a Soldier*, 1847

Oil on canvas, 31.1 × 26.1 cm
Collection of Stiles Tuttle Colwill

Inscribed: lower right: "RCW. 1/47" in red; on top stretcher bar: "Düsseldorf 1[?] July 1847 Caton's first study head painted in 1847" in faded ink; on left stretcher bar: "Woodville" in pencil

Provenance: Woodville family, by descent, until 1997; Stiles T. Colwill, 1997, by purchase

Technical Notes: The painting is in nearly original condition. The presence of most of the original tacks suggests that the painting was never removed from its original lap-joined, mortise and tenon stretcher. Burnt umber paint is smudged on the left, right and bottom turn-over edges; it appears that there is a brown finger print on the right side. The support is a fine, commercially prepared twill canvas. There is no detectable underdrawing over the cream-colored, lead-based ground, although a thin, red-brown underpainting, used to lay in the figure, is visible between passages of thicker oil paint. A thin coating of natural resin varnish is present over the entire underpainting and the visible paint layer. The paint application is uncharacteristically loose and thick, with wet-into-wet modeling and includes some brushstrokes of pure, unblended color.

This oil study of a soldier, produced early in the artist's student years in Düsseldorf, indicates how quickly Woodville progressed in that rich artistic environment under the tutelage of Academy instructor and renowned portrait painter Carl Ferdinand Sohn. Woodville imbued his subject with martial energy; the head is tossed back to three-quarter profile, his teeth are bared, and his eye glints menacingly. He inhabits a world in conflict, not only the historical moment of the English civil wars, but in the contemporary context of the democratic revolutions in Europe and the brewing conflicts between the northern and southern states in America then manifest in polarized public opinion about the Mexican War.

Unusually sensitive to the marketplace and the tastes of the directors of his primary outlet, the American Art-Union, Woodville appears in this work to have been practicing the "sentimental-romantic" mode of history painting then very much in vogue. It is possible that the artist was working from the same male model in the finished painting, *The Cavalier's Return*, produced in the same year (fig. 60). That painting and this oil study show similar details of hairstyle and hairline, and the silver-buckled belt appears in both. The marked contrast between carefully rendered facial features and broader paint application in the figure and uniform is characteristic of this artist, whose eye and interest were exquisitely focused on depicting subtleties of character.

Fig. 60. Richard Caton Woodville, *The Cavalier's Return*, detail. New-York Historical Society, bequest of Kate Warner (1914.2), cat. no. 6

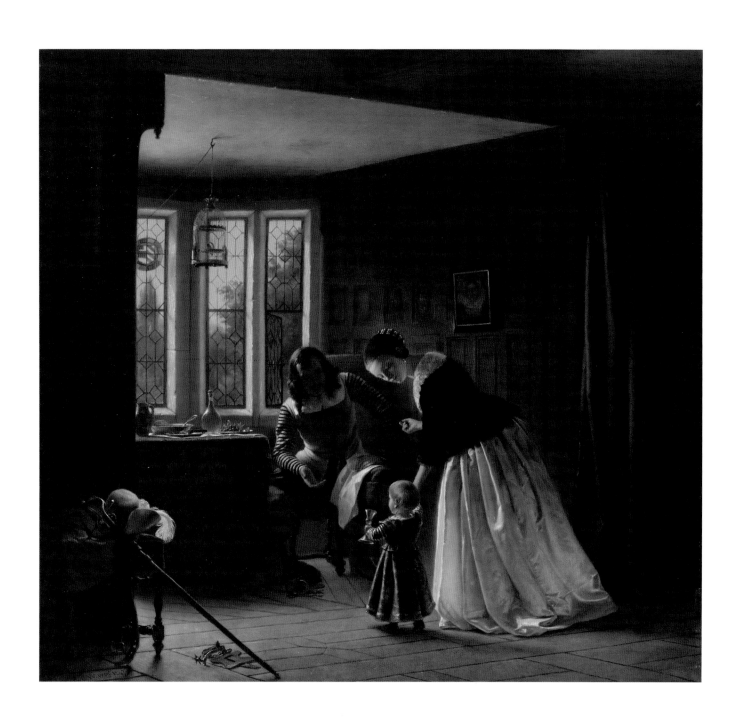

6. *The Cavalier's Return*, 1847

Oil on canvas, 72.4 × 76.8 cm
New-York Historical Society, bequest of Kate Warner (1914.2)

Inscribed: lower left: "R.C.W. Ddorf. 1847" as if carved into the floorboards.

Provenance: American Art Union, New York, 1848; Augustus I. Foster, Wakefield, North Carolina, 1848; Andrew Warner, New York, by 1853; Kate Warner by descent; New-York Historical Society, by bequest, 1914

Technical Notes: The support is plain-weave linen. Evidence in graphite of a square-grid on the cream-colored, lead white ground layer (seen in the infrared through the lighter colors [see fig. 48]) points to the use of a transferred sketch. Additionally, extensive graphite underdrawing can be discerned in the carved wall panel, crown molding, lead mullions, and foreground chair. The wall, ceiling, and floor were broadly painted before the figures. Minor adjustments were made in the soldier's left arm, the back silhouette of the woman, and the placement of her right hand. The lower right window was opened, the saber adjusted, and the width of the curtain narrowed. Wet-into-wet painting created the satin skirt, cavalier's tunic, and tablecover. Glazes of pure red lake reinforce the intense hue of the cherries, cape, and stained-glass window.

A cavalier returning from the English civil wars meets his young child for the first time. The tender family moment is set in a sunlit alcove, its theatrical quality reinforced by the green curtain swept to the right, and the striking stage properties of feathered hat, sword, belt and spurs on the left and the serving dishes, plate of cherries, and full bottle of wine on the rug-covered table at center. The young soldier holds out his hand for the wine glass the child carries to him. The young mother, inclined to the sumptuously attired child and gently urging it forward, is costumed in lace, ermine, pearls, and glistening white satin. Woodville seems intent on showing his mastery of complicated forms in the challenging rendering of perspectival space, including the opened leaded window added late to the composition. Woodville had already seen the work of Gerard ter Borch, the Dutch artist known for his masterful rendering of textiles, in Baltimore, where collector Robert Gilmor owned *A Musical Party with a Lady in White Satin* attributed to that artist.[1] Woodville also traveled to the Netherlands, visiting the collection of the Trippenhuis in Amsterdam with his friend the painter Emanuel Leutze in August 1846.[2]

Such "sentimental-romantic" history painting enjoyed considerable popularity on both sides of the Atlantic in the 1840s. Much has been made of the veiled allusion in these works to the American national character types of northern Puritans descended from English Roundheads and southern gentlemen with Cavalier ancestors and thus to the growing national schism over the issue of slavery.[3] Though the scene is costumed and set in an architectural space evoking the time of Charles I in England, unlike his friend Leutze, Woodville did not depict specific historical events or characters.[4] With his other painting on a cavalier theme, *The Game of Chess* (private collection) known only through the engraving (see checklist no. 19), the artist also tapped into a yearning for images of decorum and courtliness in a time of increasing discomfort over the social changes brought on by urbanization and immigration. In his drawing *The Fencing Lesson* (1847–49) (fig. 61) Woodville placed a similar scene of family life in a carefully constructed period interior.

Woodville took up the historicizing fashion practiced by many of his Düsseldorf compatriots, including Leutze, soon after his arrival there. This work is among the largest in Woodville's oeuvre and gained him continuing public praise by the American Art-Union, where it was exhibited in 1848 and "admired here by thousands."[5] It was purchased by the Art-Union and distributed by lottery to subscriber Augustus I. Foster of Wakefield, North Carolina, in that year. As was a pattern with the work of this artist, *The Cavalier's Return* appears to have been purchased back from the winner, as it was in the collection of Colonel Andrew Warner, the president of the Art-Union and a prominent New York patron, by 1853.

NOTES

1. Humphries 1998, vol. 2, 73.

2. Clark 1982, 236–37.

3. Greenhouse 1995, 272.

4. Galletti 2011, 314–15.

5. *Bulletin of the American Art-Union*, December 10, 1848, 19.

Fig. 61. Richard Caton Woodville, *The Fencing Lesson*. Corcoran Gallery of Art, Washington, D.C. (1996.38.1), checklist no. 15

7. *Portrait of Maria Johnston*, 1847

Oil on canvas mounted on board, diameter 14.4 cm
Private Collection

Inscribed: lower right: "RCW. Ddorf 1847"; reverse "Mr[s]. Maria/S. Johnston/(by R.C. Woodville)/ Düsseldorf 1845"

Provenance: Private collection by descent from the sitter

Technical Notes: The very fine, thin plain weave fabric support was cut into a circle and glued onto a greenish-gray artist's board, perhaps by the artist. As there is no paint on the board and the paint layer extends to the edge of the fabric, it appears that the painting was cut and attached to the board after it was painted. The ground is a thin layer of lead white bound in oil; there is no detectable underdrawing. A reddish-brown underpainting is visible between thin passages of paint and used as a mid-tone, especially in the sitter's hair. The figure was painted in thin, fluid oil paint, and may have been laid in mass tones before highlights and shadows were glazed with thinner paint. The face is delicately painted, predominantly with small hatching brushstrokes around the eyes, nose and mouth. Most of the brushwork in the face, hair, and cap is microscopic; the background was laid in around the figure, first in olive green, extending past the cut edges of the canvas. An embedded fingerprint in the wet brown paint at the center right cut edge, one inch from the signature, reveals the olive green background below.

The frame, which contains a toned, gold, heavy paper liner with a circular window that correlates to the incised line in the paint layer, may be original and has a fairly plain, unadorned profile.

Miss Maria Johnston (1781–1875) was the older companion who traveled to Germany with Woodville and his pregnant American wife, Mary Theresa Buckler Woodville, in the spring of 1845. From the same elite social circles as the artist, she was mentioned as a "famed Baltimore beauty" when she served as a bridesmaid in the 1814 wedding of William A. Ridgely and Elizabeth Genevieve Dumeste along with two of the famed "Misses Caton," grand-daughters of Charles Carroll of Carrolton.[1] This small circular portrait, painted with great delicacy and precision, spares no detail of the sitter's advanced age or homely appearance, softened by the delicacy of the lace cap and pink ribbons. In scale and in the forthright address of the viewer, it is similar to the many artist portraits assembled to record the social networks around the art academy in Düsseldorf (see fig. 8). The portrait could be seen as Woodville's ironic comment on that practice, down to the carefully crafted feminine headgear; he, like other American artists, was not included in the group portraits and assemblages of small portraits that defined the Düsseldorf *Kunstgesellschaft*. This portrait helps to identify Miss Johnston as the model for the woman in the window in *War News from Mexico* (fig. 62).

In the account book she kept of her Düsseldorf household expenses, Mary Woodville noted in September 1845 at the time of the birth of their son Henry Woodville, "I was taken sick and unable to keep the accounts [*illegible*: farther/father?]. Miss Maria took the book on the 16th of September so that I lost three days accts." The next summer, she recorded the expense of "Miss Maria's trip on the Rhine" and "postage paid for Miss Maria when she was absent on the Rhine."[2] Although there is no record of the older woman's trans-Atlantic passage when Mary Woodville traveled from Germany in November of 1849 with her two children, it is likely that Maria Johnston accompanied her, bringing the portrait back to Baltimore, where it descended in her family.

NOTES

1. Pennington family records.
2. Photocopy of the Mary Buckler Woodville ledger.

Fig. 62. Richard Caton Woodville, *War News from Mexico*, detail. Crystal Bridges Museum of American Art, Bentonville, Arkansas, cat. no. 8

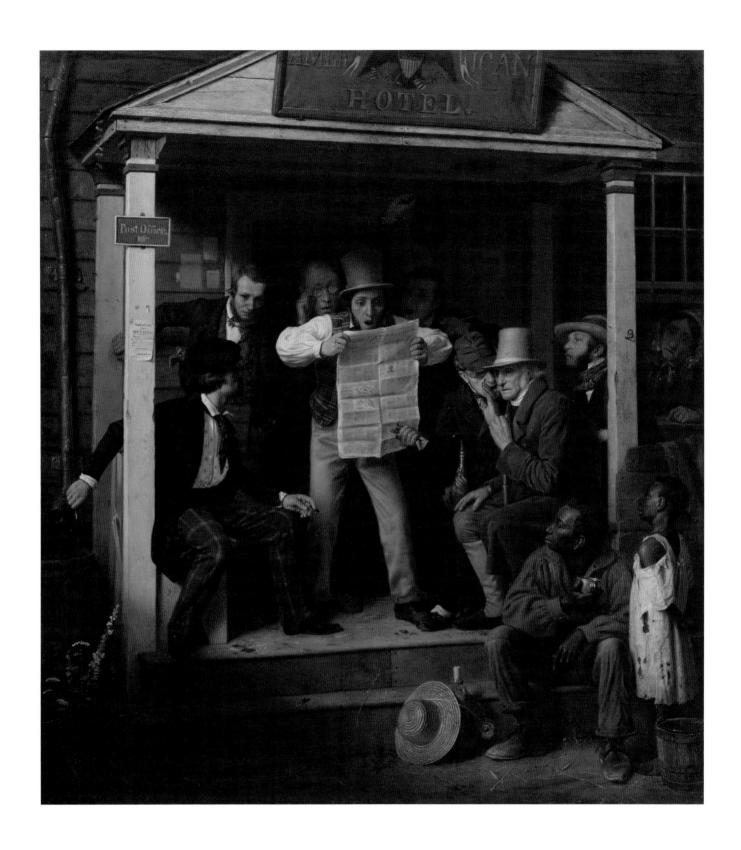

8. *War News from Mexico*, 1848

Oil on canvas, 68.6 × 63.5 cm

Courtesy Crystal Bridges Museum of American Art, Bentonville, Arkansas

Inscribed: lower left: "RCW 1848"

Provenance: American Art-Union, New York, 1849; George W. Austen, 1849; Mr. and Mrs. Marshall O. Robert, 1856; Ortgies & Company, New York, January 1897; Samuel P. Avery, 1897; John D. Crimmins, 1897; National Academy of Design, New York, 1897; Richard and Jane Manoogian Foundation, Inc., 1994; Crystal Bridges Museum of American Art, 2004

Technical Notes: The support is a commercially prepared twill-weave linen with a cream-colored lead white and oil ground. A 2 cm-wide grid was laid out over the ground, indicating that the composition was transferred from a smaller sketch. Graphite underdrawing can be detected around the composition. The painting was heavily reworked, although many of the changes are subtle. The two most striking are the overhead sign, which was widened and changed from "TAVERN" to "AMERICAN HOTEL," and the blond man leaning forward at left. Initially he swung a large broad-brimmed hat up in the air in his right hand and looked directly at the viewer with an expression of surprise or joy. When repainting this figure, Woodville lowered his arm and hat and cast his gaze downward, omitting the hat entirely and painting the figure's knuckles rapping the back post (see fig. 49). Woodville included minute quantities of cadmium in his palette for this painting, detected primarily around the deep orange highlights of the peacock feather in the foreground (see fig. 44). This was a fairly new and expensive pigment for the late 1840s.

Painted in Germany during the contentious American war with Mexico (1846–48) Woodville's most famous work is set on the home front, cataloguing the reaction of different American "types" to news from the battlefield. Set on the porch of the *American Hotel*, the scene is centered on a newspaper.

That *Extra* was a technological marvel of the moment, denoting the speeding up of information transfer as breaking news was transmitted by telegraph, published in hundreds of daily newspapers, and distributed throughout the country by the new postal system.

The composition is populated with people who will be affected to widely varying degrees by the war's outcome. The sympathetic portrayal of the two African-American figures (in red, white, and blue clothing), whose future is most at stake is the closest we come to a sense of where Woodville might have stood on the central issue. The "go-ahead" young men encircling the reader have avoided military service, underscored ironically by the sign advertising for "Volunteers for Mexico" and the pile of ashes and spent matches at the feet of the fashionably attired young man loafing on the left. Woodville altered the initially uniformly celebratory scene to show varied reactions to the news, from the wide-mouthed, hat-swinging enthusiasm of the black-suited man in the back right to the concern of the pensive younger man knocking wood on the left. The patrician old man in Revolutionary-era breeches and yeoman's straw hat receives word of the war indirectly and through the questionable source of a goggled and capped young man, whose tattered traveling gloves and umbrella signify the rapidity and urbanism of the modern moment.

From the time President James K. Polk brought his "War Message" to Congress in May of 1846, asking not for a formal declaration but for authorization to bring the war to a "speedy and successful termination," his expansionist ambitions divided the nation, drawing political battle lines for the Civil War two decades later. Southern Democrats supported the war, which would

expand slave-holding territories, while northern Whigs opposed such "landgrabbing" as contrary to the nation's founding principles. Woodville's home state of Maryland showed the internal fault lines that would appear again in 1861; Whig Senator Reverdy Johnson, whose son was Woodville's Baltimore schoolmate, abandoned his party to vote for fighting "to have American rights recognized, and American honor vindicated."[1]

Woodville produced *War News from Mexico* in Düsseldorf in 1848, when revolutionary activity prevailed, full of energy but ultimately unsuccessful in achieving the goals of democratic representation, a free press, and more equitable distribution of wealth. Several of the artists in Woodville's circle, the German-American Emanuel Leutze in particular, took active part in the protests and demonstrations that swirled in the streets around the Kunstakademie.

The painting was shown at the American Art-Union in 1849, the same year as Leutze's *The Storming of the Teocalli by Cortez and His Troops* (see fig. 26). It was hailed as "perfectly AMERICAN in its character" and reproduced as a large folio engraving in an edition of 14,000 distributed to Art-Union subscribers in 1851.[2]

NOTES

1. Schroeder 1973, 78. Woodville entertained Senator Johnson's son Reverdy, who graduated from St. Mary's College in 1843, with James Buckler (the brother of Mary Buckler Woodville) in Düsseldorf. She noted the expenses of a "dinner for Reverdy Johnson" and "purse for Reverdy Johnson" in her ledger book.

2. Hills 2011, 71.

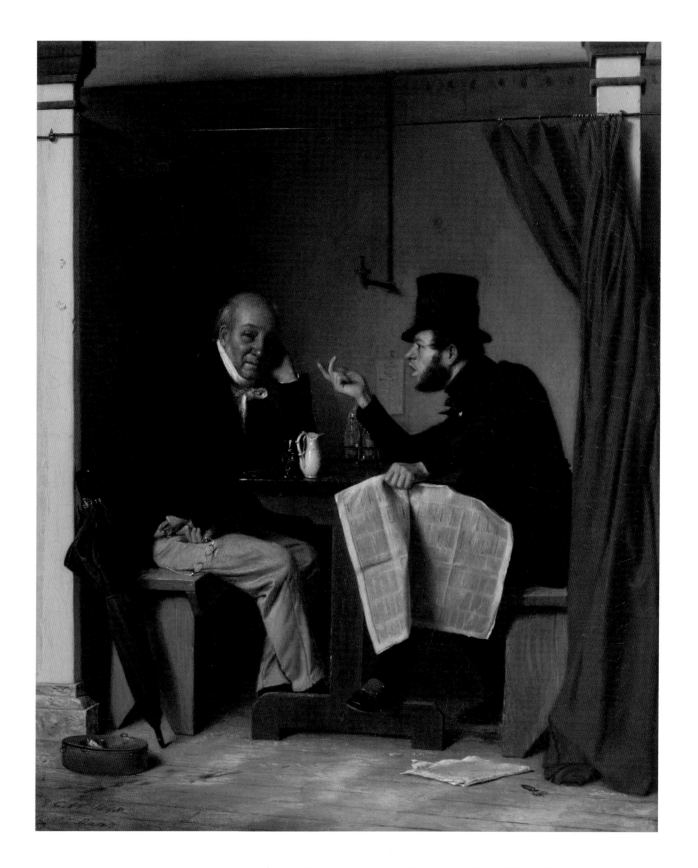

9. *Politics in an Oyster House*, 1848

Oil on fabric, 41.2 × 33.1 cm
The Walters Art Museum, Baltimore, gift
of C. Morgan Marshall, 1945 (37.1994)

Inscribed: lower left: "R. C. Woodville. 1848./
Dusseldf"

Provenance: John H. B. Latrobe, 1848 (from the
artist); C. Morgan Marshall [date of acquisition
unknown; possibly purchased from the estate of
Mrs. John H. B. Latrobe in 1905]; Walters Art
Museum, 1945, by gift

Technical Notes: The support is a commercially pre-
pared plain-weave linen with an oil and lead white
ground. The painted image is approximately 1 to 2
cm smaller than the stretcher, creating an unpaint-
ed border. On this exposed ground, drafting lines
in graphite and a thinned manganese-based paint
block in the composition, lining up columns and
floorboards on the lower left, right, and bottom
fifth as well as the top edge of the canvas. Small,
illegible graphite inscriptions on the left and right
sides line up at the eye level of the figures. Infrared
images reveal underdrawing in the figures, table,
newspaper, and background as well as hatched
lines in shadows. Subtle changes were made
between the underdrawing and the final painted
image in the left figure. In the underdrawing, he
appears younger, with a full head of hair, gazing
at the viewer with a tired expression (fig. 63); in
the final image, he is older, balding, and has an
engaged, quizzical look.

Woodville adopted the subject of newspa-
per reading seen in works by his Düsseldorf
contemporaries Johann Peter Hasenclever
and Wilhelm Kleinenbroich, placing it in
a distinctly American interior, described by
a contemporary critic as "one of those sub-
terranean temples devoted to the immolation
of bivalves . . . vulgarly known as oyster cel-
lars."[1] After their meal, the younger of the
two figures, bearded and wearing his top
hat indoors, leans across the table, counting
arguments off on the fingers of one hand and
clasping the newspaper that fuels his opin-
ions in the other. The older man, balding,
ruddy-faced, and red-nosed, warmed by the
liquor in his half-empty glass, looks out with
amusement at the viewer. The booth in which
they are seated, with its red privacy curtain
pulled aside, creates a shallow proscenium
stage for this scene of intergenerational argu-
ment. The characters are engaged with the
politics of their time, on which Woodville,
characteristically, takes no stand. The fore-
ground details of recognizable objects—the
red spittoon, the umbrella, the penny news-
paper, and the discarded "segar" stub—set
this drama squarely in contemporary times.

This small-scale cabinet picture was
painted for prominent Baltimore citizen John
H. B. Latrobe. Latrobe might have commis-
sioned it in person on his Grand Tour of
Europe, which took him "down the Rhine"
in 1847.[2] After shipment to New York for a
brief exhibition at the American Art-Union,
it was delivered to Latrobe's residence in
Baltimore on May 29, 1848, with a note from
William Woodville V, the artist's father,
saying "Caton desires me to say to you, that
if you do not like it, you must not hesitate
about returning it to me, and he will, with
the greatest pleasure, paint another for you."[3]
Apparently, the painting pleased Latrobe a
great deal; he loaned it to the first annual
exhibition of paintings at the Maryland His-
torical Society,[4] and it hung in the parlor of
his home at Charles and Read Streets until
the death of his widow in 1905.

Woodville exhibited a copy of this work
with the title *A New York Communist Advanc-
ing an Argument* to some acclaim at the Royal
Academy in London, where he was then resi-
dent, in 1852. A woodblock print of the paint-
ing illustrated the review of the exhibition in
The Illustrated London News, which called it
"a spirited little piece . . . of more than ordi-
nary merit."[5] The lithograph of the picture,
produced by Fanoli, printed by Lemercier,
and distributed by Goupil & Co. included a
"dedication to John H. B. Latrobe, Esq." (see
fig. 38 and checklist no. 21). It was offered in
a full-page advertisement, along with several
prints after works by William Sidney Mount,
in the December 21, 1850, issue of *The Literary
World* as "a most exquisite representation of
American politicians."

NOTES

1. *The Literary World* 9 (September 27, 1851), 251.

2. Semmes 1917, 466.

3. Curatorial files, Walters Art Museum, acc. no.
37.1994

4. Wolff 2002, 73.

5. *The London Illustrated News*, July 31, 1852, 84

Fig. 63. Infrared detail of *Politics in an Oyster House*

10. *Self-Portrait in a Black Coat*, 1848–50 (?)

Oil on canvas, 23.5 × 18 cm
The Walters Art Museum, Baltimore, gift of Mr. & Mrs. Kurt Versen, 1989 (37.2645)

Provenance: Mr. and Mrs. Kurt Versen, by descent from the artist, prior to 1989; Walters Art Museum, 1989, by gift

Technical Notes: The support is a fine, plain-weave linen with a ground of finely milled lead white particles in oil. Infrared reflectography revealed a portrait of an older man (not the artist) beneath the self-portrait in a similar position and scale (fig. 64). Clearly defined brushstrokes that form the head and facial features of the earlier portrait are visible in lighter areas under infrared reflectography, and opaque gray paint to the right of the artist's silhouette delineates the original figure's outline. After the earlier portrait dried, the artist applied a thin varnish and another ground layer consisting of yellow particles in a yellow-lead white matrix in oil, all visible in cross sections. There is no evidence of underdrawing for either portrait. Microscopic points of blue and pink in the eyes and delicate highlights in the beard and mustache suggest the use of magnification.

At some point in its history, the tacking margins were removed and the painting was trimmed to its current dimensions and tacked on top of *Portrait of a Woman* (Mary Buckler Woodville) (cat no. 4) at the four corners. The discolored paper label on the reverse of the frame reads: "[. . . / . . .]/von/Gold-und Politurleisten, Spëgeläser/C. C. Schäfer/CASSEL/Obere Carlsstrasse Nr. 15./Geb.Gotthelt., Cassel."

In this small half-length self-portrait, Woodville fashions himself as an privileged urban gentleman, in a formal black coat, white shirt with wing collar, and a black bow tie. He has the smooth, broad forehead that contemporaries associated with superior intelligence and virtue; indeed, artist Chester Harding, who founded and guided the Boston Artists Association in the 1840s, was known to have told an aspiring painter he could never succeed "because his head was not big enough."[1] Woodville fixes a penetrating, arrogant gaze on the viewer, embodying the elite social world in which he was raised and which he left behind in choosing the life of an artist.

Woodville studied as a private pupil of figure and portrait specialist Carl Friedrich Sohn and throughout his career showed a remarkable capacity for sophisticated depiction of character. The artistic community in which he lived in Düsseldorf was notable for the production of *Freundschaftsgalerien*, large friendship pictures that gathered small portraits of individual artists (see fig. 8). Although none of the American artists were included in these assemblages, Woodville's friend Leutze was a member of the social club known as Malkasten or "Paint Box," where the same artists gathered to eat, socialize, and hold amateur theatrics. Both this self-portrait and the *Self-Portrait with Flowered Wallpaper* (see cat. no. 11) are sophisticated bids at self-representation, which the artist retained in his possession. The painting descended in the family of the artist's second marriage and concealed beneath its canvas an unfinished *Portrait of a Woman* (cat. no. 5), that is a likely image of his first wife.

NOTE

1. Colbert 1997

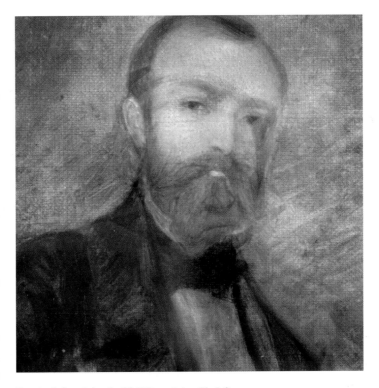

Fig. 64. Infrared detail of *Self-Portrait in a Black Coat*

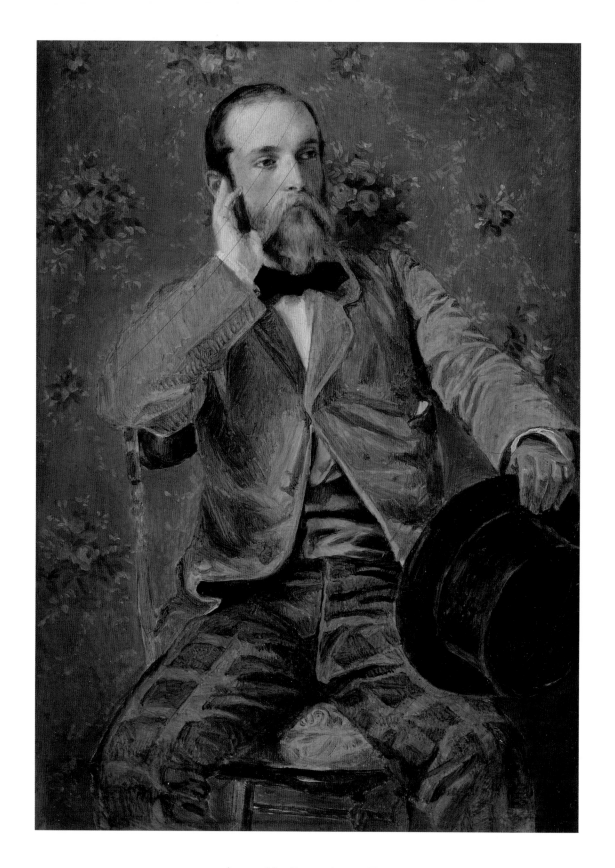

11. *Self-Portrait with Flowered Wallpaper*, 1848–50 (?)

Oil on panel, 23.2 × 17.5 cm
The Walters Art Museum, Baltimore, gift of Mr. and Mrs. Kurt Versen, 1989 (37.2644)

Provenance: Mr. and Mrs. Kurt Versen, by descent from the artist; Walters Art Museum, 1989, by gift

Technical Notes: The reverse of this commercially prepared panel bears a label identifying its supplier as G. Rowney of 51 Rathbone Place. In 1849 mahogany panels of this size sold for about two shillings.[1] There is an overall thin translucent gray tone over the ground and a subtle graphite underdrawing in Woodville's proper left hand and cuff. Parallel graphite hatching denotes the shadow of the wrist; the cuff was originally wider, extending to the current proper right lapel. The paint application is fairly loose and transparent except in the face and hand, where there is a thicker, more finely applied build-up. The ground is evident through the thin washes of paint in the background and in Woodville's clothing; it was left exposed in his jacket breast pocket.

Woodville painted himself several times during his short career. In this charming small work on panel, the artist sits in a parlor chair, facing the viewer while looking off to the left. His casual but fashionable attire includes a haphazardly buttoned tan jacket, a white shirt with black bow tie, a gray vest, and blue-green trousers with a checkerboard pattern—the height of contemporary fashion. Woodville holds an awkwardly proportioned black top hat in his green-gloved left hand; his ungloved right hand frames his face in a gesture of contemplation. The light brown wallpaper, with its repeating pattern of bouquets of pink roses, places the scene squarely in the domestic realm.

Notable in this painting, as in others by the artist, is the contrast between the broadly worked clothing and awkward proportions of the headwear and the miniaturist technique of the carefully rendered face. The racially charged "science" of phrenology popular in the early decades of the nineteenth century held that inner character showed in external signs, particularly the head, "the seat of the intellectual . . . and moral organs."[2] Woodville painted his own visage with loving detail, giving himself the broad forehead, aquiline nose, and white skin touched with color held up as the Anglo-Saxon ideal. The hand-to-face pose, suggesting pensive introspection, is found frequently in works after photographs during this period, as it held the head still through the long exposure the medium required.[3] Woodville's career coincided with the popular introduction of the daguerreotype portrait; already in 1842, one of his professors at the University of Maryland Medical College, William A. E. Aiken, dabbled in the new technology.[4]

A photographic portrait of the artist from Düsseldorf (location unknown)[5] shows that the painting was true to life. A Baltimore schoolmate remembered Woodville was "of aristocratic lineage, courtly manners and very handsome, he was essentially the artist."[6] Already in Baltimore, he was sensitive to his appearance (see checklist no. 3), and in Germany, his young wife noted in her ledger books numerous expenditures typical of a man of fashion: gloves, cravats, and costumes along with club dues, models, art supplies and "segars."

NOTES

1. Templeton 1849, 73.

2. Orson S. Fowler, *Fowler's Practical Phrenology* (1840), quoted in Burns and Davis 2009, 316.

3. Scharf 1974, 50.

4. Kelbaugh 1989, 102.

5. Illustrated in Wolff 2002, 6

6. Unidentified schoolmate quoted in a supplement to the *Baltimore Sun*, November 15, 1881, 1.

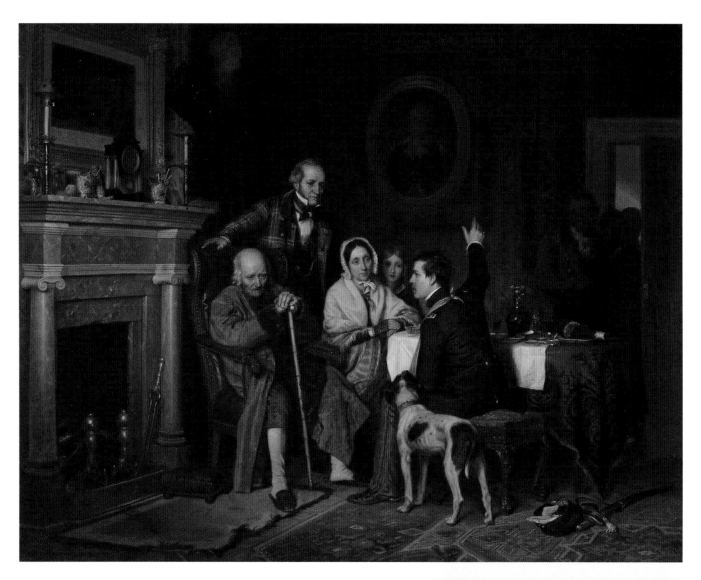

Fig. 65. Richard Caton Woodville, *The Soldier's Experience*. The Walters Art Museum, Baltimore (37.945), checklist no. 13

12. *Old '76 and Young '48*, 1849

Oil on canvas, 53.6 × 68 cm

The Walters Art Museum, Baltimore (37.2370)

Inscribed: lower left: "R. C. Woodville. 1849"

Provenance: American Art-Union Sale, New York, 1852; William H. Webb, New York, 1852, by purchase; George William Abell, New York; Mrs. Francis Theodore Homer [Jennie M. Abell], Baltimore; Mrs. Ferdinand C. Lee [Jane Palfrey Homer], Baltimore; Mr. and Mrs. George Jenkins, Baltimore, 1954; Walters Art Museum, 1954, by purchase

Technical Notes: The support is a twill-weave canvas prepared with a thin lead white in an oil ground. There is evidence of carbon-black underdrawing possibly in charcoal and thinned paint followed by a red-brown tone that can be seen through some cracks.

X-rays and infrared images reveal that Woodville made significant adjustments to the painting. A demarcation between the back wall and ceiling was covered over, a large hutch behind the father became a narrower dark wood cabinet, and the bust of Washington was elevated. The open door was initially hinged on the left; by moving it to the right, the servants were included in the family circle. The positions of the Trumbull print and the oval portrait were reversed, and a print over the doorway was completely removed. A basket and bellows (the pentimenti still visible) originally leaned against the left side of the hearth fender, and the hide rug formerly lay parallel to the picture plane. While the soldier's right arm is raised in the watercolor and the final painting, at one point his elbow rested on the table. His original uniform had gold piping across the back and tails. The young girl, the two female servants, and the dog were added later.

This intergenerational drama is set in a sumptuously furnished dining room. A young soldier, his injured left arm in a sling, his boots and trousers mud-spattered, and sword and gloves flung on the carpet, has just returned from service in the Mexican War. Gesturing expansively toward the Revolutionary portrait, he seeks approval from his older relative, who appears lost in memory. Other family members, presumably the soldier's parents and sister, dressed in the fashion of the moment, listen with concern. In the doorway to the right, three African American house servants attend to the conversation.

Old '76's status as a veteran of the Revolutionary War is made clear by attributes, including knee breeches worn in the previous century, the portrait in military dress on the far wall, and the bust of George Washington behind him. The painting rewards close scrutiny, with such unexpected details as an apple and corncob interspersed with the clock, porcelains, lamps, and book on the mantelpiece, the tabletop still-life, and the adroit rendering of textiles and furniture. The glass on the print of Trumbull's *Signing of the Declaration of Independence* shows a crack, a symbol of the divisiveness of the political moment. Woodville may have seen this detail in a work of decisive political content in Düsseldorf, *Workers before the Magistrate* (see fig. 29) by Johann Peter Hasenclever, painted in 1848.

One of the puzzles posed by *Old '76 and Young '48* is how the artist, living in Europe, acquired his knowledge of the specifics of the Mexican War uniform, in which shoulder straps indicated rank and stripes on trousers denoted different regiments, details that Woodville changed as he completed the painting. No one in his immediate family served in that war, though his friend Stedman Tilghman enlisted as a surgeon in 1846 and succumbed to the strain, dying in New Orleans two years later.[1] Woodville may have studied illustrations in American newspapers or daguerreotypes. Clearly aware of the polarized opinion on this war in the United States, and having suffered a personal loss, the artist takes an ambiguous stance in the argument that is this work's central narrative.

Woodville produced *The Soldier's Experience*, a highly finished watercolor on a similar subject, in 1847 (fig. 65).[2] The scene is set in a more modest interior, with the family gathered around a woodstove. The older man, though leaning on a cane, is robust and engaged, the tricorne hat and musket displayed on the wall above him attesting to his military action in 1776. In the oil, produced for the New York market he understood so well, Woodville elevated the narrative into a middle-class interior. It was exhibited at the American Art-Union in 1850 and hailed as "one of the best works of this distinguished artist, and it abounds with feelings that will touch the hearts of all who see it."[3] In his exhibition review, poet Walt Whitman pointed to the artist's unique capabilities: "The mother and the old '76er are beautifully done; the whole picture is good and free from that straining after effect . . . which mars most of the pictures here."[4]

NOTES

1. Wolff 2002, 31.

2. The date of 1847 was revealed when the watercolor was unframed for conservation in 2011. Previous accounts of this work have sought to explain its martial references and finished technique within the context of an 1844 date. See Grubar 1967, 25, and Wolff, 2002, 114–17.

3. *Bulletin of the American Art-Union*, November 1850, 135.

4. Paumanok [Walt Whitman], "Letter from New York," *National Era*, October 31, 1850. In Burns and Davis 2009, 319.

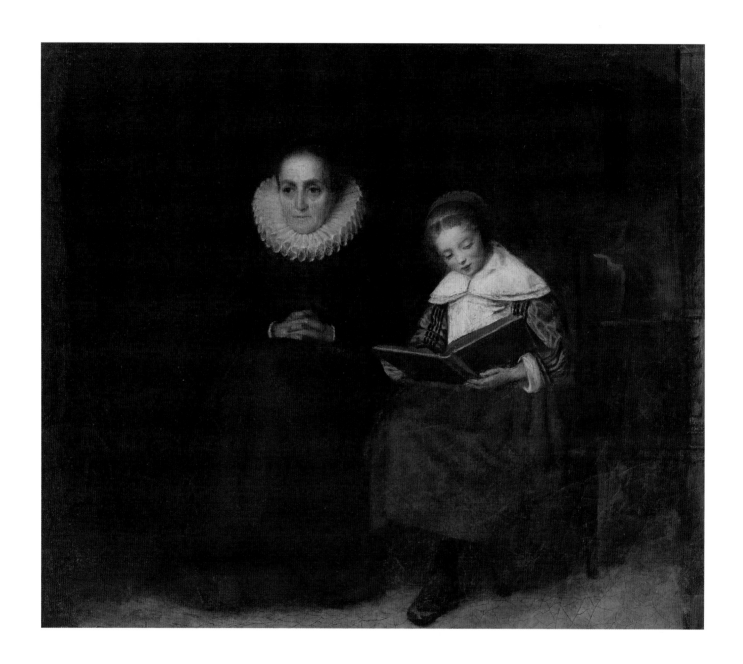

13. *Old Woman and Child Reading a Book*, 1840s

Oil on canvas, 30.4 × 35.6 cm

The Walters Art Museum, Baltimore, museum purchase with funds provided through the bequest of Laura Delano Eastman by exchange, 2011 (37.2930)

Provenance: Antoinette Schnitzler to Richard Caton Woodville II; William Passenham Woodville, by descent; Elizabeth Caton Woodville Callender, Bridgetown, Nova Scotia, by descent; Walters Art Museum, 2011, by purchase

Technical Notes: The support is an open, plain-weave linen with a commercially prepared lead white ground. A faint underdrawing can be discerned under infrared reflectography. There is some indication of cursory drafting lines for the architecture of the room and the main compositional figures, created with assured strokes of thinned paint. The background appears to be delineated with wall panels and stiles, which closely mimics the paneled wall in the background of *The Cavalier's Return* (cat. no. 6). The paint layer appears deftly applied, loose, with only minimal detailing in the faces and woman's ruff. Subtle hatching of wet-into-wet paint define the brows, eyes, mouths, and ruff, made with a soft, pointed brush. This painting may have been abandoned by the artist unfinished, or meant as an oil sketch. The painting passed through his second wife's family, and may have been augmented by a descendant.

In this scene of quiet domesticity, an old woman sits with her feet propped on a hassock, looking pensively into the distance. The young girl at her side reads from a large book. Such details of costume as the woman's lace ruff and the girl's unfinished carved chair place this in the seventeenth-century period context that was prized by American collectors and fashionable among Düsseldorf artists in the period before the American Civil War. The relationship between generations that is a recurrent theme in Woodville's work is treated here as contented coexistence.

One of the defining social transformations underway in the early decades of the nineteenth century was the physical separation of male employment from the home, as industry became more concentrated and the population grew more urban. The developing middle class coped with the rigors and anxieties of this new economic structure in part by imbuing the home with deep associations of private refuge. The "separation of spheres" by gender placed women at the center of domestic life, where their role, according to a contemporary etiquette book, was to be "a corrective of what is wrong, a moderator of what is unruly, a restraint on what is indecorous."[1] Many of Woodville's genre works are set in the rough-and-tumble public sphere of primarily male interaction, and exude a sense of anxiety about the ambiguous relations between strangers in anonymous public spaces. In this painting, which descended in the family of his second marriage, he turned from the unruly and indecorous external world to the calm and quiet of the home. The fact that the two subsequent generations of that family were accomplished artists may account for the inconsistencies of paint application in this unfinished work.

Woodville painted several pictures in this period mode in the late 1840s, including *The Cavalier's Return* (cat. no. 6) and *The Game of Chess*, both of which were exhibited and received with acclaim at the American Art-Union. Mary Woodville's ledger records the purchase of a "Gothic" chair and material for costumes as well as fees for models during this period.

NOTE

1. *Young Lady's Own Book* (Philadelphia: Key, Mielke, and Biddle, 1833) , 15.

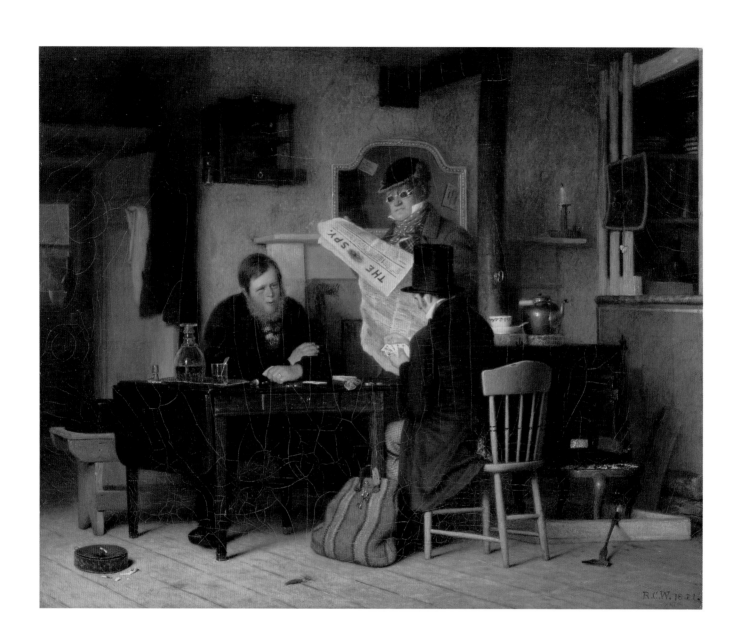

14. *Waiting for the Stage*, 1851

Oil on canvas, 38.1 × 46.2 cm

Corcoran Gallery of Art, Washington, D.C., Museum Purchase, Gallery fund, William A. Clark Fund, and through the gifts of Mr. and Mrs. Lansdell K. Christie and Orme Wilson (60.33)

Inscribed: lower right: "R. C. W. 1851 / Paris"

Provenance: Collection of the Artist; Woodville Family; Samuel P. Avery, New York, by 1867; Lucius Tuckerman, 1867, by purchase; Mrs. James Lowndes, Miss Emily Tuckerman, Mr. Lucius C. Wolcott, and Mr. Walter R. Tuckerman, Washington D.C., by descent, by 1907. Private collection [mode of acquisition unknown], by 1959–60. Corcoran Gallery of Art, museum purchase, 1960

Technical Notes: The support is a fine, plain-weave linen with a ground composed of finely milled lead white particles in oil. Underdrawing in dry graphite was reinforced in areas with brushstrokes of thin gray-blue paint and can be discerned in the proper right hand of the foremost figure. Changes are visible in an infrared image: the top edge of the newspaper was raised and angled, exposing more of the text; the standing figure originally glanced out at the viewer, his eyes unconcealed by dark glasses; the foremost figure's low, brimmed hat was refashioned as a top hat; and the face of the seated figure (originally clean shaven) facing the viewer aged. The carpet bag was added near the end of the painting process; in the x-radiograph, the complete chair leg can be detected beneath it. A young African American female figure peeking through the back window is nearly invisible in the painting due to the increased transparency of the paint layer with time. The figure is more clearly visible in Goupil's print.

Woodville returned to a familiar subject and setting in this, one of his last known paintings. Three men sit at a drop-leaf table in a tavern, playing cards and drinking as they wait for the next stagecoach. The open face and wry expression of the bearded player and the rough-hewn details of his knitted sweater and large hands contrast with his nattily attired and top-hatted opponent, whose spread-out hand of cards is more visible than the details of his averted face. Standing above the players is another well-dressed traveler wearing dark glasses, whose role in the conspiracy is telegraphed by his newspaper, *The Spy*. The mood is both sinister and humorous; while the space is dark and cramped, it is filled with beautifully rendered objects in silver, porcelain, glass, painted metal, and pewter. One trompe l'oeil detail, a crude sketch of a devilish bearded face on the chalkboard at right, has been suggested to be the artist's own.[1] As is often the case in Woodville's work, the narrative is ambiguous, as it is unclear who is being duped.

This work was painted in Paris, during a time of great change for the artist. He had left Düsseldorf and his wife and children for the painter Antoinette Schnitzler, whom he would later marry. The ready market for paintings he had enjoyed with the American Art-Union came to an end with the closing of that venue in 1851 on charges of operating an illegal lottery. One of the reasons for the move to Paris was likely to be in closer proximity to the firm of Goupil & Co., print publishers with whom his friend Emanuel Leutze was already working. The lithograph after this painting, titled *Cornered!*, was quickly produced by Lemercier in Paris and published by Goupil in New York in 1851 (see fig. 30, and checklist no. 22).

Woodville appears to have followed his normal practice and sent the painting back to his father in Baltimore. In his *Book of the Artists: American Artist Life* of 1867, Henry T. Tuckerman noted that the family sold three of Woodville's paintings, including this one, "because of the exigencies of the Civil War."[2] In keeping with the artist's favored status among New York collectors, it was purchased by Lucius Tuckerman, pioneering manufacturer of iron and a founder of the Metropolitan Museum of Art, in whose family it descended.

NOTES

1. Wolff 2002, 153.
2. Tuckerman 1867 [1966], 409–11.

15. *The Sailor's Wedding*, 1852

Oil on fabric, 46.2 × 55.2 cm

The Walters Art Museum, Baltimore (37.142)

Inscribed: lower left: "RCW 1852"

Provenance: William T. Walters, Baltimore, 1861, by purchase [S. P. Avery as agent]; Henry Walters, Baltimore, 1894, by inheritance; Walters Art Museum, 1931, by bequest

Technical Notes: The support is a plain-weave linen with a lead white ground. A stamp on the reverse reads: "RE [] EAUBOEUF / Vente et / LOCATION DU TABLEAUX / ET DESSINS / Rue de Verché St. Honore 5." Thin lines of graphite underdrawing are detectable in infrared light throughout the painting, notably in light-colored areas, such as the bride's dress and over the mantle. The figures, furniture, and architecture of the room were drawn; only a few elements were painted without drawing, such as the books on the floor, spittoon, and chair at far left. Few changes are detectable between the underdrawing and the finished painting. The jug and arms of the servant girl at left shifted slightly, the chicken leg shortened, and the square, straight legs of the table were refashioned to create the distinctive shape of a Baltimore claw-and-ball table leg. In the crown molding at the upper right, the drawing was reinforced with heavier lines of wet, gray-blue paint. The paint is thin and fluid, predominantly applied with very small-tipped brushes. Some of the smallest highlights, such as the glint on the marriage broker's lower lip, measure less than half a millimeter, suggesting the use of magnification. *The Sailor's Wedding* has less impasto than Woodville's other paintings.

In this late painting, Woodville arranged a large group of figures in the light, airy space of an office of a justice of the peace. At the center, a strapping red-haired sailor holds the arm of his demure bride. The dramatic moment is rendered with remarkable economy, from the irritated reaction of the judge interrupted at his supper, to the conciliatory gesture of the bowing groomsman,

to the oblivious pride of the sailor and the humble expectation of the elderly members of the wedding party in their "Sunday best." A subsidiary drama unfolds in the doorway, where two African-American figures hold back a crying child and a grizzled old sailor looks in from the street. The details that set the scene, from the books and papers overflowing the horsehair trunk, to an almanac page pasted to the bookcase, to the red spittoon and glistening andirons, all "finished as with a microscope," add to its visual effect. The work evokes genre painting's earlier roots, mocking its lower-class subjects for the amusement of patrons of presumably higher station, while depicting the modern moment.

Little is known about Woodville's time in Paris. His colleague Eastman Johnson noted the artist's departure from Düsseldorf in 1851, and in the same year the *Bulletin of the American Art-Union* published this news: "Woodville has been engaged at Paris upon a new work, *The Wedding before the Squire*, which we understand has been purchased in advance by Goupil & Co. It is a subject well adapted to the artist's peculiar powers."[1]

Goupil & Co. produced a lithograph after the painting, titling it (in English, French, and German) *A Civil Marriage in the United States* (fig. 66). It was advertised for sale in

the *New-York Daily Tribune* in June of 1855 by the Fine Arts Gallery at 366 Broadway, as "*The Sailor's Wedding* after the well-known painting by Woodville."[2] The painting was among the few American works exhibited at the 1853 Crystal Palace Exhibition in New York, known as the Exhibition of the Industry of All Nations. It was purchased for $300 on February 14, 1861, by Samuel Putnam Avery, the friend and New York agent of William Walters.[3] Avery used his broad acquaintance in the art world to help to build Walters' collection of art, while Walters served as a silent partner, financing Avery's art dealing. By 1867, William Walters was named as the painting's owner in Henry Tuckerman's *Book of the Artists*.[4] An aspirational collector, Walters was likely as drawn to the painting by the artist's stellar standing among New York collectors as by Woodville's Baltimore roots.

NOTES

1. *Bulletin of the American Art-Union*, July 1851, 63.

2. Wolff 2002, 193 n. 79.

3. Receipt in Walters curatorial files, acc. no. 37.142. For information about Avery, see *The Diaries, 1871–1882, of Samuel P. Avery, Art Dealer*, ed. Madeleine Fidell-Beaufort (New York: Arno Press).

4. Tuckerman 1867 [1966], 409–10.

Fig. 66. Claude Thielley, *Un mariage civil aux États-Unis.* after Richard Caton Woodville, *The Sailor's Wedding.* Collection of Stiles Tuttle Colwill, checklist no. 23

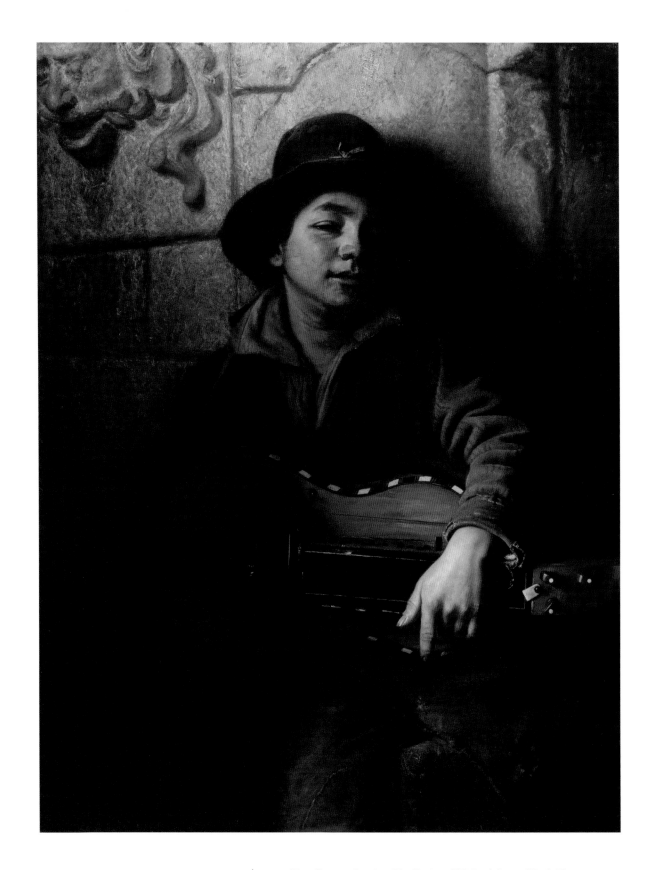

16. *The Italian Boy with Hurdy-Gurdy*, ca. 1853

Oil on canvas, 92.2 × 71.4 cm
The Walters Art Museum, bequest of George C. Doub, 1982 (37.2602)

Inscribed: "RCW 1853"

Provenance: George C. Doub, Baltimore [date and mode of acquisition unknown]; Walters Art Museum, 1982, by bequest

Technical Notes: The support is a fine, plain-weave linen with a lead white commercially prepared ground. The figure appears to be sketched in graphite or other dry media directly on the ground, though an entire compositional underdrawing is not apparent. Initially, a thick, dark gray-green imprimatura was applied around the drawing of the boy. Woodville made several changes to the figure, allowing the paint to dry thoroughly before reworking the composition. The boy had two or three different head positions, and in one variant, he looked squarely at the viewer from under the lowered brim of his hat (see figs. 46, 47). Additionally his right hand was shifted farther to his left. No instrument is evident in the earliest versions, and a thick layer of varnish (believed to be a composite of many thinner layers of varnish) separates the brown paint layer of his jacket from the red glazes of the instrument. When painting the instrument, Woodville repositioned the profile of the left hand, including the finer details such as dirt under the boy's fingernails and highlights off the frayed edge of the left cuff. The interlayer varnish may be bleached shellac, considered to be "the most perfect of varnishes," as it was soluble in alcohol, and could be washed, filtered, and bleached with chlorine gas. The use of this varnish by American artists has only recently come to light, and has been identified in a few paintings by American artists.[1] In general, the paint layer is uncharacteristically loose, thick, and textural for Woodville, with impasto in the light-colored stone background.

Young boys from the Savoy region of Italy who made their living as street musicians and chimney sweeps were popular subjects among European artists in the nineteenth century. They are often represented as ragged but sensual figures. In Woodville's painting, a young boy in worn clothing rests on a stone balustrade, holding his instrument and gazing out from under hooded eyes. The background is a crumbling wall exposing a brick underlayer. The gargoyle over the boy's shoulder is a menacing presence to the boy's independence and a lewd pendant to his self-assured and seductive gaze. The boy's left hand is worked in the tiny brushstrokes and rich detail associated with this artist, down to the dirt under the thumbnail. At the same time, the right hand holding the instrument is clearly unfinished. The hurdy-gurdy so central to the composition, which the artist added at a late stage, was developed in the medieval period and popular in the Renaissance. It produces sound with a crank-turned rosined wheel rubbing against strings, and by Woodville's time, was associated with street musicians.

Dated 1853, this work is singular in the artist's oeuvre. The larger canvas size, the loose brushwork and monochromatic palette, the individual subject with one accessory, all depart from the multifigured narratives filled with carefully rendered details seen in the rest of his work. We know very little about Woodville's life in general and the years he spent in Paris and London from 1851 to 1855 in particular. He no longer had the ready outlet of the American Art-Union, which was disbanded in 1851. He may have been experimenting with the popular subject of a single musician with an instrument after seeing the success of his Art-Union compatriot William Sidney Mount's prints of African-American banjo and bone players for Goupil & Co. Woodville's American colleague Eastman Johnson, with whom he had been acquainted in Düsseldorf, painted four versions of Savoyard subjects during his time in The Hague. Johnson's *Savoyard Boy* of 1853 is similar in the limited, earthy palette of its background and the precise depiction of the figure (fig. 67).

The artist's brother William Woodville VI mentions this work as belonging to the widow of his brother Myddleton Lloyd Woodville.[2] It was discovered in Baltimore in an attic storeroom at the Maryland Club at Charles and Eager Streets, where Myddleton, who lived in Philadelphia, may have kept a room.

NOTES

1. Mayer and Myers 2011, 165.

2. William Woodville VI to William Pennington, June 13, 1879, Pennington Family papers, Maryland Historical Society.

Fig. 67. Eastman Johnson, *The Savoyard Boy*, 1853. Oil on canvas; 94.5 × 81.8 cm. Brooklyn Museum, bequest of Henry P. Martin (07.273)

Checklist of Works on Paper

1. *Battle Scene with Dying General*, 1839

Watercolor; 39.3 × 46.8 cm
Elizabeth Caton Woodville Callender

Provenance: Woodville family, by descent
through Antoinette Schnitzler Woodville

2. *RCW Sketches* from *The Dr. Stedman R. Tilghman Scrapbook*

Maryland Historical Society, Baltimore, J. Hall Pleasants Papers, 1773–1957 (MS 194)

p. 96: *Early Efforts of R.C. Woodville*, ca. 1838

Watercolor wash and graphite on paper; top: 61. × 4.8 cm, center: 7.4 × 8.6 cm, bottom: 5.6 × 5.6 cm

Inscribed: page: "16," "'Early Efforts' of RC Woodville—while a student / of St Mary's College—Baltimore—1838. / SRT," "96" in pencil

p. 3: *Nathan Potter, M.D.*, 1842

Graphite on paper; 16.5 × 10.2 cm

Inscribed: sketch: "R.C.W." in pencil; page: "Nat. Potter M.D. / Prof. of theory & Practice of Med.—University of Md. / 1842" in ink, "1" in pencil

p. 58: *Ghosty*, ca. 1842

Graphite on paper; 12.7 × 7.4 cm

Inscribed: sketch: "'Ghosty'" in ink, "RCW." in pencil; page: "Student of Med." in ink, "9," "58" in pencil

p. 66: *Dixon Gough*, 1842

Graphite on paper; 12.7 × 7 cm

Inscribed: sketch: "'Dixon Gough'," "R.C.W." in ink; page: "Student of Med." in ink, "10," "66," "1842" in pencil

p. 76: *Cadmus*, 1842

Graphite on paper; 12.7 × 7 cm

Inscribed: sketch: "'Cadmus'," "R.C.W." in ink; page: "'Cadmus' Student of University of Md. / Taken while listening to a lecture / of M.R. Smith." in ink, "12a," "76," "1842" in pencil

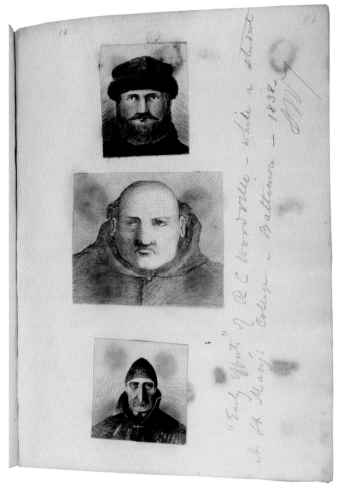

p. 96

p. 80: *Professor Aiken*, 1842

Graphite on paper; 13.7 × 8.6 cm

Inscribed: page: "Prof Aiken—Prof Chemistry / in University of Maryland," in ink, "13," "80," "R.C.W.," "1842." in pencil

p. 86: *An Operation for "Necrosis of Radius," at the Baltimore Infirmary*, ca. 1842

Graphite on paper; 11.4 × 10 cm

Inscribed: sketch: "6," "5," "4," "3," "1," "8," "2" in ink, "RCW" in pencil; page: "N.R. Smith—2. Char B. Gibson—3. Dr Maddox. / [4.] Bob. Spence—5. 'Sister Ambrosia' 6 'Cobb' / [7.] S.R. Tilghman—," "This group represents an operation / for 'Necrosis of the Radius,' at 'Baltimore In-/firmary—by Prof. N.R. Smith—/ drawing by R.C.W" in ink, "14a," "86" in pencil

p. 49: *Dutch Woman at the Alms House*, ca. 1845

Graphite on paper; 10.4 × 12.7 cm

Inscribed: sketch: "Dutch Woman at Alms House," "R.C.W" in ink

p. 91: *L.C. Pignatelli*, 1845

Graphite on paper; 9.1 × 5.7 cm

Inscribed: sketch: "RCW / '45" in pencil; page: "91," "15," "L.C Pignatelli / Balt° Alms House" in pencil

p. 68: *Man on Crutches with Hat*, n.d.

Graphite on paper; 11.2 × 7.6 cm

Inscribed: sketch: "RCW" in pencil; page: "11," "68" in pencil

 p. 3

 p. 58

 p. 66

 p. 76

 p. 80

 p. 86

 p. 49

 p. 91

 p. 68

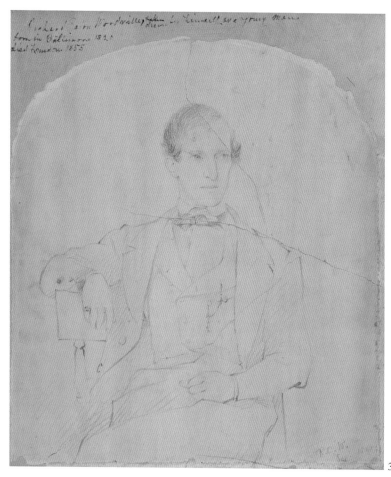

3

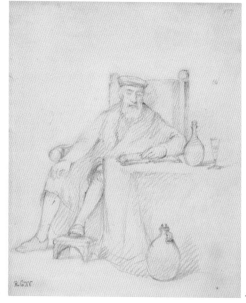

4

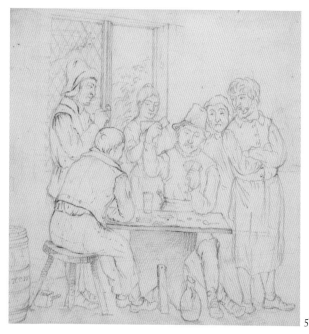

5

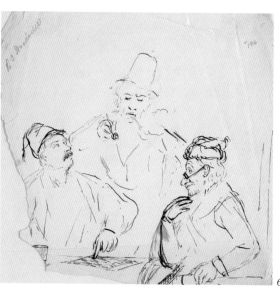

6

3. *Self-Portrait*, 1844

Graphite on paper; mount: 29.6 × 25.5 cm
Collection of Stiles Tuttle Colwill

Inscribed: in drawing, at lower right: "R.C.W. /
Sep. 1844" in graphite; on mount, at upper right:
"Richard Caton Woodville, taken [word crossed
out] drawing by himself as a young man / born in
Baltimore 1820 / died London 1855" in ink

Provenance: Woodville family, by descent, until
2012; Stiles T. Colwill, 2012, by purchase

4. *Man at a Table*, ca. 1840s

Graphite on paper; 19.4 × 15.8 cm
Collection of Stiles Tuttle Colwill

Inscribed: "R.C.W."

Provenance: Acquired in early twentieth cen-
tury by Asa H. Twitchell, Albany; to Michael
D'Shengerin, New York City; to John D. Hatch,
Albany; to William T. Hassett, Hagerstown, MD;
to John Newcomer Auction; Stiles T. Colwill, by
purchase

5. *Group of Men Playing Cards*, ca. 1845

Graphite on paper; 28 × 20 cm
Collection of Stiles Tuttle Colwill

Inscribed: "R.C.W."

Provenance: Woodville family, by descent, until
1996; Weschler's Auction, Washington, D.C., 1996;
Stiles T. Colwill, September 21, 1996, by purchase

6. *Three Local Characters*, 19th century

Pen on paper; 17.9 × 18.4 cm
The Walters Art Museum, Baltimore, gift of
William T. Hassett, 1947 (37.2007)

Provenance: Asa B. Twitchell, Albany [date and
mode of acquisition unknown]; Michael D'Shen-
gerin [date and mode of acquisition unknown];
John D. Hatch, Jr., 1941, by purchase; William T.
Hassett, Hagerstown, MD [date unknown], by
gift; The Walters Art Museum, 1947, by gift

7. *Sketch Portrait in Watercolor (Profile)*, n.d.

Watercolor on paper; sketch: 6.6 × 6.2 cm
Collection of Stiles Tuttle Colwill

Provenance: Woodville family, by descent, until
1996; Weschler's Auction, Washington, D.C., 1996;
Stiles T. Colwill, September 21, 1996, by purchase

8. *Sketch Portrait in Watercolor
(Man in a Red Hat)*, n.d.

Watercolor on paper; mat window: 5.9 × 4.5 cm
Collection of Stiles Tuttle Colwill

Provenance: Woodville family, by descent, until
1996; Weschler's Auction, Washington, D.C., 1996;
Stiles T. Colwill, September 21, 1996, by purchase

9. *Sketch Portrait in Watercolor
(Man with Long Hair)*, n.d.

Watercolor on paper, mat window: 5.6 × 5.4 cm
Collection of Stiles Tuttle Colwill

Provenance: Woodville family, by descent, until
1996; Weschler's Auction, Washington, D.C., 1996;
Stiles T. Colwill, September 21, 1996, by purchase

7

8

9

10

11

10. *Bringing in the Boar's Head*, ca. 1845

Graphite on paper; 16.5 × 12.2 cm
The Walters Art Museum, Baltimore, gift of
William T. Hassett, 1947 (37.2006)

Provenance: Asa B. Twitchell, Albany [date and
mode of acquisition unknown]; Michael D'Shen-
gerin [date and mode of acquisition unknown];
John D. Hatch, Jr., 1941, by purchase; William T.
Hassett, Hagerstown, MD [date unknown], by
gift; The Walters Art Museum, 1947, by gift

11. *Bringing in the Boar's Head*, 1845

Ink on paper; 19.3 × 14.9 cm
The Walters Art Museum, Baltimore (37.1547)

Inscribed: on front: "Bringing in the Boar's
head. R.C.W. 1845" in pencil; on reverse: "Dear
Frank—Don't expect me to—I will not be able
R.C.W"

Provenance: William T. Walters [date and mode
of acquisition unknown], previously included in
William T. Walters album *Original Designs by
American Artists* (11.1); Henry Walters, 1894, by
inheritance; The Walters Art Museum, 1931, by
bequest

12. *The Card Players (recto) / Classical Scene
(verso)*, 19th century

Graphite on paper; 26.9 × 39.5 cm
The Walters Art Museum, Baltimore, gift of
Mr. Kurt Versen, 1991 (37.2650)

Provenance: Antoinette Schnitzler Woodville,
Düsseldorf; Alice Marquart, by descent; Anny
Versen, before 1895, by descent; Mr. Kurt
Versen, Florida, ca. 1910, by descent; The Walters Art
Museum, 1991, by gift

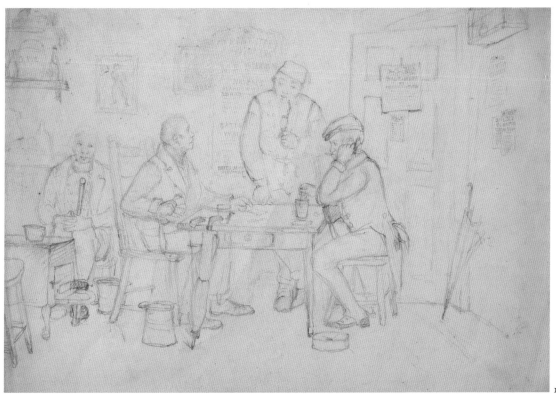

12 (recto)

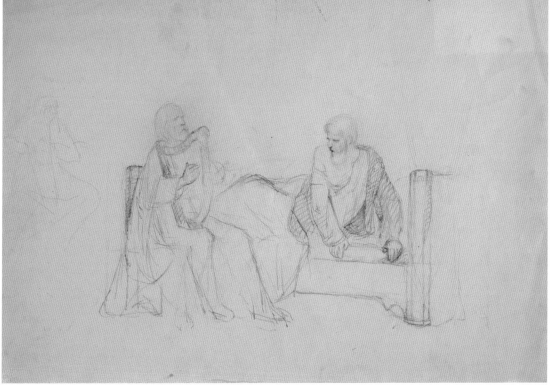

12 (verso)

13. *The Soldier's Experience*, 1847

Watercolor on paper; 24.7 × 27.3 cm
The Walters Art Museum, Baltimore (37.945)

Inscribed: "R. G. W. May 1844" (spurious); "R. C. W.
May 1847" below mat

Provenance: William T. Walters or Henry Walters;
The Walters Art Museum, 1931, by bequest

14. *Man in Green Coat with Umbrella*, 1848

Watercolor on paper; 15.6 × 13.1 cm
The Walters Art Museum, Baltimore (37.1538)

Inscribed: "1848 R. C. W."

Provenance: William T. Walters [date and mode
of acquisition unknown], previously included in
William T. Walters album *Original Designs by
American Artists* (11.1); Henry Walters, 1894, by
inheritance; The Walters Art Museum, 1931, by
bequest

1848 R.C.W.

15. *The Fencing Lesson*, ca. 1847–1849

Graphite on paper; 20 × 26.4 cm
Corcoran Gallery of Art, Washington, D.C.,
gift of the Estate of William Woodville, VIII
(1996.38.1)

Provenance: William Woodville, VIII, by descent;
Corcoran Gallery of Art, by gift

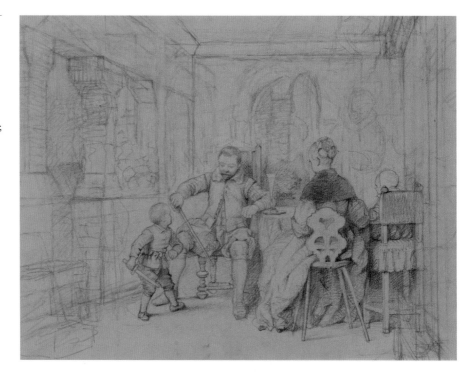

16. *Knight and Scribe*, 1852

Graphite heightened with white crayon;
sheet: 18.4 × 19.3 cm
The Baltimore Museum of Art, gift of Mrs. John
Sylvester, Augusta, Georgia 1936 (BMA 1936.597)

Inscribed: Recto: at lower left, "RCW 1852 Feb 22" in
graphite; Verso: across top, by later hand, "R. Caton
Woodville / to F. B. Mayer. / Baltimore 15 May 1854"
in graphite

Provenance: Frank Blackwell Mayer (1827–1899),
by gift, from the artist, 1854; Mrs. John Sylvester,
Augusta, Georgia, by descent from her stepfather;
The Baltimore Museum of Art, by gift, 1936

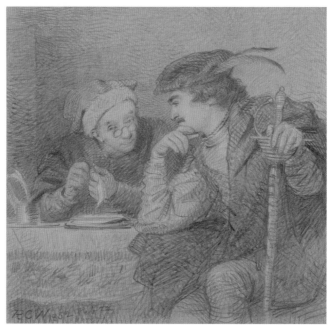

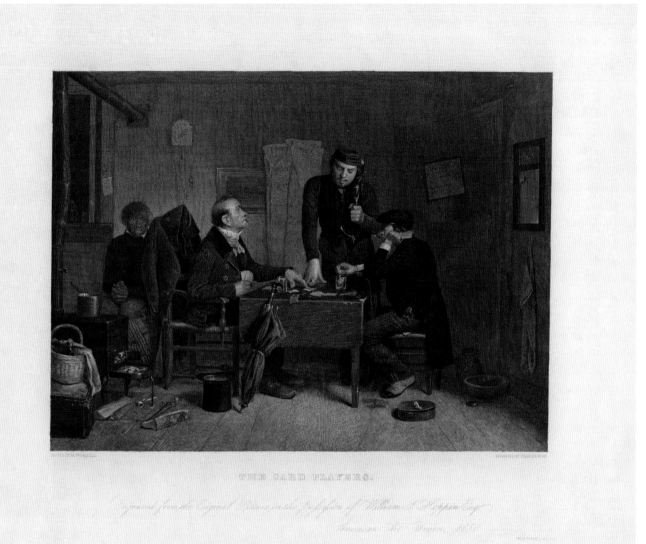

17. *The Card Players*

Charles Burt after Richard Caton Woodville
New York: American Art-Union, engraved 1850,
issued 1851

Engraving; sheet: 36.5 × 47 cm
Collection of the New-York Historical Society,
American Art-Union Collection (PR 159)

18. *Mexican News*

Alfred Jones after Richard Caton Woodville, *War News from Mexico*

New York: American Art-Union, engraved 1851, issued 1853

a: Engraving with hand-coloring, 63.7 × 54.1 cm
 Collection of Stiles Tuttle Colwill

b: Engraving; 73.2 × 60.6 cm
 Corcoran Gallery of Art, Washington, D.C., gift of the Estate of William Woodville, VIII (1996.38.3)

c: Engraving; 78.5 × 65.7 cm
 Collection of the New-York Historical Society, American Art-Union Collection (PR 159)

d: Engraving with hand-coloring, 63 × 54.6 cm
 The Walters Art Museum, Baltimore (93.142)

e: Engraving; 64.8 × 51.7 cm
 The Walters Art Museum, Baltimore (93.146)

f: From the gift book *Ornaments of Memory* (New York: D. Appleton, copyright 1854, issued 1856)

 Engraving; page: 24 × 31.5 cm
 George Peabody Library, The Sheridan Libraries, The Johns Hopkins University, Baltimore (818.3 076 quarto c. 1, p. 153)

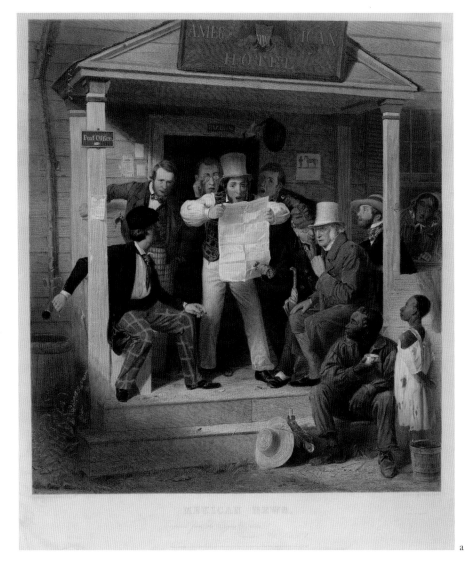

a

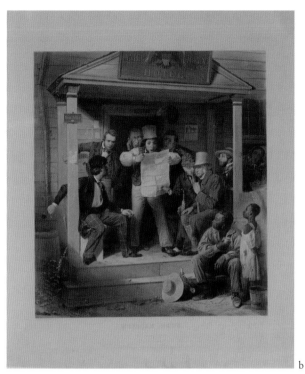

b

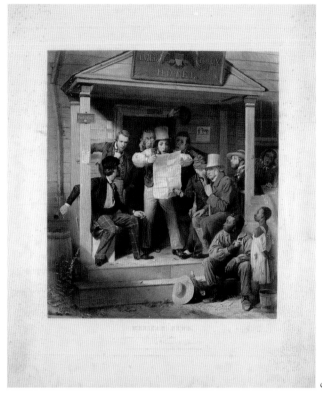

c

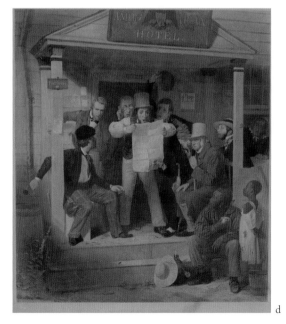

d

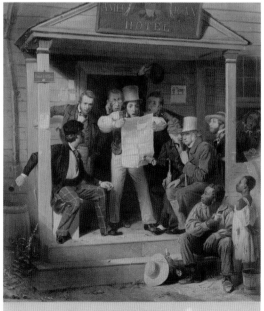

e

f

19. *The Game of Chess*

Charles Burt after Richard Caton Woodville

a: From *The Bulletin of the American-Art Union*
(July 1, 1851), opposite p. 53
Engraving, page 23.5 × 28.9 cm
Collection of the New-York Historical
Society (N11 .A3A31)

b: From the gift book *Ornaments of Memory*
(New York: D. Appleton, copyright 1854,
issued 1855)
Engraving, page: 24 × 31.5 cm
The Milton S. Eisenhower Library Special
Collections, The Sheridan Libraries, The
Johns Hopkins University, Baltimore, gift of
C. Marshal Barton (PQ510 .O7 1855 Q c. 1, p. 35)

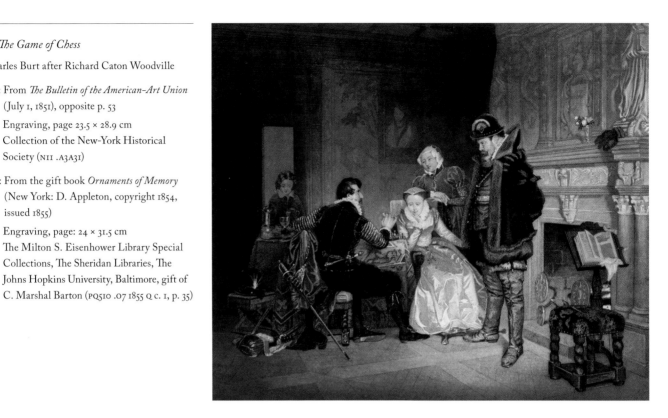

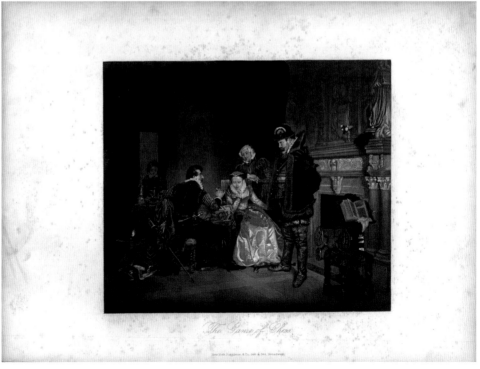

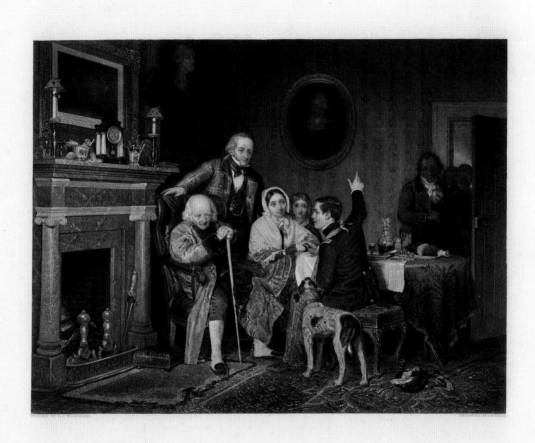

OLD '76 AND YOUNG '48.

From the original picture in the possession of the American Art-Union
American Art-Union 1851.

20. *Old '76 and Young '48*

J. I. Pease after Richard Caton Woodville

New York: American Art-Union, engraved 1851,
issued 1853

Engraving; 34.3 × 45.4 cm
Collection of the New-York Historical Society,
American Art-Union Collection (PR 159)

21. *Politics in an Oyster-House / Les Politiques au Cabaret*

Michele Fanoli after Richard Caton Woodville

Paris, New York, London: Goupil & Co., 1851

a: Lithograph with hand coloring;
 sheet: 37.1 × 29.9 cm
 The Baltimore Museum of Art, gift from
 the Estate of Mrs. Thomas Harrison Oliver
 (BMA 1942.72)

b: Lithograph with hand coloring; 38.4 × 31.1 cm
 Corcoran Gallery of Art, Washington, D.C.,
 gift of the Estate of William Woodville,
 VIII (1996.38.2)

c: Lithograph with hand coloring; 48 × 36.4 cm
 The Walters Art Museum, Baltimore, gift
 of Miss Sadie B. Feldman in memory of her
 brother, Samson Feldman, 1987 (93.145)

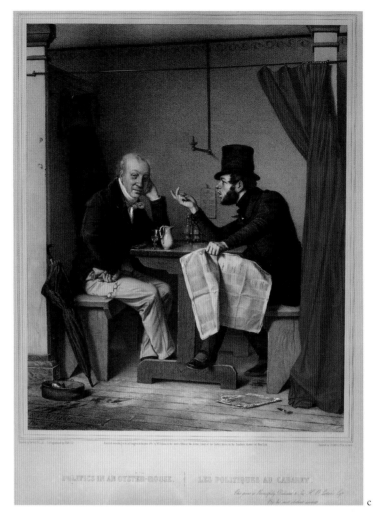

c

a

b

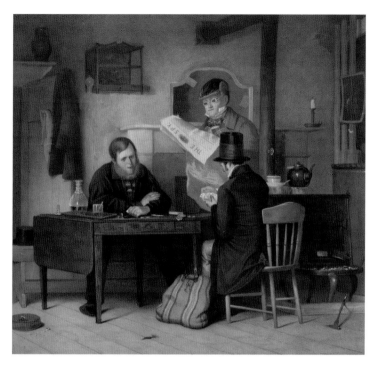

22. *Cornered!*

Christian Schultz after Richard Caton Woodville, *Waiting for the Stage*

Paris, New York, London: Goupil & Co., 1851

Lithograph with hand coloring; sheet: 37.2 × 40 cm
The Baltimore Museum of Art, gift from the Estate of Mrs. Thomas Harrison Oliver (BMA 1942.73)

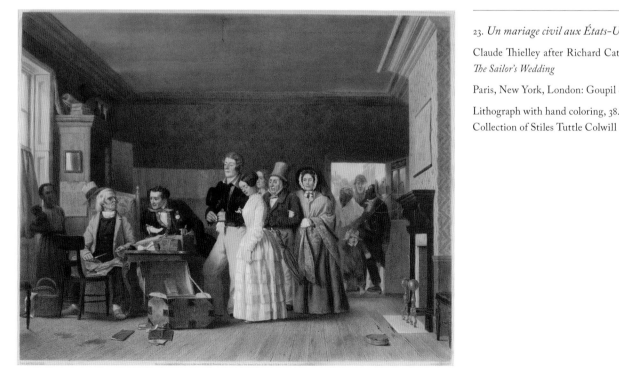

23. *Un mariage civil aux États-Unis*

Claude Thielley after Richard Caton Woodville, *The Sailor's Wedding*

Paris, New York, London: Goupil & Co., 1855

Lithograph with hand coloring, 38.5 × 48.9 cm
Collection of Stiles Tuttle Colwill

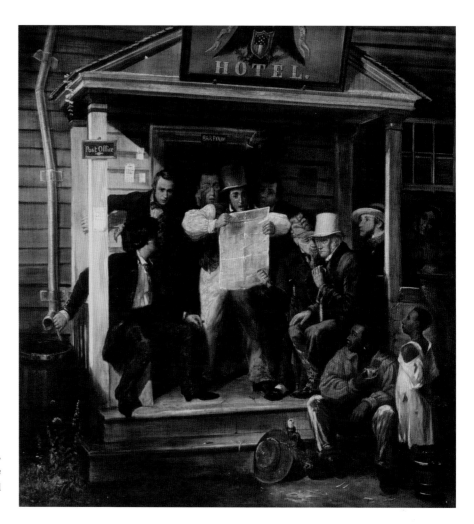

Fig. 68. Unknown artist, *Confederate News*, 1860s, after Richard Caton Woodville, *War News from Mexico*. Oil on canvas, 106.7 × 101.6 cm. Maryland Historical Society, Baltimore (1918.8.2)

The wide impact of Woodville's images during his lifetime and beyond is a topic worthy of further study. Baltimore had many Southern-sympathizing citizens, including the prolific German artist/dentist Adalbert Volk (1828–1912), who might have produced this unsigned painting. A copy from the print of Woodville's most famous work, this painting was owned by the Germania Club established in Baltimore in the 1840s. It was given to the Maryland Historical Society in 1918 by the Club at the peak of anti-German sentiment during the First World War. One detail has been changed from the Woodville original that may help date the painting to the period of the Civil War: rather than "Volunteers for Mexico," the placard on the left in the present work calls for "Volunteers for the Southern Conf. Army."

Abbreviated References

Baltimore 1945 *Two Hundred and Fifty Years of Painting in Maryland.* Exh. cat., Baltimore: Baltimore Museum of Art.

Baltimore 1984 William R. Johnston, ed. *A Taste of Maryland: Art Collecting in Maryland, 1800–1934.* Exh. cat., Baltimore: The Walters Art Museum.

Brooklyn Museum 2006 Theresa Carbone with Barbara Dayer Gallati and Linda Ferber. *American Paintings in the Brooklyn Museum: Artists Born by 1876.* Brooklyn and London: Brooklyn Museum in association with D. Giles Limited.

Brownlee, 2011 Peter John Brownlee, "The American Art-Union: Blank or Prize." *Perfectly American: The Art-Union and Its Artists*, 81–99. Exh. cat., Tulsa: Gilcrease Museum.

Burns and Davis 2009 Sarah Burns and John Davis. *American Art to 1900: A Documentary History.* Berkeley and Los Angeles: University of California Press.

Clark 1982 Henry Nichols Blake Clark. "The Impact of Seventeenth-Century Dutch and Flemish Genre Painting on American Genre Painting, 1800–1865." Ph.D. diss., University of Delaware.

Colbert 1997 Charles Colbert. *A Measure of Perfection: Phrenology and the Fine Arts in America.* Chapel Hill: University of North Carolina Press.

Corcoran Gallery of Art 2011 Sarah Cash, et al. *Corcoran Gallery of Art: American Paintings to 1945.* New York: Hudson Hills Press.

Detroit Institute of Arts 1991–2005 Nancy Rivard Shaw et al. *American Paintings in the Detroit Institute of Arts.* 3 vols. New York: Hudson Hills Press.

Düsseldorf 2011 Bettina Baumgärtel, ed. *Die Düsseldorfer Malerschule und ihre internationale Ausstrahlung, 1819–1918.* 2 vols. Exh. cat., Düsseldorf: Museum Kunstpalast. Petersberg: Michael Imhof.

Galletti 2011 Barbara Dayer Galletti et al. *Making American Taste: Narrative Art for a New Democracy.* New York and London: New-York Historical Society with D. Giles Limited.

Greenhouse 1995 Wendy Greenhouse. "Imperiled Ideals: British Historical Heroines in Antebellum American History Painting." In *Redefining American History Painting*, ed. Patricia Burnham and Lucretia Hoover Giese, 263–76. Cambridge: Cambridge University Press.

Grubar 1967 Francis S. Grubar. *Richard Caton Woodville: An Early American Genre Painter.* Exh. cat., Washington, D.C.: Corcoran Gallery of Art.

Hills 2011 Patricia Hills, "The Art-Union and the Ideology of Empire." *Perfectly American: The*

Art-Union and Its Artists, 44–79. Exh. cat., Tulsa: Gilcrease Museum.

Hoopes 1972 Donelson F. Hoopes. "The Düsseldorf Academy and the Americans." *The Düsseldorf Academy and the Americans*, 19–34. Exh. cat., Atlanta: High Museum of Art.

Humphries 1998 Lance Lee Humphries. "Robert Gilmor, Jr. (1774–1848): Baltimore Collector and American Art Patron." Ph.D. diss., University of Virginia.

Husch, 1993 Gail E. Husch, "Freedom's Holy Cause: History, Religious and Genre Painting in America, 1840–1860." In William Ayres, ed. *Picturing History: American Painting, 1770-1930*, 101–115. New York: Rizzoli.

Johns 1991 Elizabeth Johns. *American Genre Painting: The Politics of Everyday Life.* New Haven and London: Yale University Press.

Kelbaugh 1989 Ross J. Kelbaugh, "Dawn of the Daguerrean Era in Baltimore, 1839–1849." *Maryland Historical Magazine* 84:101–18 (repr. *The Daguerreian Annual* 1998).

Klein 1995 Rachel Klein. "Art and Authority in Antebellum New York City: The Rise and Fall of the American Art-Union." *Journal of American History* 81, no. 4 (March 1995): 1534–61.

Lee 1998 Lance Lee. "Robert Gilmor, Jr. (1774–1848): Baltimore Collector and American Art Patron." Ph.D. diss., University of Virginia, 1998.

Mayer and Myers 2011 Lance Mayer and Gay Myers. *American Painters on Technique: The Colonial Period to 1860.* Los Angeles: J. Paul Getty Museum.

Rutledge 1949 Anna Wells Rutledge, "Robert Gilmor, Jr., Baltimore Collector." *Journal of the Walters Art Gallery* 12:19–41.

Scharf 1974. Aaron Scharf, *Art and Photography.* Harmondsworth: Penguin Books.

Schroeder 1973 John H. Schroeder. *Mr. Polk's War.* Madison: University of Wisconsin Press.

Semmes 1917 John E. Semmes. *John H. B. Latrobe and His Times, 1803–1891.* Baltimore: Remington.

Templeton 1849 J. S. Templeton. *The Guide to Oil Painting.* London: G. Rowney.

Tuckerman 1867 [1966] Henry T. Tuckerman, *Book of the Artists: American Artist Life, Comprising Biographical and Critical Sketches of American Artists: Preceded by an Historical Account of the Rise and Progress of Art in America.* (New York: G. P. Putnam & Son, repr. New York: James F. Carr, 1966.

Tyler 1993 Ron Tyler, "Historic Reportage and Artistic License: Prints and Paintings of the Mexican War." William Ayres, ed. *Picturing History: American Painting, 1770–1930*, 81–99. New York: Rizzoli.

Wolff 2002 Justin Wolff. *Richard Caton Woodville: American Painter, Artful Dodger.* Princeton and Oxford: Princeton University Press.

Woolf 1984 Bryan J. Woolf, "All the World's a Code: Art and Ideology in Nineteenth-Century American Painting," *Art Journal* 44 (Winter 1984): 328–37.

Index

References to illustrations are in *italics*. Artists' life dates, to the extent known, are given parenthetically.

Photography Credits

Courtesy, American Antiquarian Society: fig. 13, 32, 34, 35

Amon Carter Museum of American Art, Fort Worth, Texas: fig. 1

bpk, Berlin / Staatliche Museen zu Berlin, Nationalgalerie / Joerg P. Anders / Art Resource, NY: fig. 22

The Baltimore Museum of Art: figs. 3, 5; checklist nos. 16, 21a, 22

Bibliothèque nationale de France, Paris: fig. 30

Brooklyn Museum of Art, New York: fig. 67

Elizabeth Caton Woodville Callender (Photo © The Walters Art Museum, Baltimore, Susan Tobin): checklist no. 1

Collection of Stiles Tuttle Colwill (Photo © The Walters Art Museum, Baltimore, Susan Tobin): figs. 39, 66; cat. no. 5; checklist nos. 3–5, 7–9, 18a, 23

Corcoran Gallery of Art, Washington, D.C.: figs. 4, 61; cat. no. 14; checklist nos. 15, 18b, 21b

Crystal Bridges Museum of American Art, Bentonville, Arkansas (Photo © The Walters Art Museum, Baltimore, Conservation & Technical Research): fig. 49; (Photo © The Walters Art Museum, Baltimore, Susan Tobin): figs. 44, 50, 62; cat. no. 8

Detroit Institute of Arts / The Bridgeman Art Library: fig. 43; cat. no. 3

Godel & Co., Inc., New York (Photo © The Walters Art Museum, Baltimore, Susan Tobin): fig. 56; cat. no. 2

Courtesy of the Künstlerverein Malkasten, Düsseldorf (Horst Kolberg, Neuss): fig. 42

Library of Congress, Washington D.C.: fig. 21

Courtesy of the Maryland Historical Society, Baltimore: figs. 2, 16, 18, 19, 54; checklist no. 2; (Photo © The Walters Art Museum, Baltimore, Conservation & Technical Research): fig. 40, 68; (Photo © The Walters Art Museum, Baltimore, Susan Tobin): fig. 55; cat. no. 1

Page 1: *Politics in an Oyster-House / Les Politiques au Cabaret*, Michele Fanoli after Richard Caton Woodville (checklist no. 21c)

Page 2: *Self-Portrait with Flowered Wallpaper*, detail (cat. no. 11)

Page 5: *Old Woman and Child Reading a Book*, detail (cat. no. 13)

Page 7: *Waiting for the Stage*, detail (cat. no. 14)

Page 10: *War News from Mexico* (cat. no. 8)

Page 27: *The Card Players*, detail (cat. no. 3)

Page 39: *Old '76 and Young '48*, detail (cat. no. 12)

Page 51: *Cornered!*, detail, Christian Schultz after Richard Caton Woodville (checklist no. 22)

Page 65: *The Italian Boy with Hurdy-Gurdy*, detail (cat. no. 16)

Page 82: *Self-Portrait in a Black Coat*, detail (cat. no. 10)

Page 116: *Self-Portrait*, detail (checklist. no. 3)